The Saga of The Cariboo Gold Rush
Revised and Expanded Edition

Wagon Road North

ART DOWNS
EDITED BY KEN MATHER

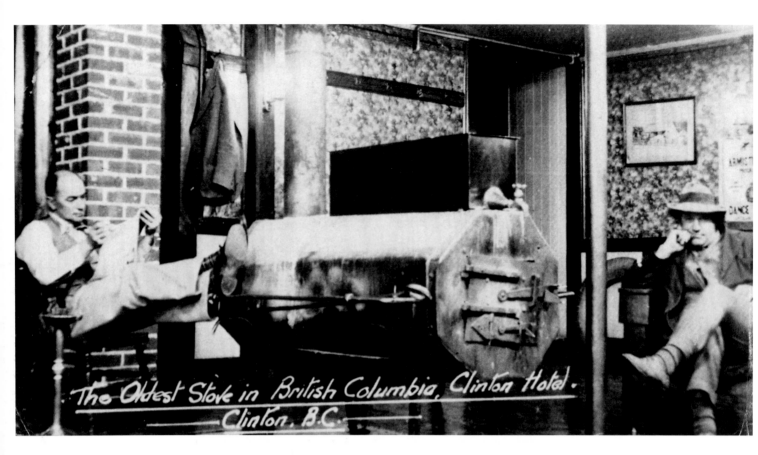

The Oldest Stove in British Columbia, Clinton Hotel. Clinton, B.C.

above This venerable stove in the lobby of the Clinton Hotel warmed guests for almost a hundred years. It is now in the Clinton Museum. HERITAGE HOUSE ARCHIVES

Heritage House Publishing Company Ltd.
heritagehouse.ca

Originally published in the *Northwest Digest* in 1960.

Cataloguing information available from Library and Archives Canada

ISBN 978-1-77203-360-1 (paperback)
ISBN 978-1-77203-361-8 (ebook)

Edited by Ken Mather
Copyedited by Karla Decker
Proofread by Nandini Thaker
Designed by Setareh Ashrafologhalai
Cover images: Mucho Oro Gold Mining Co., Stout's Gulch, from Heritage House Archives (*front*); Fraser country above Dog Creek, courtesy of Liz Bryan (*back*)
Maps on pages 32–33 and 144 by Gwen Lewis

The interior of this book was produced on FSC®-certified, acid-free paper, processed chlorine free, and printed with vegetable-based inks.

Heritage House gratefully acknowledges that the land on which we live and work is within the traditional territories of the Lkwungen (Esquimalt and Songhees), Malahat, Pacheedaht, Scia'new, T'Sou-ke, and W̱SÁNEĆ (Pauquachin, Tsartlip, Tsawout, Tseycum) Peoples.

We acknowledge the financial support of the Government of Canada through the Canada Book Fund (CBF) and the Canada Council for the Arts, and the Province of British Columbia through the British Columbia Arts Council and the Book Publishing Tax Credit.

25 24 23 22 21 1 2 3 4 5

Printed in Canada

THE CLINTON STOVE

Just an old, blackened monster—a warm, great, burly stove—
I abide in hotel at Clinton—on trail to the treasure trove.

I was born back in the sixties, in the days of the gold stampede;
To add to the sourdoughs' comfort, and serve the Cariboo need.

On the banks of Harrison River, in the year 1862,
A burly smith put me together, all glistening and strong and new.

But not long there in abiding, they boosted me on the oxcart.
And sent me up to Clinton to take my stampeding part.

'Nigh eighty years this winter, and yet I'm hail and strong;
Daily I carry my burden—warming the motley throng

That crowd this old log structure, which houses my burly frame,
Steeped in romance and legend that built the Cariboo name.

I've seen the sourdough and miner, I've known the tinhorn and tout,
Skinner and rough old trapper, alike warmed the weak and stout.

I've stored up tales in millions of mining, romance and lore,
I know all this grand old country—stories and tales by the score.

Deep in her hills and mountains, hidden in ledges of rock,
Buried in gravels of rivers, tilled with her golden stock

Of trout—gamey, slivered and sporting—the spot where the salmon spawn.
Shy honker seeks seclusion, and all the wood denizens throng.

Golden-tinged hills of alder, laughter-filled and gay,
Babbling streams and brooklets—for that is the Cariboo Way.

Yes! I know the romance of gold rush!—I know the present as well!
Many's the tragic occurrence could vouch if I cared to tell!

I live today as you see me—a grand old, husky pioneer—
Dispensing my warmth and comfort, trying the weary to cheer.

'Nigh eighty years I've done service through days of the golden past,
Still am I hale and hearty, to duty still holding fast.

Just an old, rusting monster, yet have I the heart of a king.
Romantic days of the stampede—yet am I able to sing!

"SILVERTIP" BROWN
New York City
February 1, 1938

Contents

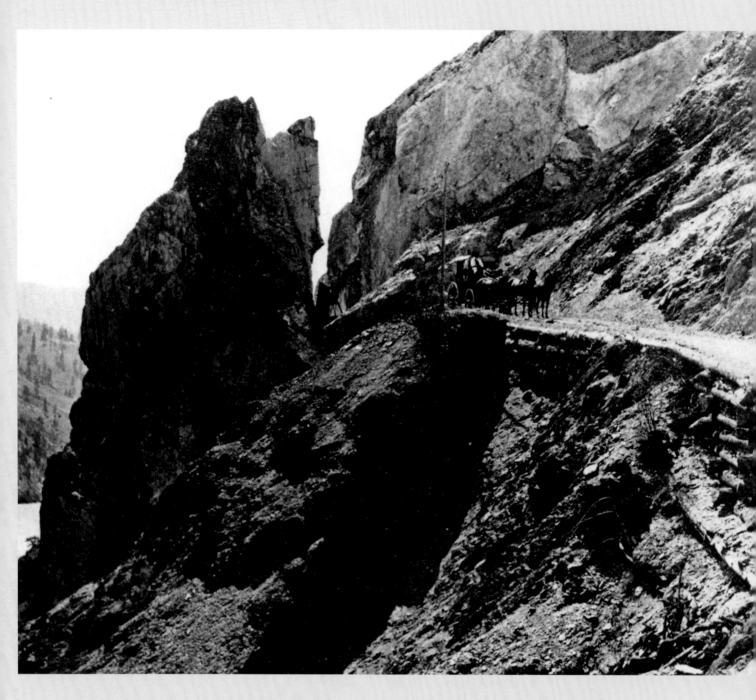

A BC Express stagecoach on the Cariboo Wagon Road in 1871 at Hells Gate along the Thompson River. The sheer, unprotected dropoffs through the Fraser and Thompson River Canyons were very dangerous. Among those killed was the wife of Steve Tingley, who was part owner of the BC Express Company.

HERITAGE HOUSE ARCHIVES

PREFACE

I ARRIVED IN BARKERVILLE in the spring of 1979 after working six years in heritage sites in Alberta. At that time, Barkerville was under the administration of the Government of British Columbia Parks Branch. The "powers that be" in the Parks Branch were somewhat at a loss as to what to do with this park that was not a park. Barkerville Historic Park had been established by Order-in-Council on January 12, 1959, with an initial area of 64.84 hectares. This was increased in 1973 to 457.29 hectares. In the early 1960s, a small museum and an introductory video had been developed in the museum building to orient visitors before they entered the historic town. Some signage and displays and a school program had been developed, but interpretive activities were mostly limited to a more-vaudeville-than-history show at the Theatre Royal. So it was that twenty years on, the Parks Branch was realizing that the preservation and presentation of the unique collection of not just buildings but also memorabilia of Barkerville needed to be approached more as a museum than as a park. A curator and support staff were added to the permanent staff under a manager. I stepped into the position of Interpretation and Education Coordinator.

The immediate challenge for the curatorial staff was to ascertain the details of Barkerville's rich history. What we soon discovered was that the "textbook" of Cariboo gold-rush history and Barkerville's place in it already existed: a modest publication of eighty pages titled *Wagon Road North: The Story of the Cariboo Gold Rush in Historical Photos*, put together by a man named Art Downs. Within its pages could be found a treasure trove of gold-rush photographs taken by the first photographers in British Columbia. And, even

though it was primarily intended to be a book of "historical photos," it was rich with the stories and anecdotes of those who travelled to the Cariboo in search of fortune. The book helped make the gold rush and the town of Barkerville come alive for me. *Wagon Road North* provided the stories and images that I was able to use in developing interesting and informative experiences for visitors to Barkerville. That same year, I paid my first visit to the Provincial Archives of BC and, guided by the vast sources contained in *Wagon Road North*, I began to do my own research on the history of the Cariboo gold rush and its main settlement, Barkerville. I have been in the provincial archives just about every year since then and have found on almost every trip a first-hand account of the gold rush or the Cariboo Road that Art Downs had found before me. What I have not found are errors in fact that might alter the historical narrative put together by Downs.

In the summer of 1980, I had the pleasure of meeting Art Downs as he worked on the third revised edition of *Wagon Road North*. By then, I had learned enough about Barkerville to really appreciate what he had put together. We chatted for a bit and I found him to be a friendly down-to-earth man whose passion for Cariboo history was obvious. For what it was worth, I told him I thought one of the photos he had chosen for the new edition included the famous barber of Barkerville, Wellington Delaney Moses. I was immensely gratified to find, when the new edition came out, that he had included that photo and fact on page 55, referring to "historians" who wondered if the man was indeed Moses the barber. Wow! He numbered me among historians.

ARTHUR GEORGE DOWNS was born in 1924 in England and immigrated to Canada when he was five years old. The family settled in northeastern Saskatchewan and suffered through the Depression years. At the outbreak of the Second World War, Art's father joined the Canadian Navy and the family moved to the west coast. At the age of nineteen, Art joined the merchant navy and spent seven years, mainly as a radio officer. He had always wanted

to be a reporter but, upon coming ashore, went to help his father on a ranch in the Quesnel River Valley in the Cariboo. Art later recounted, "Our ranch was the same as about ninety percent of Cariboo ranches. The owner needed an outside job to support the operation. I reluctantly abandoned ranching but left with a double legacy—the knack of stilling a potent beverage christened 'Quesnel River Screech' and an incurable malady known as Caribooitis. The most noticeable symptom of the latter affliction is an unsettled feeling when the victim is anywhere else except the Cariboo."

Art was fascinated with Cariboo history right from the start of his time there. He wrote his first Cariboo history article, "The Saga of the Upper Fraser Sternwheelers," in 1950. It was published in the *Cariboo Digest*, a periodical that had started up in 1945. In 1955, he partnered with Wes Logan and purchased the *Cariboo Digest* from its founder, Alex Sahonovich. Under Art's editorship, the magazine became BC *Outdoors,* which successfully blended history, the outdoors, and wildlife conservation. His commitment to conservation was ahead of its time, and he used the magazine as a platform to make his case for the preservation of wilderness and wildlife. He served as president of the BC Wildlife Federation and later as a director of the Canadian Wildlife Federation and a member of the Pacific Salmon Commission.

Art was always passionate about history and in 1960, the year after Barkerville Historic Park was established, he put together *Wagon Road North*. It contained a wealth of anecdotes and stories that Art had collected over the years and used photos from the BC Archives, which he had mined extensively. The book was an instant success and was reprinted in 1961, 1962, 1963, 1965, and 1967, becoming one of the bestselling books of its time. Its success prompted Art and his wife, Doris, to start their own publishing business in 1969, appropriately named Heritage House. Its first publication was yet another revised edition of *Wagon Road North*. The book continued to sell in great numbers and, in 1973, a second revised edition was published, followed by a third

revised edition in October 1980. By then, Art had sold BC Outdoors to concentrate on Heritage House to publish "books by BC writers for BC readers."

Heritage House under Art's guiding hand soon gained a reputation for publishing books that were engaging and accessible to everyone, proving that an interest in history was not just the realm of academic historians but that "popular history" was interesting to all. Art continued to write books that covered areas of BC history, including two on another of his favourite topics, paddlewheelers: *British Columbia–Yukon Sternwheel Days* and *Paddlewheels on the Frontier*, and another, *The Hope Slide: Disaster in the Dark.* He also compiled and edited the four volumes of *Pioneer Days in British Columbia,* a selection of historical articles from *BC Outdoors,* and four volumes of *The Law and the Lawless: Frontier Justice in British Columbia and Yukon.* Heritage House was sold by Art Downs to Rodger Touchie in 1995. Art Downs passed away on August 13, 1996.

Art's legacy remains in many areas: as a writer, as an editor, and as a publisher. But perhaps his greatest legacy has been *Wagon Road North*, which is still being purchased and read sixty years after its first edition and fifty years after it became the first publication of Heritage House Publishing. It has proven to be a readable and accurate account of the Cariboo gold rush for generations of BC readers. The *Encyclopedia of British Columbia*, published in 2000, in its entry on "Book Publishing in British Columbia" noted the success of the book: "The most notable published book to follow the 1958 breakthrough was *Wagon Road North* (1960) by Art Downs, which is still in print and is in the top 5 all-time best sellers."

Its most recent expanded and revised edition came out in 1993. Much has happened since then and, as the fiftieth anniversary of Heritage House approached, I was asked to "spruce it up for a modern audience." As I read through this popular history that I have referred to umpteen times during the past forty years, I was struck by how well it has withstood the test of time. In this new edition, I have altered lightly the work begun by Art Downs in 1960, preferring only to update language and attitudes of the day toward BC's Indigenous Peoples, and to correct small errors that researchers like myself have discovered over the years. This revised edition does not purport to be academic in its analysis of history or even politically correct. The story of British Columbia has now thankfully come to include more fully the stories of women and Indigenous and Chinese people, and this new edition recognizes their contributions in more detail. But, with these small additions, *Wagon Road North* can stand on its own and will no doubt be read for generations to come.

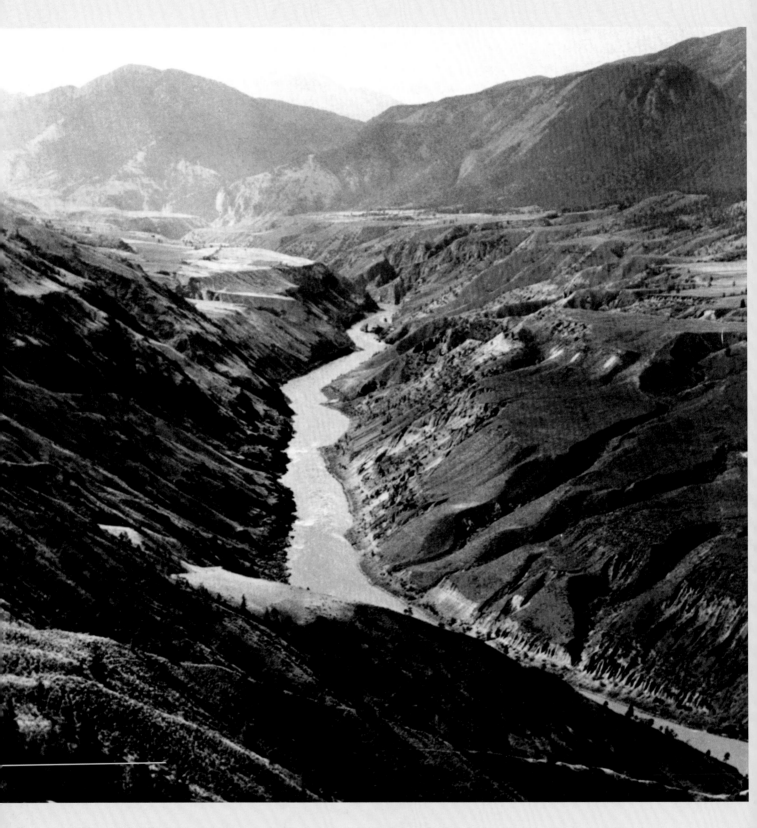

The Fraser River: Gold on her bars lured people north, promise of greater riches hastened them upstream, and mountain tributaries yielded a bonanza in a land that became known as Cariboo. HERITAGE HOUSE ARCHIVES

Foreword

THE FIRST OF our western mountains, a range that today we call the Selkirks, was born an estimated 100 million years ago. Then, as the earth's core continued shrinking, titanic pressures were exerted on the crust, forcing it to warp and buckle, upthrusting additional mountains. In this manner, perhaps 80 million years ago, was born the range known today as the Rockies. During ensuing millennia, additional ranges appeared west of the Selkirks and, perhaps one million years ago, the land was moulded to the general shape we know today.

In these mountains that pierced skyward over thousands of square miles were a hodgepodge of minerals, with a yellow element that would one day be called "gold" among the scarcest. It was fairly soft in comparison to other minerals, it was heavier than most, and it was comparatively rare. But here and there, in yellowish stringers, it was squeezed and threaded through cracks in the rocks that formed the mountains. And like the rocks themselves, it was worn away by the inexorable forces of nature. Winter snow, spring frost, summer sun, and autumn storm were the abrasive elements. A chip fell here, a grain there. The process was dreadfully slow, but nature is not rushed.

As the dull-yellow slivers weathered from their rocky embrace, they came under the influence of other shaping forces. Spring flood and summer freshet tumbled and rolled them along the bottom of countless waterways. In many places they fused with other pieces or with rocks, stones, and clay. Since they were heavier than most substances, they were less affected by water currents. In pools of shallow water they came to rest; behind boulders they formed in pockets, and in eddies they rolled and came to rest like odd-shaped

eggs in a basket. Far in the future they would be known as "nuggets."

While this process continued, ponderous mountains of ice were inching southward; ice that eventually covered the land in a sheet three thousand and more feet thick. The glacial mass churned and ground the earth, wiped out established waterways, carved new ones, scoured to bedrock in one place and heaped piles of rubble in others. Creeks and rivers were born and died, water flowed one way then the other, torrent was replaced by trickle, lake by valley, and valley by lake.

Millions of square miles were scarred by the ice, including a region ultimately to be called the Cariboo Mountains. But here, there was a difference. Mixed with the boulders and gravel and clay in many places were unusual concentrations of the yellowish

metal. In some places it had been ground as fine as flour, in others it lay in flakes and kernels; frequently it fused to form chunks up to a pound or more.

In the course of time, nature changed the plant and animal life in the region. Human beings appeared about thirty thousand years ago. They had bronze skin and modest wants that were supplied by animals and plants of the forest and fish from the streams and rivers. Over the centuries their way of life changed little. The Indigenous Peoples along what would later be called the Fraser River consisted of the Sto:lo along the Lower Fraser, the Nlaka'pamux (Thompson), the Stl'atl'imx (Lillooet), the Secwépemc (Shuswap), and the Dakelh (Carrier). A major food source for these peoples was the salmon that was found in abundance in the Fraser.

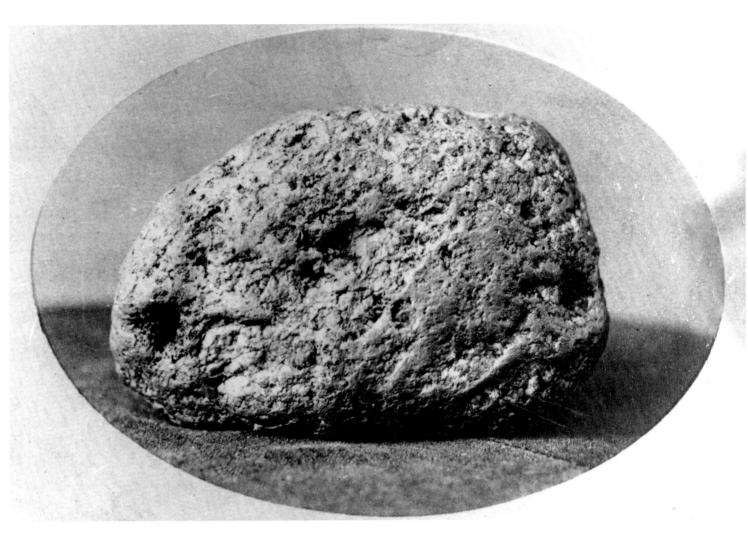

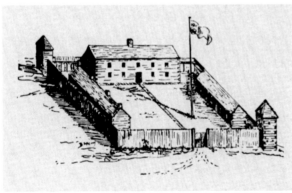

opposite Indigenous people fishing in the Fraser River close to Yale. Note the drying racks up on the shore. Since the river was such an important source of food, thousands of Indigenous Peoples lived along its shores. CITY OF VANCOUVER ARCHIVES. AM753-S1-F2-: CVA 256-02.11

above A nugget of gold from the creeks of the Cariboo, the treasure that triggered the rush. HERITAGE HOUSE ARCHIVES

left Fort St. James as it looked during the 1830s. It was typical of the chain of HBC forts throughout the land prior to the gold rush. HERITAGE HOUSE ARCHIVES

But around two hundred years ago, other people arrived. They had white skin, and they were to cause upheavals not only to the Indigenous Peoples but to the very land itself.

The wants of these men were not simple and modest. They were not satisfied with being sufficient for their daily requirements, but were aggressive. They wanted the animals of the forest trapped and skinned, the skins pressed into bales, and the bales sent by canoe to a land beyond the mountains. The first of these people arrived with eight companions, but he didn't change the land. He was on a voyage of discovery, and after reaching the ocean and etching on a rock, "Alexander Mackenzie, from Canada, by land, the 22nd of July, 1793," he went home.

Nine years later came other white men. On several lakes and rivers, they erected log buildings and surrounded them with picket fences and called these structures "forts." They planted crops and traded for the skins of the forest such items as pots and pans, rifles, clothing, beads, and many other things of value to the Indigenous Peoples of the region.

While the small number of fur traders remained, the country changed little. They were interested in furs and they discouraged anyone from settling in the region or trading with the Indigenous folk. They wanted the area to remain a wildlife sanctuary. But they set in motion forces that would overwhelm them and forever change a way of life that had endured for centuries. The trigger of this force was gold.

Stampede to the Fraser River

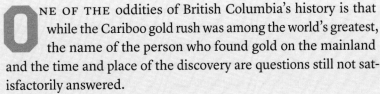

ONE OF THE oddities of British Columbia's history is that while the Cariboo gold rush was among the world's greatest, the name of the person who found gold on the mainland and the time and place of the discovery are questions still not satisfactorily answered.

Some say that Chief Trader Donald McLean of the Hudson's Bay Company at Fort Kamloops bought gold from Indigenous people as early as 1852. Another story tells that in 1856, an Indigenous man paused on the bank of the Nicomen River for a drink and noticed a yellowish pebble in the gravel. He fished it out and it proved to be gold. Soon the entire community was at work recovering the yellow stones and selling them to the Hudson's Bay Company.

Of this latter fact there is no doubt. By February 1858, the Company had 800 ounces of gold. It also faced a dilemma. A horde of miners clumping through the wilderness was the last thing the Hudson's Bay Company wanted. Over the years, they had built a monopoly in the fur trade and they knew from past experience that newcomers always disrupted this monopoly with a corresponding drop in Company profits. But Company officers were also practical. The 800 ounces of gold was of little commercial value in its raw state. It had first to be minted—and the nearest mint was in San Francisco. Accordingly, in February 1858, the nuggets and flakes were loaded on the steamer *Otter* for shipment to the mint.

At that time in San Francisco, almost anyone of importance belonged to the Volunteer Fire Department, and the mint superintendent was no exception. At a firemen's meeting shortly after the arrival of the *Otter,* the conversation turned to gold. The superintendent was present and remarked, "Boys, the next excitement will be on the Fraser River." He then told about the coarse

gold which the purser of the *Otter* had brought to the mint.

Since the California gold rush had taken place only a few years previously, San Francisco was very gold-conscious. This new area sounded like a good prospect. Accordingly, a small party of miners immediately set out for the region. They arrived on the Fraser in early spring and headed upriver past Fort Langley to Fort Hope. They asked for information, but the HBC factor, Donald Walker, in keeping with Company policy, refused to talk about the country. To the free and easygoing Californians, this attitude seemed strange, but it didn't discourage them. James Moore, one of the miners, later wrote:

The next morning we left Hope and camped on a bar at noon to cook lunch. While doing so, one of our party noticed particles of gold in the moss that was growing on the rocks. On the bar he washed a pan of that moss and got a prospect. After lunch we all prospected and found good pay dirt. We named the bar 'Hill's' after the man who got the first prospect.

And thus by accident was made the first discovery of what became known as the Cariboo gold rush. Hill's Bar proved the richest ever discovered, and was ultimately to yield $2 million. The miners promptly sent word of their find to San Francisco, and the HBC had triggered what it wanted least—a stampede to the river.

The first major influx was on April 25, 1858, when the paddlewheel steamer *Commodore* docked at Fort Victoria with 450 men, sixty of whom were British and the remainder Americans, Germans, Italians, and a variety of other nationalities. At that time, the European population of southern Vancouver Island was about four hundred, for the most part employees of the HBC and English colonists attempting to develop farms. The *Commodore* arrived just as Sunday church services were completed. As citizens watched the wooden vessel, they little realized that the fur-trade era was being replaced; starting was a rousing decade that would change the land and the people forever.

The *Commodore* was followed by the *Golden State*, the *Constitution*, and then a virtual wave of vessels.

On May 8, just thirteen days after the arrival of the *Commodore*, Governor Douglas estimated that 1,000 men were already on the Fraser, and a week later he increased this estimate to 1,500. Steamship records show that from San Francisco alone, 455 miners left for Victoria in April; 1,262 in May; 7,149 in June; and 6,278 in July.

But these figures were conservative. In reality each vessel was laden to two or three times its capacity, and shipowners didn't dare give true passenger lists. The *Sierra Nevada*, for instance, officially carried 900 passengers, but at Fort Victoria she disembarked 1,900. The *Orizaba* and the *Cortez* left San Francisco with 1,400 passengers, but after nonstop voyages to Victoria landed 2,800. A reliable estimate is that in May, June, and July, 23,000 people left San Francisco by sea and another 8,000 made their way overland.

But San Francisco wasn't the only community in a frenzy. In New York, excitement was so great that one prospective gold seeker stood in line all day for a ticket on a ship bound for San Francisco. The *London Times* had its correspondent in San Francisco send continuous reports of developments at the diggings. From Washington, boats, canoes, and every other species of craft carried people to the Fraser River. In Puget Sound, sailing ships lay idle as crews deserted them to head for the goldfields, and even soldiers in United States forts left their posts and headed northward. As a newspaper correspondent reported, "None too poor and none too rich to go. None too young and none too old to go, even the decrepit go."

Many gold seekers arrived at Fort Victoria after extremely hazardous journeys, only to learn that their problems had just started. They were still over two hundred miles from the goldfields, half the distance across reef-studded ocean laced by treacherous tide rips, currents, and gale-force winds. Many perished in the cold ocean and many more drowned in the river itself, but the lure of gold was so strong that the newcomers worried not about personal danger. Their goal was the river, and in June 1858, one observer reported that in one ravine alone at Fort Victoria, over one hundred boats were being built.

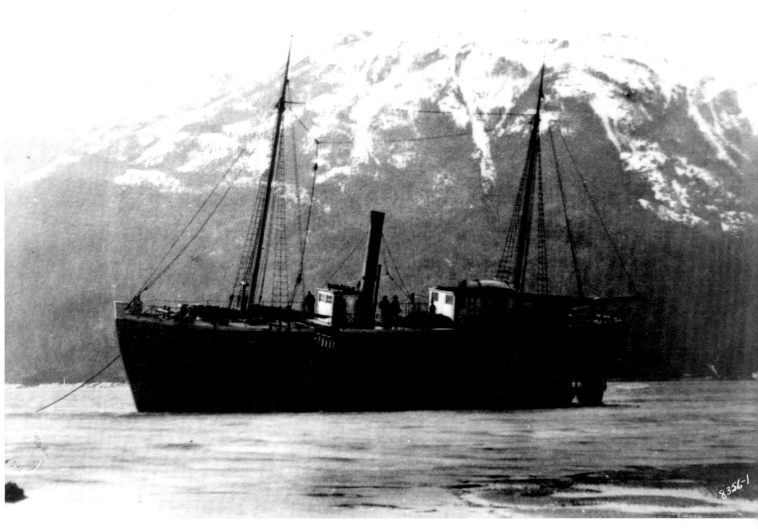

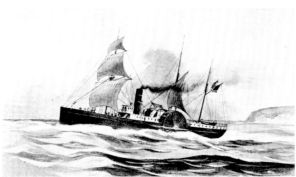

above The Hudson's Bay Company's steamship *Otter*. In February 1858, the nuggets and gold dust loaded at Fort Victoria for the mint at San Francisco changed the land. A region that had been a vast HBC fur preserve became the colony—and later the province—of British Columbia. CITY OF VANOUVER ARCHIVES. AM54-S4-: BO P64

left On a Sunday morning in April 1858, the paddlewheel steamer *Commodore* rounded the southern tip of Vancouver Island and anchored near Fort Victoria. She carried 450 miners from San Francisco, the vanguard of a horde that would top 30,000 before summer's end. HERITAGE HOUSE ARCHIVES

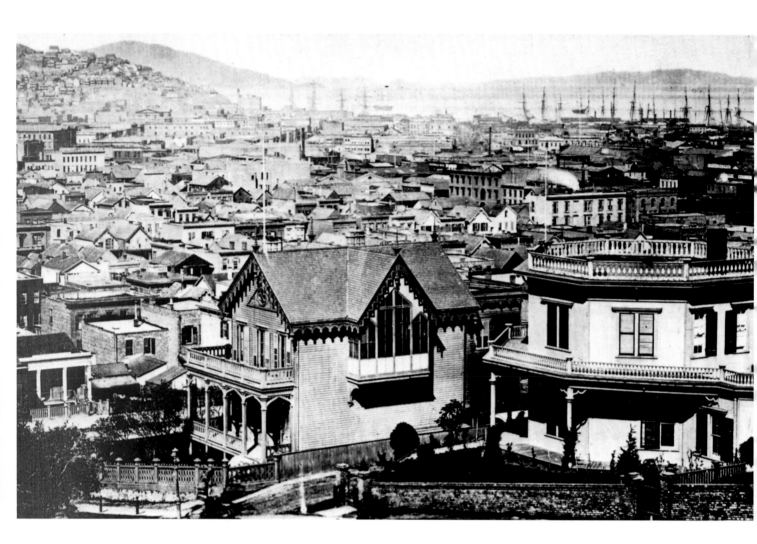

San Francisco was the main point of embarkation for Fort Victoria and the Fraser River. In the spring of 1858, the city was described as follows in the *Pioneer and Democrat* newspaper: "The roads from the mountains were lined with foot-passengers on their way to San Francisco. Stage coaches came rolling into Sacramento, groaning under their living cargo of sturdy miners. The worm-eaten wharves of San Francisco trembled almost daily under the tread of the vast multitudes that gathered to see a northern steamer leave. With that reckless disregard of human life so characteristic of the American ship-owner, old hulks, which had long been known to be unseaworthy and rotten, were refitted for the new El Dorado. Engines, rusty from years of idleness, were polished up; leaky boilers were repatched—paint and putty filling gaping seams; and with names often changed, to hide their former reputations, steamer after steamer sailed from our port, loaded to the guards with freight, and black with the crowds who were rushing to the newly-discovered land of gold." HERITAGE HOUSE ARCHIVES

An English author, Kinahan Cornwallis, described the typical gold seeker: "The American is eager, pushing, and impetuous; he is fond of rush, if there is the remotest chance of gaining anything by it; and in undertakings of a hazardous and uncertain nature he is without a rival in his achievements. He will 'drive a trade' and explore, in the hope of gain, farther and quicker into the heart of a country no matter what the hardships and obstacles to be contended against, than any other; not even his Anglo-Saxon cousins excepted."

The same author provided a description of an individual miner:

"He was a gaunt, stringy, dried up looking Kentuckian, with a gutta-percha coloured (dark-brown) face, sunk into which, on either side of his nose, twinkled two all alive and piercing eyes. His hair was long and light, and crisped up with the dry heat of the weather, so much so that it gave me the idea of extreme fragility and brittleness. He carried a couple of revolvers, and a bowie knife, with the point of which he took the opportunity of picking his teeth immediately after supper."

Another writer in June 1858 described the incoming Americans in the following words: "They were all 'packed,' that is, they all carried more or less baggage across their shoulders, and were all equipped with the universal revolver, many of them carrying a brace of such, as well as a bowie knife."

On the Fraser River itself, there was no doubt that gold was there. Those who fought their way upstream in early spring found gold on bars and ledges, in crevasses, and in the sand and gravel. One miner later wrote,

"We found gold everywhere, and my only surprise was that a region so auriferous should have remained so long unproclaimed and hidden from the gaze of civilization. I found a very choice quartz specimen, six ounces in weight, which contained at least four ounces of gold, half jutting out of the sand on the river's bank. During this day's work, seven nuggets, varying from about half an ounce to five ounces in weight were picked up, while the average yield of dust was no less than four ounces each man, and all I had to work with was a gold pan."

On April 29, 1858, another miner named Franklin Matthias wrote as follows:

Friend Plimmer:

We have arrived in these mines at last, after one of the hardest trips on record. I shall not attempt to give you a narrative of the difficulties and dangers of travelling on this river, as it would be impossible for me to do justice to it at present. It was next to impossible to get up when we came, and when the river rises to its full height no canoe or boat can possibly get up or down.

We are now located thirty miles above the junction of the Fraser and Thompson Rivers, on Fraser River. The distances up are as follows: From the mouth of Fraser River to Fort Langley, thirty miles; from there to Fort Hope, sixty miles; from Fort Hope to Fort Yale, one day's travel; from Fort Yale to the Forks, eight days' travel, and from the Forks to where we are now, thirty miles; making in all about two hundred miles. About one-fourth of the canoes that attempt to come up are lost in the rapids, which extend from Fort Yale nearly to the Forks. A few days ago six men were drowned by their canoe being upset in attempting to go down. There is more danger in going down than in coming up. There can be no doubt about this country being immensely rich in gold. Almost every bar on the river from Fort Yale up will pay from three to seven dollars a day to the man, at the present stage of the water, and when the river gets low, which will be about next August, they will pay very well. One hundred and ninety-six dollars was taken out by one man last winter in a few hours, but the water was then at its lowest stage.

The prices of provisions here are as follows: flour, $35 per cwt.; pork, $1 per lb.; beans, 50 cents per lb., and other things in proportion. Every party that starts from the Sound should have their own supplies to last them three or four months, and should bring the largest sized Chinook canoes, as small ones are very liable to swamp in the rapids. Each canoe should be provided with about thirty fathoms of strong line for towing over swift water, and every man well armed."

Prices on the Fraser were extremely high compared to those in Victoria, just over two hundred miles away. On September 5, 1858, a miner named Joseph Hiller from somewhere on the Fraser wrote the following account to his family in the eastern United States: "Food is very dear, one pound of flour,

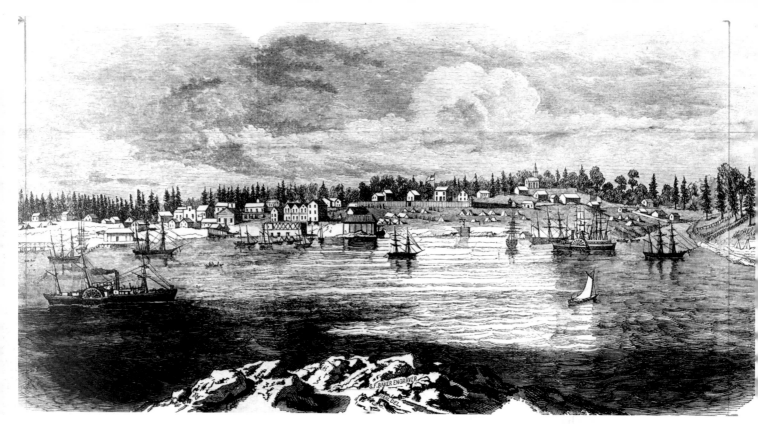

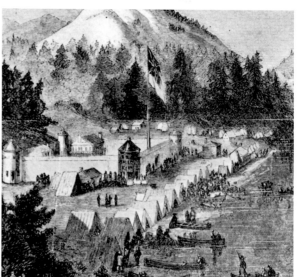

above A sketch of Victoria in the latter part of July 1858, with the stockade of the fort near centre right. In the spring, the settlement had been a quiet trading post with a population of HBC officers, their servants, and a handful of settlers—less than four hundred overall. But with the arrival of the *Commodore* and the first miners, the peaceful way of life was shattered.

Virtually overnight, hundreds of tents spread from the harbour side to crowd up and over the surrounding hills. Stores and saloons and other buildings appeared. Land that couldn't find a buyer for five dollars an acre soared up a hundred times this price and soon to three thousand dollars an acre. Quiet deliberation of the fur trade yielded to frenzy as stampeders pounded together a maze of craft to cross the riptides of the Strait of Georgia to Fort Yale and the Fraser River.

As the rush of 1858 ebbed, there was a lull; but with the discovery of Antler and Williams Creeks, the fire of speculation glowed, then burst to flame. Between 1860 and 1862, fifty-six brick buildings and hundreds of frame buildings rose, streets were macadamized, spacious hotels with every comfort and luxury appeared, and so did a hospital, theatre, and other buildings. In 1862, in a burst of enthusiasm, Victoria was incorporated, with sixty saloons among the business establishments.

left Fort Yale in 1858, from a sketch in *Harper's Weekly*.

$1.50; pork $1.75 a pound; beef $1.00 a pound; sugar $1.50; beans $1.45; tobacco, $6.00. I would like to send $100.00 to you but it would cost more than $50.00 to send it and I am not sure you would get it on time."

The next year in December, Franklin Matthias wrote from Victoria, explaining, "I came over here mostly on account of my health. When you are out on the river you haven't got anything to eat but bread, beans, and pork. Last winter we were all in sick with swollen legs and rheumatics.

"It cost me $100 to get here. Everything is cheaper here on Vancouver Island. Potatoes 1½ cents a pound; flour $6 to $12 a barrel; onions 8c; beef 20c; pork 25c; tobacco 50c per pound; schnaps $7 to $8 a gallon, board by the week $7 to $10.00."

But high prices, monotonous food, treacherous trails and rapids, and the threat of attack were only a few of the hardships facing the miners. In its 800-mile-journey from the Rocky Mountains to the Pacific, the Fraser drains an awesome area of 91,000 square miles. Much of the area is mountainous, where winter snows lie twenty and more feet deep. Where it joins the ocean, the river is broad and sluggish, but just over a hundred miles northward, it squeezes through the coastal mountains in a channel about forty times narrower than its mouth. During early summer, when the river receives the full rush of its innumerable tributaries, it can climb a hundred feet above low-water level.

It was these flood conditions that most of those thronging to the river in 1858 encountered, and traffic became two-way: the impatient newcomers wanted to push upstream at all costs, while those already in the canyon noted the rapidly rising waters and headed downstream. And as the volume of water churning through the canyon rose steadily, the river became even more dangerous.

Fifty years before, Simon Fraser, the first European man to explore the river, had written the following account of his experience on one short stretch of the hundred-mile-long canyon: "The water which rolls down this extraordinary passage in tumultuous waves and with great velocity had a frightful appearance; however, it being absolutely

Sheer rock bluffs, treacherous whirlpools, and tumultuous rapids made the Fraser River canyon the most formidable obstacle facing the miners.

In 1808, Simon Fraser, with John Stuart, Maurice Quesnel, and nineteen voyageurs became the first Europeans to venture through the misty gorge of the river.

"And as for the road by land," Fraser wrote, "we could scarcely make our way even with (only) our guns. I have been for a long period in the Rocky Mountains, but have never seen anything like this country. It is so wild that I cannot find words to describe our situation at times."

A half century later Judge Matthew Baillie Begbie summed up the trail used by Indigenous people through the Fraser Canyon as "utterly impassable for any animal but a man, a goat, or a dog." HERITAGE HOUSE ARCHIVES

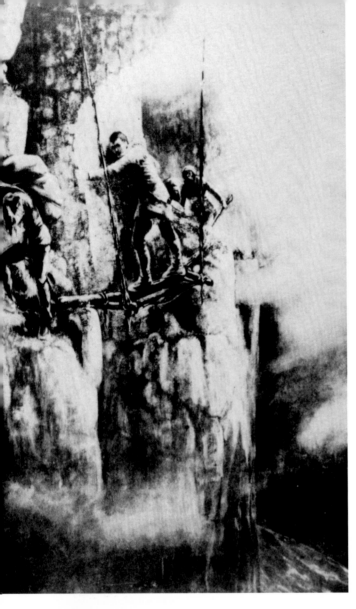

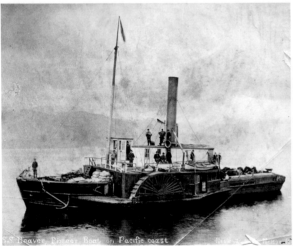

impossible to carry the canoes by land, all hands without hesitation embarked upon the mercy of this awful tide. Once engaged the die was cast, and the great difficulty consisted in keeping the canoes clear of the precipice on one side, and the gulfs formed by the waves on the other, then skimming along as fast as lightning."

Fraser's companions were the famed voyageurs, men who had spent a lifetime in canoes, yet in one four-day period in the canyon, they travelled only thirty miles—and they were heading downstream. Finally the waters became too formidable even for Fraser and his men, and they left the river and proceeded overland.

This proved as dangerous as the river. As Fraser wrote, "An Indian climbed to the summit, and by means of a long pole drew us up, one after another. This work took three hours. Then we continued our course up and down, among hills, and along steep declivities of mountains, where hanging rocks and projecting cliffs at the edge of the bank of the river made the passage so small as to render it difficult at times, even for one person to pass. In places we were obliged to hand our guns from one to another, and the greatest precaution was required to pass singly free of encumbrances... We had to pass where no human being should venture."

Yet along this route came the miners, impatient, laden with heavy packs, fighting to wedge their clumsy boots into footholds meant only for moccasins. Many were to crash to the rocks; many others were to perish in the river.

In May 1858, Governor James Douglas reported, "Many accidents have happened in the dangerous rapids of that river; a great number of canoes having been dashed to pieces and their cargoes swept away by the impetuous stream, while of the ill-fated adventurers who accompanied them, many have been swept into eternity."

As thousands of miners began to work their way up the Fraser Canyon, they entered the traditional territory of the Nlaka'pamux (Thompson) Nation. Most of the miners were from California and saw Indigenous people as inferior and expendable. When a Nlaka'pamux woman was raped by miners, her

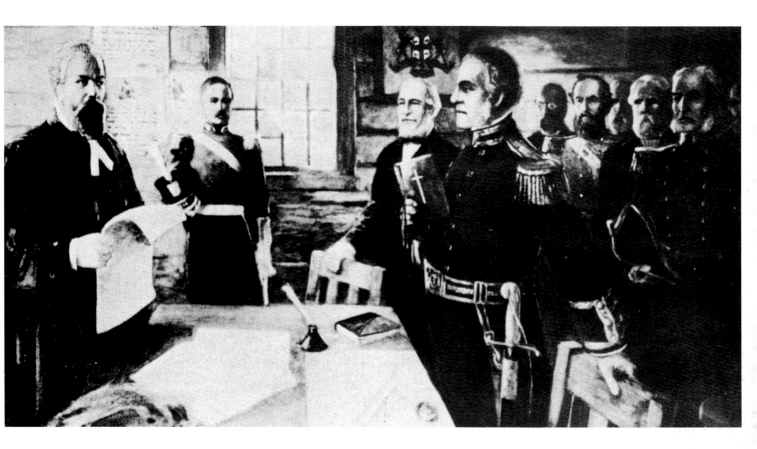

opposite, top A painting by John Innes showing Simon Fraser in the Fraser canyon. In some places, the only pathway was over a swaying platform of sticks, trees, and vines suspended hundreds of feet above the churning waters of the river. "We were often in imminent danger," Fraser remarked in a classic understatement. **HERITAGE HOUSE ARCHIVES**

opposite, bottom The Hudson's Bay Company's paddlewheel steamer, the *Beaver*, at Victoria in 1870. The *Beaver* was the first steamer on the North Pacific coast, arriving at Fort Vancouver from England in April 1836. She played a prominent part in the gold rush, ferrying hundreds of miners and tons of supplies from Fort Victoria to the Fraser River. She also carried Governor Douglas and other dignitaries from Fort Victoria to Fort Langley for the installation ceremonies marking the birth of the Crown Colony of British Columbia. **CITY OF VANCOUVER ARCHIVES. AM54-S4-2-: CVA 371-2583**

above The flood of miners surging up the Fraser River in 1858 caused considerable apprehension to James Douglas, the Governor of Vancouver Island. They were virtually all Americans, and Douglas knew that unless British law were enforced, incidents might arise that could result in the United States annexing

the area. Douglas knew, too, that his jurisdiction over the mainland was tenuous at best, and even if he had full powers over the area, he had no way of enforcing that power.

Fortunately, the summer passed without serious challenge to his authority and by autumn, his problems had been solved by the British government. He was appointed as governor of the new Colony of British Columbia, and a judge and soldiers were sent to help maintain law and order throughout the region.

The image above is from a painting by John Innes and shows Judge Matthew Baillie Begbie swearing Douglas in as governor. The ceremony was held at Fort Langley on November 19, 1858.

The soldiers sent to assist Douglas comprised 165 men of the Royal Engineers. They were hand-picked and included blacksmiths, painters, carpenters, surveyors, miners, and architects—in fact, representatives of just about all trades and professions. They served the colony well, including in their accomplishments the surveying of townsites such as New Westminster, Lytton, Lillooet, and Quesnel; building roads and trails; supplying military protection; and generally helping to provide stability. They were disbanded in November 1863, but many stayed in British Columbia and their skills contributed considerably to the early development of the colony. **HERITAGE HOUSE ARCHIVES**

people began to fight back; skirmishes between the miners and the Nlaka'pamux were numerous, with loss of life common. In August, the Nlaka'pamux effectively blockaded the river. Large groups of miners assembled at Yale, one of which, calling itself the Whatcom Guards, was determined to "fight a battle of wholesale extermination" and the other, under the leadership of Captain Henry Snyder, was determined to establish peace. The two groups proceeded up the Fraser Canyon, the Whatcom group destroying food caches and potato fields but encountering few Nlaka'pamux, and the Snyder group sending word ahead that they wanted to make peace.

The only serious fighting happened when the Whatcom group, thinking they were under attack in the night, panicked and started shooting at each other in the dark. Many men were killed in the resulting confusion.

Fortunately, Snyder's group were the first to encounter the Nlaka'pamux. There had been a grand council of the Nlaka'pamux and other Indigenous representatives at the point on the Fraser where the Thompson River joined it. It was led by Chief David Spintlum, who was able to convince the other chiefs against war. Snyder and his men spent ten days making their way up the river and establishing treaties with the Indigenous nations from Yale to Lytton. Chief Spintlum and Snyder met and agreed on peace and mutual respect, avoiding all-out war and allowing miners to work along the river.

In spite of this agreement, the skirmishes with Indigenous people, the high water, the high cost of food, the lack of transportation, and similar hardships discouraged many. Of the thirty thousand who stampeded to the river, twenty-five thousand returned home, referring to the Fraser derisively as "a great humbug."

But those who remained were the hardy core and not easily discouraged, filtering up the rocky trench of the Fraser. Aaron Post ventured nearly four hundred miles to the mouth of the Chilcotin River, the first miner to prospect the area. He found gold on all bars, although lack of supplies forced him back. But he had shown the way. Others were to follow the next year, finding gold in unimagined abundance and eventually leading to the creation of a new province that would become part of a new nation.

TWO

The Golden Gravel

AS THE CHANGING leaves of autumn herald the approach of a new season, so the hesitant progress of miners up the rocky gorge of the Fraser River led the way to a new era. It was 1859, and of the stampede of over thirty thousand to the river, only about one in ten remained. The dabblers and the weak had perished or retreated; only the strong and the bold remained. They were the professionals, the determined ones. On March 24, 1859, Governor Douglas reported that three hundred boats, each carrying an average of five men, had already left Yale for the river's upper reaches.

In the vanguard was a party of Americans named Peter Dunlevy, Jim Sellers, Ira Crow, Tom Moffit, and Tom Manifee. At the junction of the Chilcotin and Fraser Rivers, they encountered a large man from the Secwépemc (Shuswap) Nation who introduced himself as Tomaah. He wondered what the miners were doing, and they showed him the flakes and nuggets from the bars. Tomaah scoffed and said he could show them a river where gold lay like beans in a pan. But, he explained in Chinook, the trade language that had been developed between the fur traders and Indigenous people, the men must wait. Tomaah was currently employed by the Hudson's Bay Company and he could not yet leave his job, but he said that in a few days he would meet them and show them the river.

He returned as promised and took the party to his tribal encampment. Here he introduced them to another Secwépemc man, Long Baptiste, who stood over six feet tall. Tomaah told the group that he was in love and didn't want to leave the area, but that Baptiste would act as their guide. In June, Baptiste led the miners through the wilderness to a river now called the Horsefly. Here they

19

found the nuggets like beans in a pan. And although the excited men weren't aware or concerned of the fact, they also became the first Europeans to pan gold in a region that would become famous—the Cariboo, a name derived from the woodland caribou that were found there.

But the gold found by the Dunlevy party was not in sufficient quantity to start a major rush, and during the summer, methodical searches continued. Between Fort Alexandria, Quesnel Lake, and Fort George, about a thousand men spaded the bars and benches; some had ventured even a hundred and fifty miles beyond Fort George. They found placer gold just about everywhere, but no major deposits, and the year closed quietly.

Early in 1860, a party led by William Foss "Doc" Keithley and George Weaver were prospecting in a region both beautiful and awesome. It was sliced by creeks into a series of gullies and valleys, and its timbered slopes rose from stream edge to six-thousand-foot peaks. In giant bowls on these mountains lay masses of glacial snow and ice, and from them tiny rivulets flowed downward. They wandered around and over moss-and-lichen-covered boulders, past the first stunted trees that marked the timberline, and joined other rivulets to become creeks. It was one of these creeks at the headwaters of the Quesnel River that Keithley was testing, and here he found gold. Although this creek (named Keithley Creek) wasn't outstandingly rich, it was the key that unlocked the way to gold—gold weighed not in ounces or pounds, but in tons.

In his book *British Columbia*, historian F.W. Howay described the discovery in these words:

"*Late in the fall of 1860, John Rose and his partner Ben McDonald, with 'Doc' Keithley and George Weaver, set out from Keithley Creek in search of new diggings. Ascending that creek for about five miles, they took a course north-eastward up a ravine. Reaching Snowshoe Creek, a branch of Keithley, they followed it some six or seven miles to its summit on the watershed dividing the streams flowing into Cariboo Lake from those flowing eastward, northward, and westward into Bear, Willow, and Cottonwood Rivers.*

Thence the whole surrounding country lay unrolled before them. Northward and eastward the horizon was bounded by rugged and lofty mountains; towards the west and northwest the prospect was more level; while immediately below lay rolling hills intersected by valleys and ravines. 'Twas man's first view of Cariboo. Over the whole region lay the mantle of solitude and silence—gold existing without contention or struggle. Traversing this summit in the same general direction they came upon another creek, at a distance of about twenty miles from Keithley. The creek winds through the centre of a narrow valley and is surmounted by hills sloping down to flats and benches of alluvial deposit; the bed-rock on which gold was found lay but a short distance under the surface, and in many places cropped out. Here was the richest deposit yet found in British Columbia, considerable quantities of gold being found on the bare rock. One pan produced $25—a second, $75. The fortunate prospectors, however, had their ardour cooled next morning by awakening to find a foot of snow on the ground."

The five men, consisting of Rose, McDonald, and Weaver, along with James Jasper May and S.M. Bowen, were determined to keep their find a secret, but the secret of gold cannot be kept. When some of the party returned to "Red-Headed" Davis's store on Keithley Creek for provisions, they were evasive and vague. The miners there became suspicious. Why, they wondered, would men remain voluntarily on an isolated creek in the dead of winter? Certainly not without reason. In any event, it was worth investigating.

Over snow five feet deep, men set out for this newly named Antler Creek, and when they learned of its riches, quickly staked their claims. In January 1861, when Gold Commissioner Philip Henry Nind visited the creek, he found over four hundred miners camped in holes in the snow, waiting to work their claims. The discoverers, Rose and McDonald, had been there long enough to build a cabin, the only one on the creek.

In the mysterious way of the wilderness, news of the discovery spread. It reached miners wintering on isolated creeks and in communities to the south. With the coming of spring, gold seekers by the tens,

then hundreds, then thousands struggled through the four hundred miles from the Lower Fraser Valley to the gorges, valleys, and mountains that characterized this new region.

One party, among whom were Ed Stout, Michael Burns, and William "Dutch Bill" Dietz, left Antler Creek and headed into the unknown. They crossed the ridge of a mountain and, according to one romantic concept, Dietz stumbled and landed flat on his back in a small creek. When he regained his wind, he resourcefully tested the gravel and found over a dollar's worth of gold in his pan.

Whether or not the tale is true is questionable, since the "discovery claim" (usually the first on any creek) was registered to "Kansas" John Metz, Peter Keenan, and James Costello, but there was no doubt about the richness of the strike. Deitz's companions named the creek "Williams" in his honour and staked their claims. As Dietz staked, the fates must have smiled. One of the ironies of the gold rush was that his claim proved among the poorest on a creek that was to be among the world's richest.

This, however, was in the future. A strike had been made. The wilderness echoed to the thud of axes as miners slashed trees, hewed log cabins, and prepared their rockers and sluice boxes.

In the beginning, the creek didn't bear out its shining promise. In fact it gave such poor results that, like the Fraser River previously, it was dubbed "a great humbug." The pay streak extended from the surface to about fifteen feet, where there was a layer of hard, blue clay. The miners supposed this to be bedrock and here found most of the gold. By accident, this theory was abruptly changed.

One day, Ivel "Long" Abbott, of the claim Jourdan and Abbott, left for supplies in Antler. For want of something to do, his partner dug right through the blue clay. To his amazement, he struck a layer of gold-bearing gravel richer than anything so far discovered. When Abbott returned two days later, Jourdan greeted him with fifty ounces of gold, equivalent to three thousand dollars for two days' work. Shortly afterward the claim yielded forty pounds of gold a day, and other claims yielded far more.

The official yield for the new goldfield in 1861 was over $2.5 million, but since many miners didn't reveal their true take, unofficial sources put the total closer to $5 million. Most of this came from Williams Creek, but even this golden output would be eclipsed by the discovery of a miner who thought he would test his luck in the deep gravel below the canyon.

Williams Creek is born on the slopes of Bald Mountain and wanders in a northwesterly direction for about nine miles. At the midway point, it flows through a canyon and broadens to a valley before joining the Willow River on its journey to the Fraser River. In 1861, all activity was above the canyon, with miners completely ignoring the area below the canyon. Ed Stout had tried a side gulch at the foot of the canyon and struck gold, but this wasn't considered significant.

Among the first to arrive on Williams Creek was a miner named Billy Barker. After trying unsuccessfully to find gold along the upper part of the creek, he decided to try below the canyon, much to the amusement of those already on the creek. It was generally thought that the canyon acted like a dam and kept the gold from going downstream. On August 17, 1862, Barker and his companions C. Hankin, R. Dexter, H. Gabel, A. Anderson, S. Travers, and A. Goldsworthy, pounded in their claim stakes and set to work. They threw up a shaft house and started digging a shaft down through the gravel and boulders left by the creek during thousands of years of carrying spring flood and summer rain from the mountainous slopes.

A legend later said that Barker was a sailor who had jumped ship to try his luck hunting for gold. But he was actually an experienced miner who had mined in California. Despite his experience, the other miners believed that there was no gold below the canyon; everyone knew that. If there was, the ground would have been staked long before. But Barker and his companions ignored the jibes and taunts. They continued digging, gradually inching through the debris of centuries.

While the Barker Company was so engaged, T. Elwyn, Gold Commissioner for the Cariboo Mining

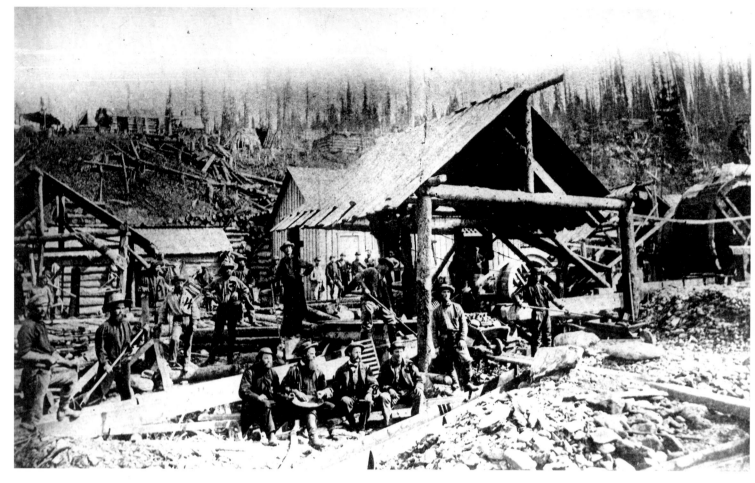

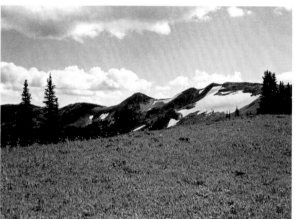

above A photo of the Cameron claim on Williams Creek was taken on August 20, 1863, by C. Fulton. The bearded man with the gold pan on his knees is John A. "Cariboo" Cameron, and sitting near the post is Robert Stevenson, one of Cameron's partners. During 1863, the claim yielded from 120 to 336 ounces a day. Its total value was almost $1 million, of which Cameron's share was $350,000. HERITAGE HOUSE ARCHIVES

right At the 6,000-foot level of the Cariboo Mountains, snow lingers until July or later and can return by September. The peaks below are part of the Snowshoe Plateau, headwaters of Antler, Williams, Cunningham, Keithley, and other creeks whose gravel yielded the gold of Cariboo. HERITAGE HOUSE ARCHIVES

opposite The Creeks of the Cariboo: The main gold-bearing creeks, showing the present road to Barkerville and the original wagon road from Van Winkle, a route abandoned in the 1880s. The first main route to the gold-rich region was up the Cariboo River to Keithley Creek, then northward to Snowshoe Creek and the 6,000-foot level of the Cariboo Mountains. HERITAGE HOUSE ARCHIVES

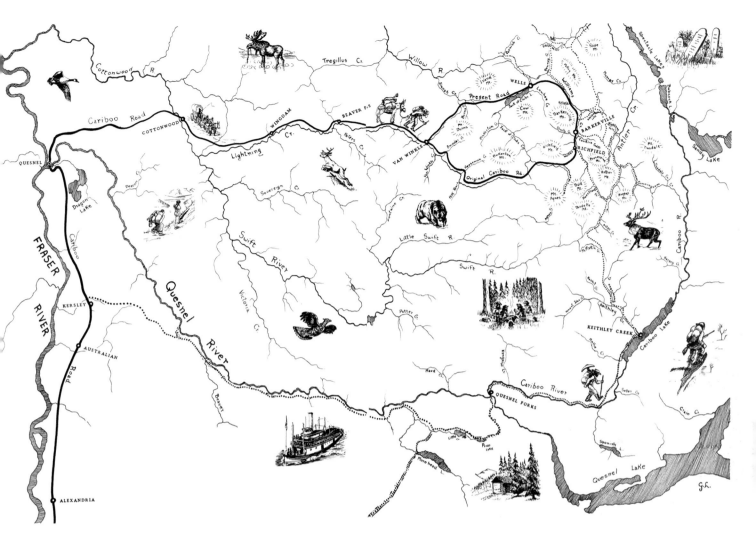

District, had written a letter to the Colonial Secretary at Victoria. Dated August 22, 1862, it read in part, "The more I see of this creek, the more am I convinced of its almost unparalleled richness and that it will be the great center of Cariboo."

On August 19, at fifty-two feet deep, Barker changed the Gold Commissioner's words from prophecy to fact. He dug into pay gravel. A pan yielded five dollars; a foot of ground, one thousand dollars; the claim was destined to yield $600,000. The miners who had laughed at Barker now stopped only long enough to grab their tools and pound claim stakes into the area below the canyon.

Among the claims staked was the Cameron, and on a creek that was to create many legends, this claim became the foremost. One of the partners, Robert Stevenson, left the following background information on it:

In July I sold out my business on Antler Creek and went to Williams Creek to get into what became known as the Cameron claim. Dr. Crane told me of the ground being vacant, and wanted me to go with him that night and stake it off. I told him I had a few friends I would like to take in with us. So I organized a company as follows: J.A. Cameron, Sophia Cameron, Robert Stevenson, Alan McDonald, Richard Rivers, and Charles and James Clendenning. I had to wait a day and a half on Cameron to come with us to stake the claim. Cameron was nearly not coming that morning to stake the claim, as he had a prejudice against doing so on a Friday, as he thought it was unlucky.

When staking, Cameron and I disagreed and quarrelled over the location, and if he had followed my advice, the claim, instead of paying one million dollars, would have paid double that amount. He would insist on single claims on the left bank of the creek and I wished to stake two claims abreast on the right bank. If my advice had been followed the Tinker

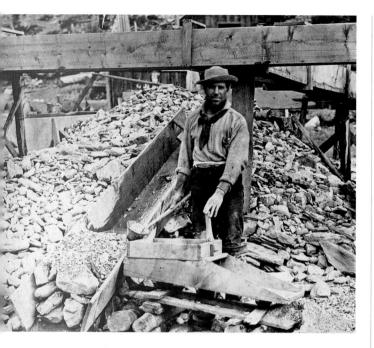

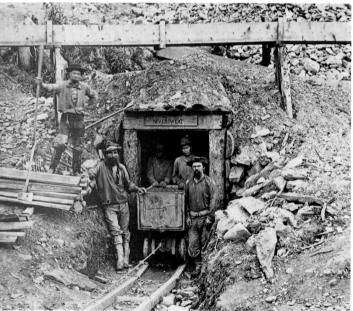

claim would not have been heard of and it paid nearly as well as the Cameron.

After staking the claim we sat down to name it. This was August 22, 1862. Dr. Crane proposed that it should be called the Stevenson because I had got up the company. I objected to this and asked the privilege of calling it the Cameron claim, and so it was called.

On December 22 we struck it very rich at 22 feet. It was 30 below and Dick Rivers was in the shaft, and Halfpenny and I were at the windlass. Rivers called up from the shaft: "The place is yellow with gold. Look here boys," at the same time holding up a flat rock the size of a dinner pail. I laid down on the platform shaft and peered into the shaft. I could see the gold standing out on the rock as he held it. He sent the piece of rock up and I got one ounce of gold from it.

Then Cameron started down the shaft, and while he was down I took my pick and went through some of the frozen stuff that had been sent up all morning and got another ounce before he came up again. Out of three 12-gallon kegs of gravel I got $155 worth of gold.

Sinking, we found bedrock at 38 feet. It was good all the way down from 22 feet to there, but the richest was at 22 feet. The coarse gold was at 22 feet, strange to say.

On October 22, 1863, two British visitors, Dr. Walter B. Cheadle and William Wentworth-Fitzwilliam, Viscount Milton, visited the goldfields and were taken down into the mine. Dr. Cheadle wrote the following account:

The shaft was about 30 feet down through gravel and clay to bedrock of slate. [There were] numerous shafts all supported by timber and very closely roofed in with flat crosspieces. [It was] wet, damp, dark, and gloomy, the shafts being in many parts very low, the "pay dirt" not being extensive perpendicularly. At the bottom shaft the pay dirt was best high up, at the upper end, down close to the bedrock.

They kindly helped us to wash out two pans which yielded some beautiful gold to the value of $21, nearly 1⅓ ounces. We could see the nuggets lying in the gravel before loosened out by the pick. Steele showed me about $1,000 in gold in a bag, and the Company's books, showing weekly expenses averaging $7,000, and the yield generally from 40 to 112 ounces per shaft, of which there were three, per day or on to $29,000 a week. Over 100 feet of claim yet quite untouched.

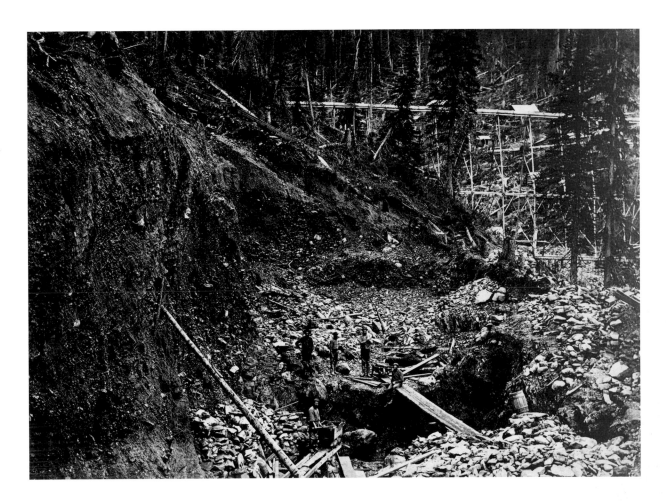

opposite, top A miner named Billy Phinney washes tailings with a hand rocker on the Caledonia claim on Williams Creek. This claim yielded $750,000. The output of some claims was remarkable. On September 25, 1861, Judge Matthew Baillie Begbie wrote, "On many claims the gold is a perfect nuisance, as the miners have to carry it from their cabins to their claims every morning, and watch it while they work, and carry it back again (sometimes as much as two men can lift) to their cabins at night, and watch it while they sleep." UBC LIBRARY. RBSC. UNO LANGMANN FAMILY COLLECTION OF BC PHOTOGRAPHS. UL_1001_0090

opposite, bottom The Neversweat claim on Williams Creek. From 120 feet of ground, it yielded $250,000. Describing the life of the miners on the creeks, one observer reported, "Skillful miners were obtaining wages of from $8 to $10 a day. They may seem high but it must be remembered that the price of food alone amounted on an average of half of this, besides other expenses. Then, too, the work is very toilsome, being labor under the cold dripping water from leaky flumes and with

clothes saturated with water from head to foot." Standing in the tunnel entrance is one of the hundreds of Chinese miners who worked on their own or other miners' claims in the Cariboo. UBC LIBRARY. RBSC. UNO LANGMANN FAMILY COLLECTION OF BC PHOTOGRAPHS. UL_1001_0092

above The Ne'er Do Well claim. From under the boulder near the wheelbarrow in the lower centre of the photo, the miners took eighty ounces of gold. But even this golden nest was eclipsed.

J.C. Bryant, superintendent for one of the claims, left the following account of an experience he had: "One day when I was cleaning up in the mine I got a place where I dug off a piece of the bedrock. It was soft and came off like cheese with the shovel. Right under this place, in a little hole not much bigger than a gold pan, I saw what I took to be solid gold. I obtained a gold pan, cleaned it out, and then washed what I took out. There were 96 ounces, or a total of $1,543. This was the richest pan of dirt that was ever taken out in the Cariboo." UBC LIBRARY. RBSC. UNO LANGMANN FAMILY COLLECTION OF BC PHOTOGRAPHS. UL_1001_0100

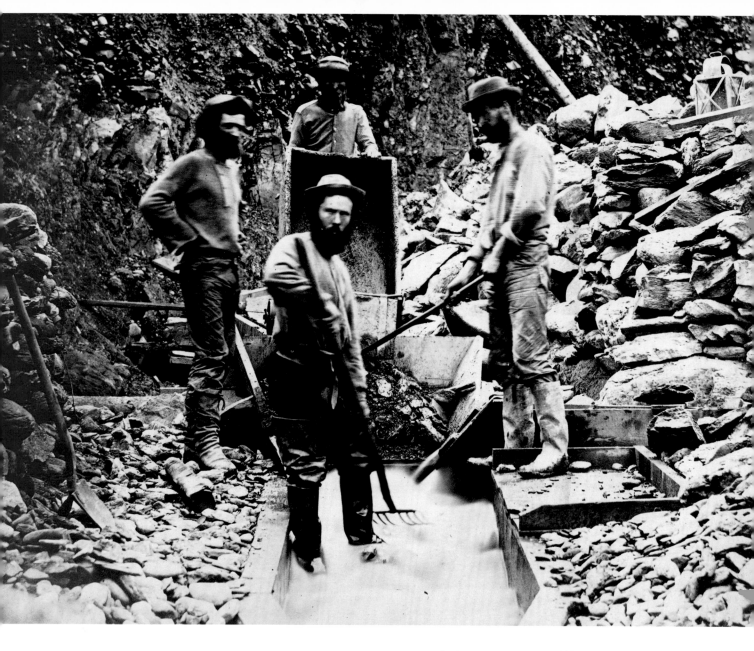

A group of miners washing the golden gravel on Ne'er Do Well claim. While Williams Creek gave the highest total yield, other creeks gave results that were just as astonishing.

On Lightning Creek, a spot called Butcher's Bench, discovered in December 1863 by Joe Gilmour, yielded $125,000 from a few square yards of bedrock. One nugget weighed 21 ounces. From the same creek, Ned Campbell took out 900 ounces one day, 500 the second, and 300 the third. UBC LIBRARY. RBSC. UNO LANGMANN FAMILY COLLECTION OF BC PHOTOGRAPHS. UL_1001_009

Around the Cameron and Barker claims grew a collection of rough buildings, one group called Camerontown, the other Barkerville. The latter was slated to survive. Its collection of log buildings, saloons, shanties, breweries, and shops of all kinds grew until, in the full glow of its development, it claimed to be "the largest community west of Chicago and north of San Francisco."

On the following pages are a selection of remarkably clear photos of the mines and miners. Most were taken over a hundred years ago by Frederick Dally, an imaginative pioneer photographer who opened a photographic shop in Barkerville but lost everything during a September 1868 fire.

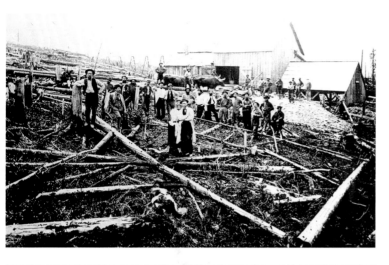

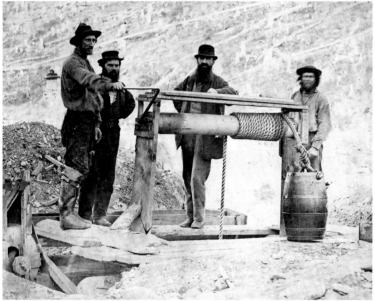

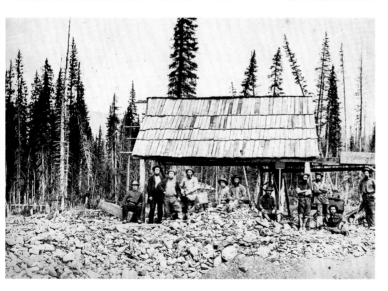

top The Forest Rose claim, which yielded $480,000 worth of gold. The oxen were used for skidding pine and spruce logs that were used for shoring in the shafts and tunnels.

The pay streak on Williams Creek was a layer of blue clay about six feet thick, mixed with gravel and believed to be the bed of an old creek. Above the canyon, the rich gravel was close to the surface, but below it varied to a depth of about sixty feet. IMAGE A-03855 COURTESY OF ROYAL BC MUSEUM AND ARCHIVES

middle One of the Barker claim shafts. In the summer of 1863, there were three shafts on the Barker Claim, each yielding an average of 100 ounces per day. That year was the banner year for Williams Creek, when four thousand miners worked the gravel for about seven miles, and over three thousand claims had been staked on the creek. The yield from the creek exceeded that obtained during the richest days of the California gold rush.

Among famous claims on Williams Creek was the Diller. For weeks it paid a dividend every Sunday of $10,000 to each of its shareholders. Bill Diller weighed 240 pounds and he declared that he wasn't leaving until he got his own weight in gold from the claim. He got this, plus the weight of his dog, and many pounds more for good measure. It all came from 100 feet of ground. The highest yield for one day was 102 pounds of gold. UBC LIBRARY. RBSC. UNO LANGMANN FAMILY COLLECTION OF BC PHOTOGRAPHS. UL_1001_0079

bottom The Prairie Flower claim on Williams Creek. It yielded $100,000, with 170 ounces the best production for one day. On Williams Creek, forty claims were exceedingly rich, and during 1863, twenty of them produced every day from 70 to 400 ounces of gold.

By 1865, the creeks still yielded over $3 million, but shallow diggings were becoming exhausted and the days of the individual miners were ending. The next phase called for the use of dredges, huge pumps, and other expensive machinery. This was beyond the capabilities of small groups of miners, and big companies started taking over control of the creeks. UBC LIBRARY. RBSC. UNO LANGMANN FAMILY COLLECTION OF BC PHOTOGRAPHS. UL_1001_0095

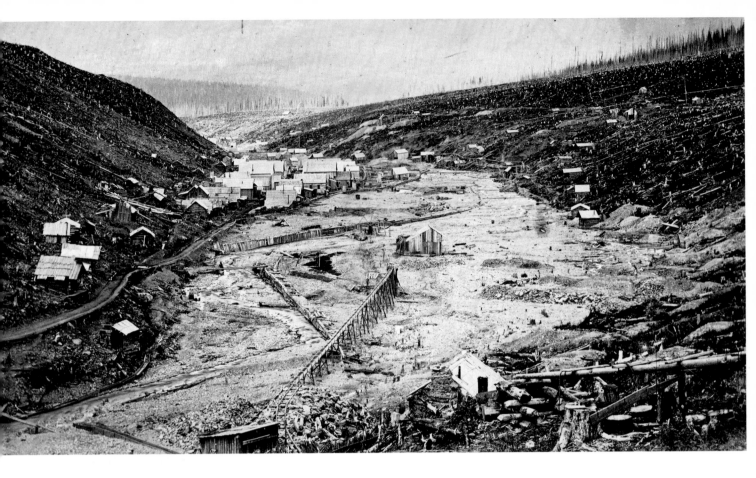

Williams Creek just below the canyon, with Barkerville at centre left. Dozens of small miners' cabins line the creek banks, which have been denuded of all trees. Most of the timber was used for cabins or for mine props and cribbing. The flume in the centre foreground carries water to a waterwheel, which in turn runs a pump to keep the shaft dry. An abandoned waterwheel can be seen in the centre of the photo and another near centre right of the photo. The wing dam in the centre of the photo was to keep the creek from flooding Barkerville, and at lower left is the Cariboo Wagon Road. In the lower centre can be seen a tailing pile from one of the shafts and also a miner's cabin with one chimney of stone and another of tin. The entire creek bed is a mass of tailings from the various claims that line the creek bank and the main channel itself. This photo was taken by Frederick Dally.

In his book *Very Far West Indeed*, R. Byron Johnson gives the following picture of the creek:

The unfortunate little stream had been treated in the most ignominious manner. A little above the town it flowed along silvery and clear as it had been wont to do; but soon inroads were made upon its volume in the shape of ditches cut from it, and continued along the sides of the hills, to feed the huge over-shot waterwheels that appeared in all directions.

Then its course became diverted in five or six different channels, which were varied every now and then as the miners sought to work the surface. At intervals dirty streams were poured forth by the sluices, in which the earth dug from beneath was being washed by the water, and here and there the stream was insulted by being shut up for a few hundred yards in a huge wooden trough called a flume.

Across the breadth of the valley was a strange heterogeneous gathering of smaller flumes, carrying water to the different diggings and supported at various heights from the ground by props, windlasses at the mouths of shafts, waterwheels, banks of tailings, and miners' log huts.

From the hills came the perpetual cracking and thudding of axes, intermingling with the crash of falling trees, and the grating undertone of the saws as they fashioned the logs into planks and boards. From the bottom of the valley rose the splashing and creaking of waterwheels, the grating of shovels, the din of the blacksmith's hammer sharpening pickaxes, and the shouts passed from the tops of the numerous shafts to the men below as the emptied bucket was returned by the windlass.

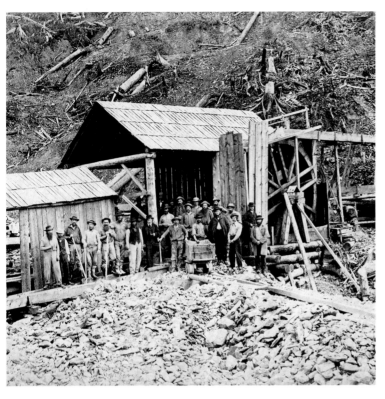

top The Aurora claim, located on the east bank of Williams Creek just downstream from Barkerville. The claim yielded $850,000, believed to be the highest official return from any claim. In many cases, however, there was a wide difference between the official yield and the actual yield. Many miners, not wishing to attract attention, kept their true totals a secret and later, when Governor Seymour placed a tax of fifty cents per ounce on gold, this policy became more widespread.

After the gold rush, Robert Stevenson, one of the most successful and best known of the miners, and several gold commissioners and other miners compared notes on the output. They estimated that production was close to $100 million, over twice that of the official yield, with about one half of this coming from Williams and Lightning Creeks.

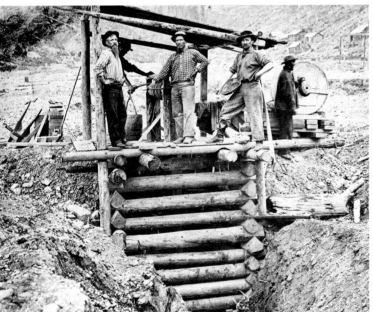

bottom The Sheepshead shaft on Williams Creek was a small claim that only produced $25,000.

Some of the claims produced fantastic yields, as shown by the experience of Henry Fuller Davis. When Davis arrived on Williams Creek, all good ground had been taken, but he noted that one of the claims looked wider than the lawful one hundred feet. It proved to be two feet wider. Davis staked the twelve-foot section and took out $12,000 worth of gold. From then on he was known everywhere as "Twelve Foot" Davis.

After Davis considered the claim exhausted, a man named Wilkinson bought it and cut deeper into bedrock. He made $12,000 over all expenses and then sold it to some Chinese miners for $2,000. The Chinese miners cut the bedrock still deeper and struck a crevice out of which they took $10,000 in two days. The following week, they struck another crevice that yielded a further $15,000. In all, this twelve-foot fraction paid over $65,000.

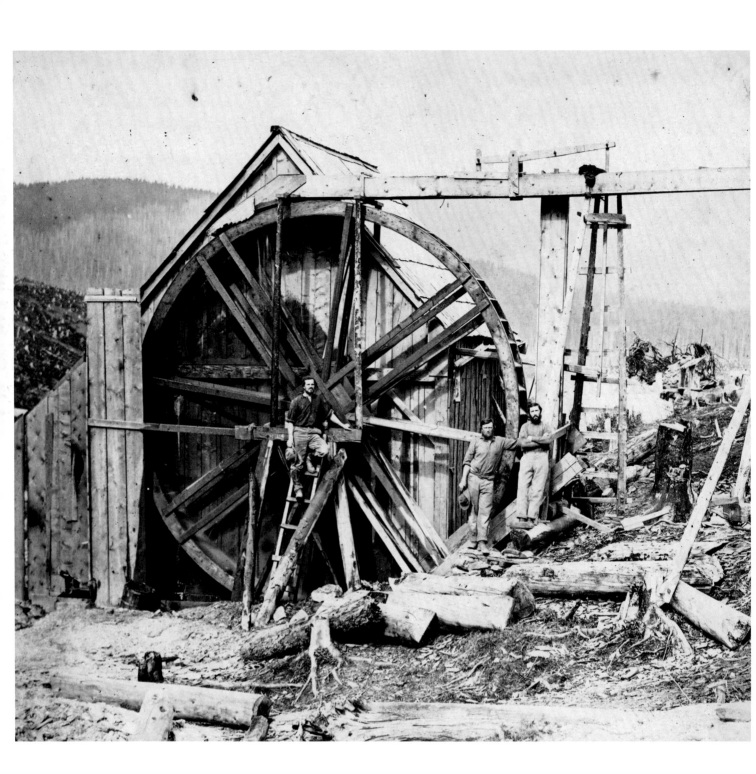

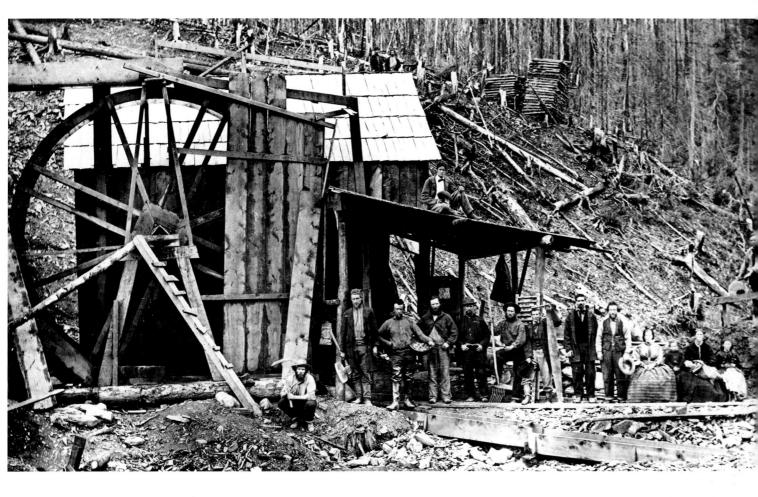

opposite The Davis claim on Williams Creek, not to be confused with the Twelve Foot Davis claim, yielded $350,000. At the mine shaft house is a Cornish wheel, so named because it was modelled on those used in the tin mines of Cornwall, England. The waterwheels operated pumps to keep the mine shafts dry and were in common use until completion of the Cariboo Wagon Road made it practical to bring in heavy steam pumps.

An unusual feature of the Cornish wheels was that while they were used to keep the mines dry, they relied on water for their operation. The water was flumed to the top of the big wheel, where it filled individual compartments on the wheel's rim. The water's weight revolved the wheel, which in turn activated the pump handle.

The wheels were handmade on the creeks. The miners' tools included a broadaxe, crosscut saw, wood auger, and regular axe—essentially the tools held by the miners in the 1868 photo above. HERITAGE HOUSE ARCHIVES

above The Alturas claim on Stout's Gulch, which paid $275,000 to its owners. As seen on the right, many successful miners brought their wives and children to the creeks and rented accommodations in the hotels.

While the two most productive creeks were Williams and Lightning, many others also paid well. Among them were Keithley, Cunningham, Grouse, Lowhee, Mosquito, California, Harvey, Snowshoe, Anderson, Chisholm, Fountain, Sovereign, Willow, Thistle, Tababoo, and Last Chance. The latter was the richest tributary of Lightning Creek.

It received its name when a miner named Donovan and his three companions were on their way out of the goldfields. They were leaving discouraged and destitute. But as they walked along Lightning Creek, they noticed a side gulch and decided to give the area one last chance. They sunk a shaft eighty feet deep, reached pay gravel, and left the Cariboo with $36,000 each.

Almost eighty years later, miners working in the same area uncovered the Donovan shaft and found the gold-rush miners' wheelbarrow and many other tools. The wheelbarrow was entirely handmade without a nail in it. All joints were fastened with wooden pegs, and even the wheel was pegged. HERITAGE HOUSE ARCHIVES

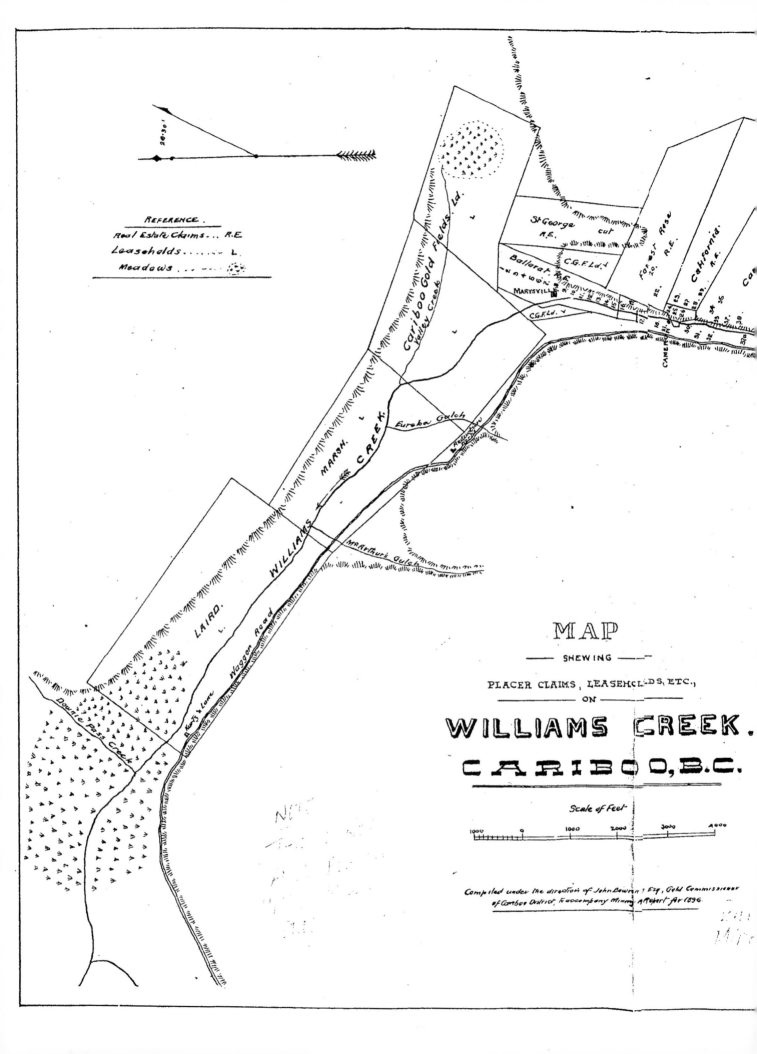

REFERENCE.
Real Estate Claims... R.E
Leaseholds......... L
Meadows ...

Cariboo Gold Fields Ld.
Valley Creek
St George cut
R.E.
Ballarat R.E.
C.G.F.Ld.
Forest Rose R.E.
California R.E.
MARYSVILLE
C.G.F.Ld.
CAMERON
WILLIAMS CREEK
MARSH.
Eureka Gulch
Redicular
McArthur's Gulch
LAIRD. L
Waggon Road
King's Lane
Downie Pass Creek

MAP
—— SHEWING ——
PLACER CLAIMS, LEASEHOLDS, ETC.,
—— ON ——
WILLIAMS CREEK.
CARIBOO, B.C.

Scale of Feet

Compiled under the direction of John Bowron Esq, Gold Commissioner
of Cariboo District, to accompany Mining Report for 1896.

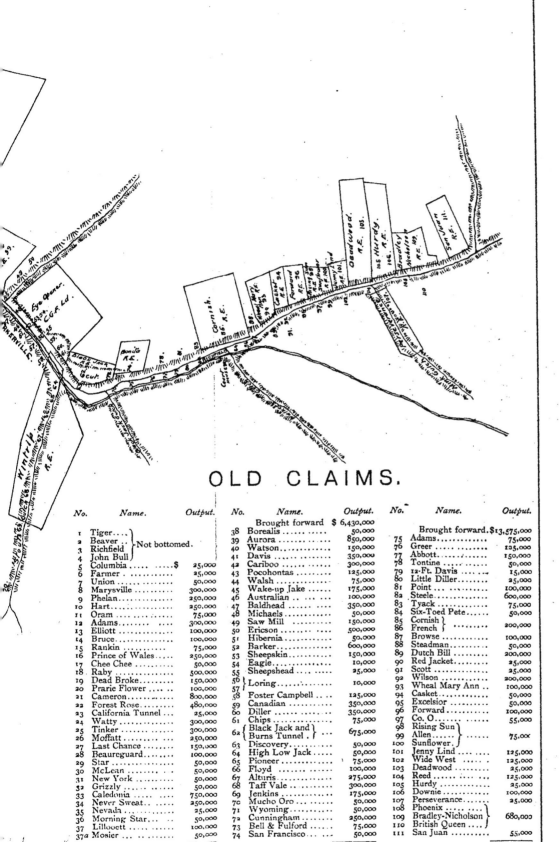

OLD CLAIMS.

No.	Name.	Output.
1	Tiger....	
2	Beaver..	Not bottomed.
3	Richfield	
4	John Bull	
5	Columbia$	25,000
6	Farmer...........	25,000
7	Union........	50,000
8	Marysville........	300,000
9	Phelan........	250,000
10	Hart........	250,000
11	Oram........	75,000
12	Adams........	300,000
13	Elliott........	100,000
14	Bruce........	50,000
15	Rankin........	75,000
16	Prince of Wales....	250,000
17	Chee Chee........	50,000
18	Raby........	500,000
19	Dead Broke........	150,000
20	Prarie Flower.....	100,000
21	Cameron........	800,000
22	Forest Rose........	480,000
23	California Tunnel...	25,000
24	Watty........	300,000
25	Tinker........	300,000
26	Moffatt........	250,000
27	Last Chance........	150,000
28	Beaureguard........	100,000
29	Star........	50,000
30	McLean........	50,000
31	New York........	50,000
32	Grizzly........	50,000
33	Caledonia........	750,000
34	Never Sweat.....	250,000
35	Nevada........	25,000
36	Morning Star...	50,000
37	Lillooett........	100,000
37a	Mosier........	50,000
		$ 6,430,000

No.	Name.	Output.
	Brought forward	$ 6,430,000
38	Borealis........	50,000
39	Aurora........	850,000
40	Watson........	150,000
41	Davis........	350,000
42	Cariboo........	300,000
43	Pocohontas........	125,000
44	Walsh........	75,000
45	Wake-up Jake......	175,000
46	Australian.....	100,000
47	Baldhead........	350,000
48	Michaels........	50,000
49	Saw Mill........	150,000
50	Ericson........	500,000
51	Hibernia........	50,000
52	Barker........	600,000
53	Sheepskin........	150,000
54	Eagle........	10,000
55	Sheepshead.....	25,000
56 57	Loring......	10,000
58	Foster Campbell....	125,000
59	Canadian........	350,000
60	Diller........	350,000
61	Chips........	75,000
62	Black Jack and Burns Tunnel.	675,000
63	Discovery........	50,000
64	High Low Jack.....	50,000
65	Pioneer........	75,000
66	Floyd........	100,000
67	Alturis........	275,000
68	Taff Vale.....	300,000
69	Jenkins........	175,000
70	Mucho Oro.....	50,000
71	Wyoming........	50,000
72	Cunningham........	250,000
73	Bell & Fulford.....	75,000
74	San Francisco....	50,000
		$13,575,000

No.	Name.	Output.
	Brought forward.	$13,575,000
75	Adams........	75,000
76	Greer........	125,000
77	Abbott........	150,000
78	Tontine........	50,000
79	12-Ft. Davis......	15,000
80	Little Diller........	25,000
81	Point........	100,000
82	Steele........	600,000
83	Tyack........	75,000
84	Six-Toed Pete......	50,000
85	Cornish	200,000
86	French	
87	Browse........	100,000
88	Steadman........	50,000
89	Dutch Bill........	200,000
90	Red Jacket........	25,000
91	Scott........	25,000
92	Wilson........	200,000
93	Wheal Mary Ann..	100,000
94	Casket........	50,000
95	Excelsior........	50,000
96	Forward........	100,000
97	Co. O........	55,000
98	Rising Sun	
99	Allen........	75,000
100	Sunflower.	
101	Jenny Lind......	125,000
102	Wide West.....	125,000
103	Deadwood........	25,000
104	Reed........	125,000
105	Hurdy........	25,000
106	Downie........	100,000
107	Perseverance.....	25,000
108	Phoenix......	
109	Bradley-Nicholson	680,000
110	British Queen....	
111	San Juan........	55,000
	Total...........	$17,355,000

	Output
Eureka Gulch, McArthur's Gulch and Valley Mountain.........	200,000
Williams Creek, Bedrock Flume...	200,000
Walker's Gulch........	100,000
Conklin's do........	765,000
Sundry Claims........	500,000
McCallum's Gulch........	200,000
Total Output, Williams Creek ...	**$19,320,000**

N.B.—The figures given in this table of outputs are approximate, and cover the ground worked from the lower end of the Ballarat Claim to McCallum's Gulch, a distance of 2½ miles.

A map of the Williams Creek claims and their values, compiled by John Bowron, who arrived on the creek in 1862 and was Gold Commissioner from 1883 until 1906. KEN MATHER COLLECTION

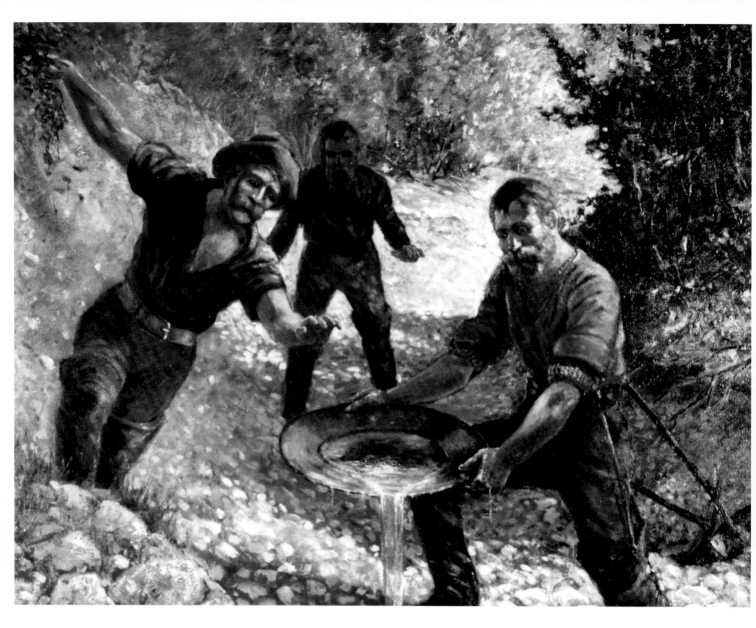

"The Discovery of Gold on Williams Creek in 1861," from a painting by John Innes and reproduced courtesy Native Sons of BC, Post No. 2. The artist selected for his theme the moment when his other partners joined William Dietz ("Dutch Bill") to once again test the place where he had struck it rich.

M.C. Brown, one of Dietz's partners on the historic occasion, gave the following account of the discovery:

We crossed the divide, eventually making the headwaters of the creek, after some tiresome travelling, down which we travelled to a place near a little gulch or canyon, where we camped for the night, building a brush shelter.

On the following morning we separated to prospect the stream, agreeing to meet again at night to report progress. The story of that day's prospecting, which we recalled over the camp fire, has become a matter of mining history in British Columbia. "Dutch Bill" made the best prospect, striking pay dirt going $1.25 a pan. I and Costello had also done pretty well, finding dirt worth a dollar or so a pan. You can well imagine we were well pleased with our day's exertions, and each man in his heart felt that we had discovered very rich ground. I shall not forget the discussion that took place as to the name to be given the creek. Dutch Bill was for having it called "Billy Creek" because he had found the best prospects of the three. I was quite agreeable, but I stipulated that Mr. William Dietz should buy the first basket of champagne that reached the creek. This appealed to Costello, and so the creek was then and there named—not Billy Creek, but '"Williams Creek."*

HERITAGE HOUSE ARCHIVES

THREE

Wagon Road North

As the news of the Cariboo's golden gravel spread southward and was borne around the world, men with a flicker of adventure in their character headed for the goldfields. Their progress was hastened by colorful stories and glowing reports carried by word of mouth and newspapers. The *Puget Sound Herald* for October 24, 1861, reported, "As far as we can learn, every miner from this new gold field has brought with him from $5,000 to $20,000, all of which has been obtained in the short space of two or three months." With the average wages at the time about two dollars a day, it is not surprising that soon thousands of men were bound for the Cariboo.

When those with the gold fever in their eyes reached the Fraser, they learned that problems encountered by the stampeders of 1858 were far surpassed by the difficulties of reaching the new El Dorado. From the end of steamboat navigation at Fort Yale on the Fraser, the new goldfields were four hundred miles north and east. The route was over country that was extremely mountainous, carved into valleys and gulches, covered for mile after mile by underbrush almost impenetrably entwined, protected by mountain passes that in April harboured snow five feet deep.

One miner, W. Champness recounted part of his experience:

Our route from Lillooet lay across the mountains to the Fraser River valley, near Lytton; thence up the wild and awful ravines in the district of the Thompson River, passing Loon Lake, and thence north, near Green and Axe Lakes to Williams Lake. This portion of our journey, being a distance of nearly 200 miles, occupied sixteen days, Sundays not included, as we were truly glad of a Sabbath rest.

Some portions of our route lay across mountain ranges from whose summits we enjoyed most magnificent views, and down whose steep pine-forested sides we had to lead our horses singly, and with the utmost care.

In other parts of the journey, especially in the river gorges, our track conducted us along the most frightful precipices. There was no help for this, as we could select no route more passable. The rivers flow ofttimes through dark and awful gorges whose rocky sides tower perpendicularly from a thousand to fifteen hundred feet. By a series of zig-zag paths, often but a yard in width, man and beast have to traverse these scenes of grandeur. Sad and fatal accidents often occur, and horses and their owners are dashed to pieces on the rocks below, or drowned in the deep foaming waters rushing down the narrow defiles from the vast regions of mountain snow melting in the summer heat.

At Deep Creek, ten miles from Williams Lake, seven of our comrades relinquished all further attempt to reach their proposed destination, being utterly discouraged by the excessive difficulties of the way and the unvarying tale of discouragement told by the parties of returning and unsuccessful miners. Truly, the numbers of these poor, broken-down fellows, with their pale, pinched faces and tattered rags, eloquent of hunger and poverty, were enough to dishearten us altogether. Hundreds of such passed us during our journey in parties of from two to a score. Sorely tempted as we were to yield to despair, yet some of us were resolved to brave out to the end.

We thought we had now reached the lowest possible depth of difficulty, but not so, for after miles of deep mud and swamp we came to a region where, for an extent of many miles, the earth was covered with innumerable thousands of dead and fallen trees, lying across each other in inextricable confusion and in every conceivable position. We were necessitated to travel over these fallen trees, stepping from trunk to trunk for a distance of 10 miles. As may be supposed, this rendered us intensely fatigued and leg-weary, for it was, throughout, a series of acrobatic performances. Often we slipped between the fallen trunks and were nearly lost to view, having sunk two feet in a thick black swamp. Whenever one of us became thus "bogged" he had to call for help, and was drawn out bodily by his comrades from his unpleasant position.

The route to the goldfields was the route of the individual: each was responsible for himself, and he who broke this law faced the prospect of a lonely death. One gold seeker wrote of his experiences: "We passed one unsuccessful miner who looked as if he had lain down to die, being pale, emaciated, worn out, and without a blanket or any covering but a few old rags. We were ourselves so scantily furnished with provisions that we were unable to render him much service. He made no complaint, and asked no relief, knowing well, as every one in this country does, that as a rule, travelling miners are unable to do more than grapple with their own problems."

On April 22, 1861, Radcliffe Quine wrote the following letter about his experiences on the trail: "I tell you it is a hard road to travel. You have to carry your own blankets and food for over three hundred miles and take to the soft side of the road for your lodgings and at daylight get up and shake the dust off your blankets and cook your own food for the day and take the road again. When you get in the mines you have to pay up to a dollar a pound for everything you eat as it has to be carried with mules and horses on their backs with a pack saddle."

Lieutenant Henry Spencer Palmer of the Royal Engineers wrote in one of his reports, "It is difficult to find language to express in adequate terms the utter vileness of the trails of Cariboo, dreaded alike by all classes of travellers; slippery, precipitous ascents and descents, fallen logs, overhanging branches, roots, rocks, swamps, turbid pools, and miles of deep mud... The only good parts are on the actual summits of the bald hills; even the upper portions of the slopes are, in many places, green, spongy swamps, the head waters of the radiating creeks; and, directly the forest is entered, the more serious evils begin."

Since these trails were also used by those packing supplies, prices on the creeks reached fabulous heights. It cost one dollar to mail a letter, and many items were a hundred times higher on the creeks than in Victoria. Even at these prices, the supply of food was frequently rationed. It became evident

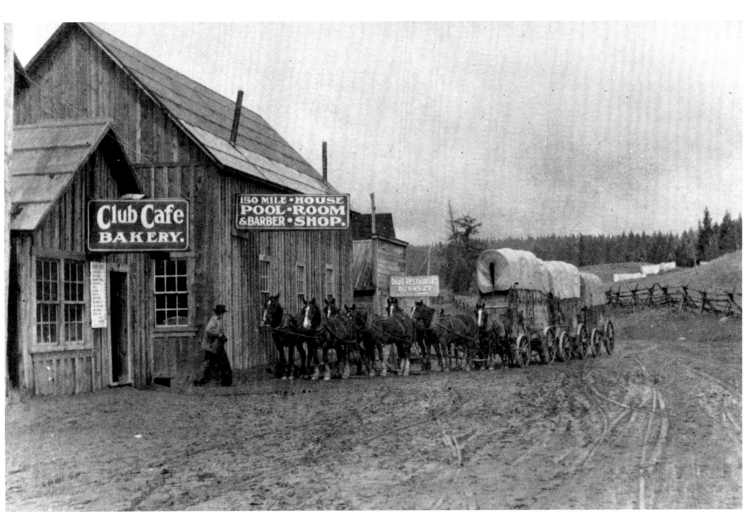

above Freight wagons on the Cariboo Wagon Road at the 150 Mile House. The first section was built in 1861 between Lillooet and 47 Mile, a name changed later to Clinton. But the route wasn't practical and two years later was bypassed by a road through the Fraser Canyon. HERITAGE HOUSE ARCHIVES

left One of the most famous landmarks on the wagon road was the Alexandra suspension bridge. It was completed by Joseph Trutch in September 1863 at a cost of $45,000. The span was nearly three hundred feet, and when it was tested with a four-horse team pulling a wagon loaded with three tons, deflection was less than one-quarter of an inch. It was the first suspension bridge in the west. UBC LIBRARY. RBSC. UNO LANGMANN FAMILY COLLECTION OF BC PHOTOGRAPHS. UL_1001_0021

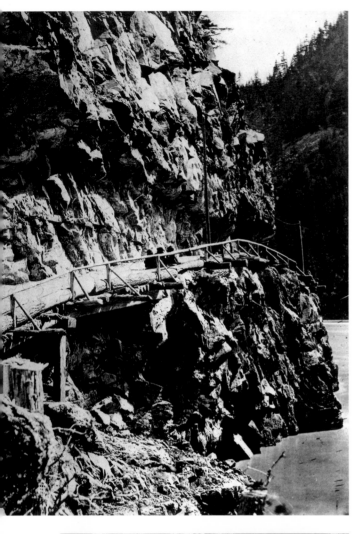

to Governor Douglas that disproportionate freight costs had to be reduced if the full potential of the area was to be realized and permanent settlers attracted.

Late in 1858, a trail had been slashed around the Fraser Canyon to Lillooet, and in 1860 it was widened to a wagon road. From Port Douglas on Harrison Lake, the road led overland thirty-eight miles to Lillooet Lake. Here, the steamer *Lady of the Lake* connected to a thirty-mile road that led from Lillooet to Anderson Lake. Service on the nineteen-mile-long Anderson Lake was provided by another sternwheeler, the *Marzelle*. From Anderson Lake, one and a half miles of road led to twenty-three-mile-long Seton Lake and another steamer, the *Champion*. From Seton Lake, a road led three miles to Lillooet. Then, in 1861, Gustavus Blin Wright began work on forty-seven miles of road from Lillooet to a point that became known as Clinton.

But this route wasn't satisfactory. The road being built by Wright climbed over a 4,000-foot mountain, and grades were steep and hazardous. From Port Douglas to Lillooet, freight had to be transferred from steamer to wagon and wagon to steamer at least eight times, each transfer resulting in an increase in freight rates. It was evident that this route would never serve as the main thoroughfare to the Cariboo.

Fortunately, there were men of vision at the head of government. In 1861, Governor Douglas outlined a plan as bold and imaginative as anything previously undertaken in North America. It called for the construction of an eighteen-foot wagon road north four hundred miles through the rock barrier of the Fraser Canyon and across the lonely wilderness miles to the goldfields. Considering that the permanent population of the colony was under 7,000 people, the project was a stupendous undertaking.

As a start, in October 1861, the Royal Engineers were ordered to survey a route from Yale through the canyon to Cook's Ferry. The same month, a contract was let for the construction of the section between Boston Bar and Lytton, which was completed in 1862. The first six miles northward from Fort Yale had to be blasted from the face of the cliffs, and some sections were built right over the river on

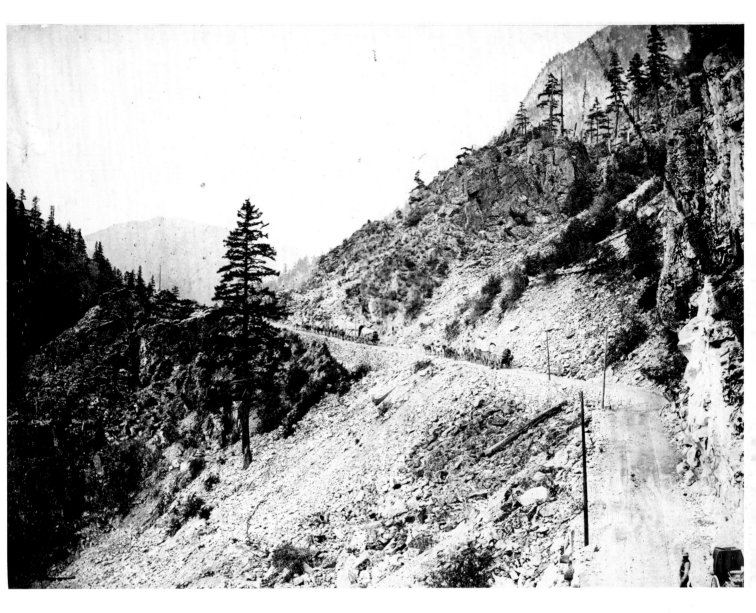

opposite, top In many places in the Fraser Canyon, the Wagon Road was literally torn from the cliffs then hung with dirt and cribbing over the rocks and river. CITY OF VANCOUVER ARCHIVES. AM54-S4-: OUT P930

opposite, bottom Before the completion of the road, travel through the canyon was hazardous and slow, as the account of an early traveller reveals: "We were detained at Lytton and when we started out next morning the snow was four and a half feet deep. We had no snowshoes and the walking was most laborious. We arrived at Yale on December 5, having taken ten days to make 57 miles." UBC UL_1001_0023

above The Wagon Road climbs over Jackass Mountain, the steepest grade on the route. There are two versions behind the naming of the mountain. One is that the grade was so steep that only a jackass would use the route. The other, and probably more accurate, is that the name is a memorial to the many pack animals that fell over the cliffs while packing to the mines. UBC LIBRARY. RBSC. UNO LANGMANN FAMILY COLLECTION OF BC PHOTOGRAPHS. UL_1001_0026

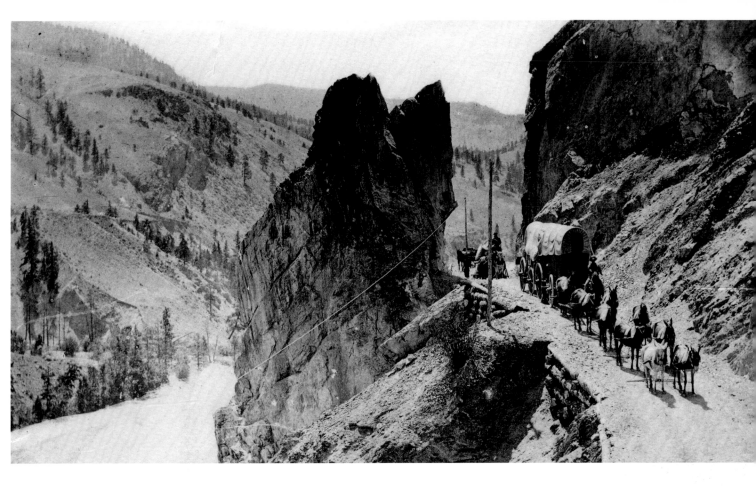

stilts and cribbing. In May 1862 the Royal Engineers started this section. Other parts of the canyon were let to private contractors, the most prominent of whom were J.W. Trutch and Thomas Spence. Meanwhile, to the north, G.B. Wright had completed the Lillooet to Clinton section and was awarded another contract from Clinton 177 miles to Soda Creek.

Work on all sections progressed steadily. By September 1863 the road was completed from Yale northward three hundred miles to Soda Creek. The project was an instant success. In July 1863, before the route was fully completed, one traveller reported meeting, in the eighty-mile section between Yale and Cook's Ferry, ten loaded wagons, each carrying two tons of freight and 250 pack animals loaded with 400 pounds each.

From the end of the road at Soda Creek to Quesnel, connection was by sternwheel steamer and from Quesnel to the goldfields by trail. But in 1864 G.B. Wright started construction of a wagon road from Quesnel to Cottonwood, halfway to the goldfields, and the next year, the road was completed to Richfield, Barkerville, and Camerontown.

opposite The Wagon Road clings to the rocks in an area of the Fraser Canyon known as China Bar Bluff. The road through the canyon was to serve the Cariboo for over twenty years, but in the 1880s, construction of the Canadian Pacific Railway destroyed much of it. With the completion of the railway, the gateway to the Cariboo changed from Yale to a new community called Ashcroft. HERITAGE HOUSE ARCHIVES

above The Great Bluff at 88-Mile Post on the Thompson River near Spence's Bridge. Dr. Cheadle, after passing along this section in 1863, wrote, "The road is frequently cut out of nearly perpendicular precipice overhanging the river, rocky and rugged, many places of a kind where I would be sorry to drive on a dark night. No fence whatever and certain death to fall over the precipices into the river."

This photo was taken in 1865 shortly after completion of the telegraph line, which can be seen in the centre of the photo. CITY OF VANCOUVER ARCHIVES. AM1376-: CVA 3-39

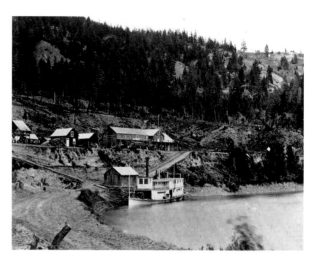

top Originally, the Wagon Road ran only as far as Soda Creek, some 270 miles north of Yale, and service from Soda Creek to Quesnel was by the sternwheel steamer *Enterprise*. The vessel was built for G.B. Wright in 1863 at a cost of $75,000. For eight years, it served on the fifty-six-mile stretch of the Fraser River between the two communities; then, in 1871, it journeyed up the Fraser, Nechako, and Stuart Rivers into the chain of lakes north of Fort St. James. The *Enterprise* was later used for carrying supplies to the Omineca goldfields, but the venture wasn't successful and the vessel burnt up on Trembleur Lake.

On October 16, 1863, on her run from Soda Creek to Quesnel, the *Enterprise* carried two Englishmen, Dr. Cheadle and Lord Milton, probably the first tourists to visit the Cariboo. Later, Dr. Cheadle wrote a book on their experiences, *The North-West Passage by Land*, which quickly sold out six editions. Of the upstream voyage, Dr. Cheadle wrote:

Steamer came in about 2 o'clock bringing a host of miners, two of whom were very drunk and continued to imbibe every five minutes; during the time we stayed in the house they must have had twenty drinks. The swearing was something fearful. After we had been on board a short time the Captain, finding out who we were, gave us the use of his cabin, a comfortable little room, and supplied us with cigars and a decanter of cocktail, also books and papers. We were fetched out every few minutes to have a drink with some one, the Captain taking the lead by standing champagne all around. We had some dozen to do before supper, no one the least affected. Milton and I shirking in quantity. The Captain told us the boat was built on the river, all the timber sawn by hand, the shaft in 5 pieces packed up on mules, cylinders in two, and boiler plates brought in same manner.

HERITAGE HOUSE ARCHIVES

bottom Nearing the end of its journey, the Wagon Road follows the north bank of Williams Creek to Barkerville, located just around the bend in right centre of the picture. UBC LIBRARY RBSC. UNO LANGMANN FAMILY COLLECTION OF BC PHOTOGRAPHS. UL_1001_0075

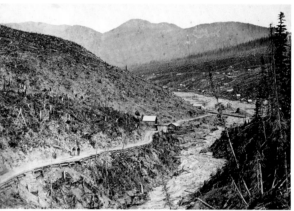

This route greatly reduced prices. In 1862 on Williams Creek, flour was $2 a pound, butter $5, nails $5, and potatoes $1.15 a pound. In 1863 and 1864, before the road was even completed, flour had dropped to 35 cents a pound; butter cost $1.25; potatoes, 20-25 cents; coffee, $1; and beef, 40 cents.

The road was considered the eighth wonder of the world and a proud achievement for the colony. Over it passed stagecoaches and lumbering freight wagons, mules and oxen, men who had reaped golden fortunes but were travelling southward on tickets bought by friends, gamblers and murderers, judges and lawyers, women of all classes and virtues, settlers and businessmen—in fact, the entire range of those who opened a frontier and built a province and a nation.

On the following pages are scenes of the original road, its route largely followed by today's paved highway.

The Roadhouses

EARLY IN the gold rush there was no set route to the creeks; each party entered the wilderness and trudged along the route they felt was best. But as more and more gold seekers pressed northward, trails were gradually beaten through the wilds. Along these trails grew a series of stopping places, many established by people who decided there were easier ways to make money than by digging gravel.

Generally the roadhouses were built in areas where grass and water were plentiful and vegetables and crops could be grown. The completion of the Cariboo Wagon Road and the start of stagecoach service greatly stimulated roadhouse construction. Eventually they were to average from ten to fifteen miles apart, but in some areas there was one every three to four miles.

Many were built by road contractors, and typical of them was the 70 Mile House. In 1862, G.B. Wright and J.C. Callbreath were awarded a contract to construct 130 miles of road from Clinton to Soda Creek, and early in the year had progressed about twenty miles north of Clinton. To them, it appeared a logical place for a stopover, so they built a wayside house, which they named 70 Mile House since it was seventy miles from the start of the Wagon Road at Lillooet. As additional stopping places appeared, they also took their mileage from Lillooet. Many of them became famous, including the 83 Mile, 100 Mile, and 150 Mile.

Since services at the stopping places depended on those in charge, the quality of food, cleanliness of beds, and overall hospitality varied widely. However, the inferior places soon lost their trade and, in general, the quality of meals and accommodation was high.

One of the best known of the early stopping places was operated by Peter Dunlevy and Jim Sellars at Beaver Lake, between Williams

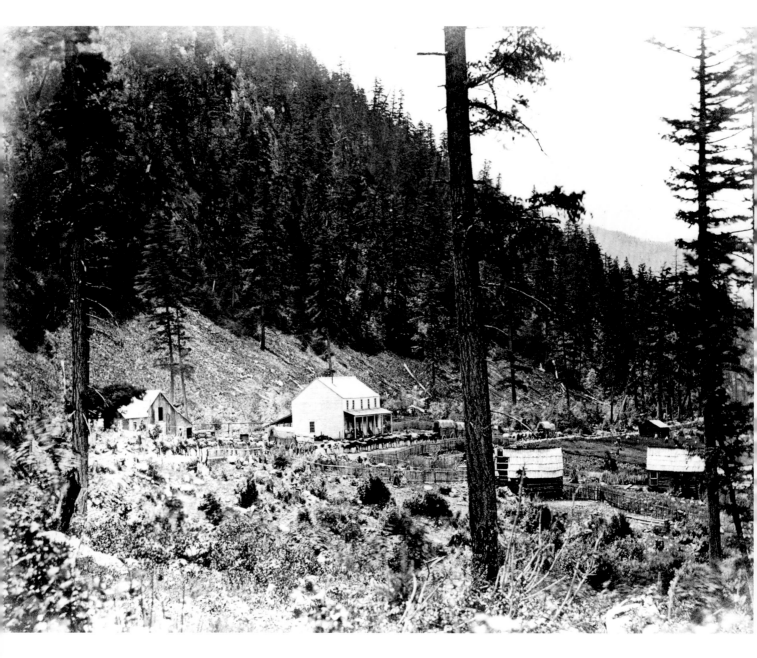

At left is Alexander's 14 Mile House in the Fraser Canyon in 1868. Mileages were Yale to Spuzzum, twelve; Spuzzum to Boston Bar, twelve; Boston Bar to Lytton, twenty-nine; Lytton to Spences Bridge, twenty-nine; Spences Bridge to Clinton, fifty-seven; Clinton to Alexandria, one hundred and sixty; Alexandria to Quesnel, thirty-five; Quesnel to Barkerville, forty-three. CITY OF VANCOUVER ARCHIVES. AM1376-: CVA 3-20

Lake and Quesnelle Forks. In 1863, a miner named John Bryant left the following description:

When the supper bell rang I went in with the crowd. At the head of the table was a large roast of beef and scattered over the table were dishes containing all kinds of vegetables. The milk and cream placed on the table were not only plentiful but of the very best. Sellars pointed to a large huckleberry pie, supported by a dish of fresh cream, and said to me, "This is your supper." This hotel was the best between Victoria and Cariboo, indeed Victoria hotels could not compare with this one in the splendid meals given to its guests.

But not all travellers were that fortunate. When Dr. Cheadle and Viscount Milton visited the Cariboo in 1863, they didn't think too highly of some of the stopping places. On October 8, they stayed at the Stage Hotel in Lillooet, and Cheadle had to battle with a tipsy miner for his bed. With that problem settled, he and Milton went gratefully to sleep, but Cheadle was rudely awakened when his bed collapsed. He spent the rest of the night on the floor.

At the 15 Mile House there was no fire and no beds. Milton slept under the counter, Cheadle beside it, someone else on the top, and four or five miners on the floor. At Cook's Ferry they fared better, having a "very good feed of beefsteaks for breakfast, with potatoes, hot rolls, and butter for one dollar."

During the latter period of the stagecoach era, many stopping places built reputations that still survive. Much of the food was garden fresh, and such commodities as meat, eggs, milk, poultry, and pork were fresh all year. After the early gold rush excitement passed and the country settled to a normal routine, prices remained standard for many years. A meal or a bed was fifty cents a person north to Quesnel and seventy-five cents beyond. Substantially the same food was served for breakfast, dinner, and supper. For breakfast, however, thick farm cream and porridge were added to a menu that would include steaks, fried potatoes, hotcakes, and coffee. Some roadhouses served pie with breakfast, and if it wasn't on the table, it was always available for the asking.

The roadhouses varied in design according to individual owners' temperament, but those on the following pages were typical.

top A six-horse stagecoach and freight wagons at Boothroyd's Roadhouse, thirty-six miles above Yale in 1868. The roadhouses stocked a wide variety of food and other supplies. On November 5, 1862, a miner named Joseph Haller wrote to his father in Pittsburgh that he had quit mining and explained, "I have got a house for travellers and a store with grub. I have 3 tons of flour, 1,000 pounds of coffee, sugar, butter, and beans, 600 pounds of pork, 90 gallons of schnaps of different kinds, and all kinds of tobacco and clothes. I have 7 head of cattle, 3 steers, 9 sheep, and a chicken house. I am 55 miles up river from Lillooet." CITY OF VANCOUVER ARCHIVES. AM54-S4-: OUT P163

bottom Bonaparte House near Cache Creek in the 1860s. In 1862, a miner named W. Champness wrote the following description of a stopping place north of Bonaparte House on Loon Lake: "Whilst staying here, we were very crowded, as the small building was filled with miners by day and night, sleeping under the table and benches as well as on top of them, and all over the floor." CITY OF VANCOUVER ARCHIVES. AM54-S4-: OUT P203

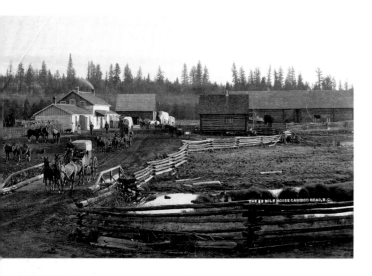

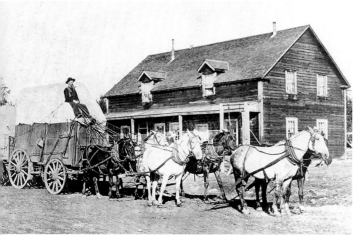

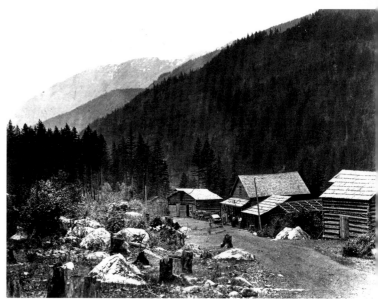

above The 83 Mile House and, below, the 59 Mile House. One roadhouse famed for its meals served three kinds of meat at dinner, a variety of vegetables, at least three kinds of pie, two kinds of cake, and other desserts such as pudding, cookies, and fruit. When everything was ready, the travellers took their places and helped themselves to whatever they wanted.
CITY OF VANCOUVER ARCHIVES. AM54-S4-: OUT P976

top, right The 29 Mile House on the Harrison–Lillooet road in 1863. There were thirteen roadhouses on this route, with the 29 Mile the most famous. However, when the Wagon Road was completed through the Fraser Canyon from Yale in 1863, the Harrison route was bypassed and in 1864 began a rapid decline. HERITAGE HOUSE ARCHIVES

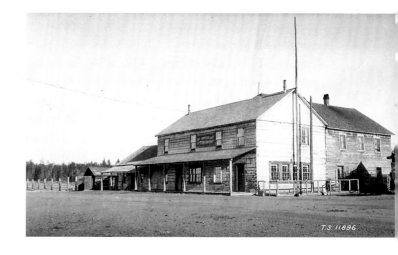

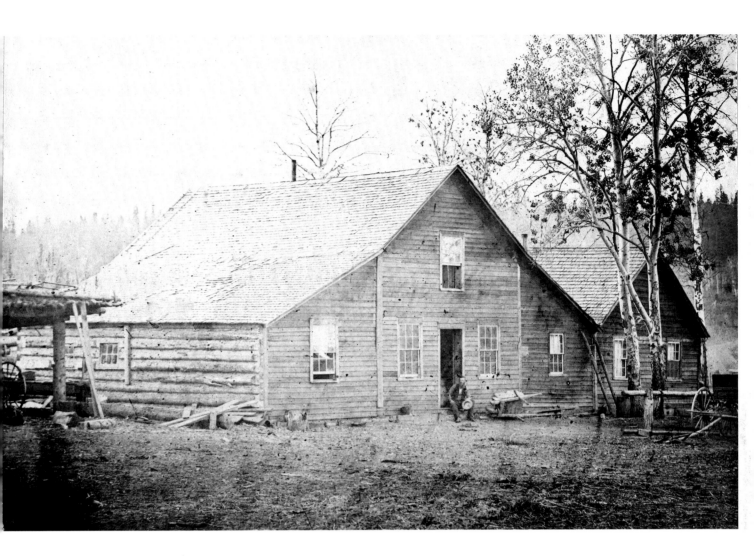

opposite, middle, right In 1868 pioneer photographer Frederick Dally took this picture of his developing wagon on the Cariboo Road in front of a roadhouse in the Fraser Canyon. One account states that it is the Halfway House, sixteen miles above Yale, while another puts the location at forty-two miles above Yale. HERITAGE HOUSE ARCHIVES

opposite, bottom, right The 70 Mile House, the first stopping place built on the Cariboo Wagon Road north of Clinton. It operated continuously from 1862 until 1956, when it burned down, a fate suffered by virtually every one of the roadhouses. In 1958 another famed landmark disappeared when the Clinton Hotel burned after serving travellers for almost a hundred years. CITY OF VANCOUVER ARCHIVES. AM54-S4-: SGN 431

above The 100 Mile House in 1868. One miner described his experience at a roadhouse in these words: "Immediately on our arrival we ordered a square meal, and an ample supply of fresh beef, beans, cabbage, pies, milk, tea, and coffee was set before us." LIBRARY. RBSC. UNO LANGMANN FAMILY COLLECTION OF BC PHOTOGRAPHS. UL_1001_0051

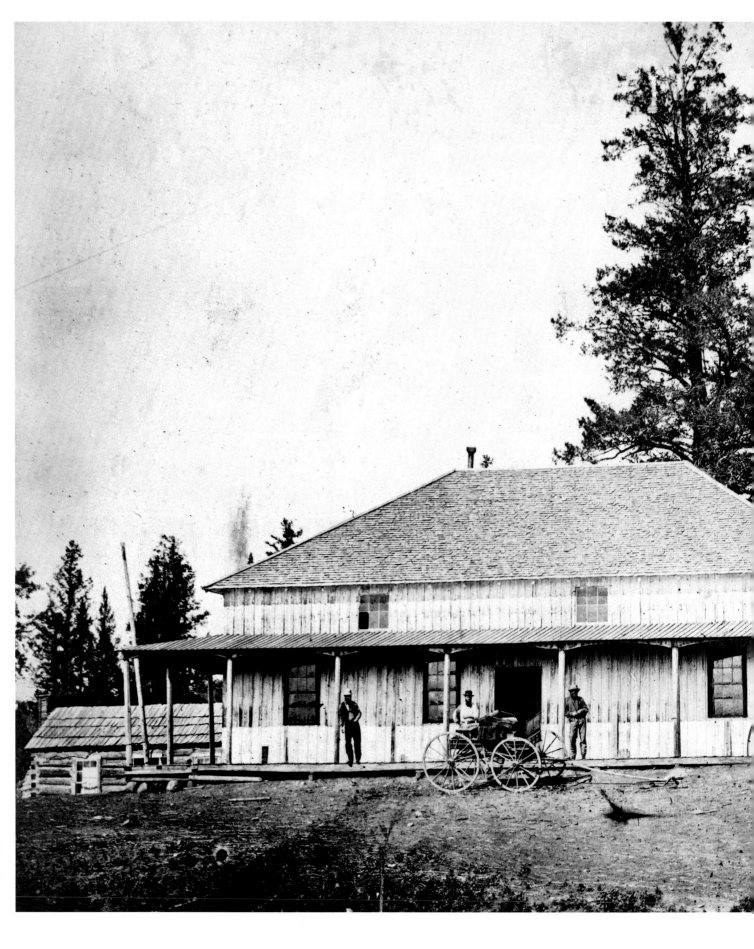

150 Mile House. On October 14, 1863, a traveller described it as "a large square unfinished house, billiard room, lots of geese, ducks, and chickens and all kinds of vegetables."

One of the buildings at 150 Mile was known as the "Home of the Dead Waltz." During winter a favorite pastime of those in the Cariboo was for groups to travel from roadhouse to roadhouse for a dance every night. These dances were the chief social activity and usually lasted until dawn. At 150 Mile, one man was an outstanding dancer and no celebration was complete without him. Unfortunately, after one series of parties, he contracted pneumonia and died.

As was the custom, a three-day wake was held. The first night was solemn and quiet, with all proprieties observed. The second night things livened up. On the third night a dance was held in his memory. Since the man had been an outstanding waltzer, most of the music consisted of his favorite waltzes. At dawn the event broke up, but someone suggested that since the deceased was particularly partial to waltzes, they should give him one last fling on the floor. This was done and so was born the nickname. CITY OF VANCOUVER ARCHIVES. AM54-S4-:OUT-P245

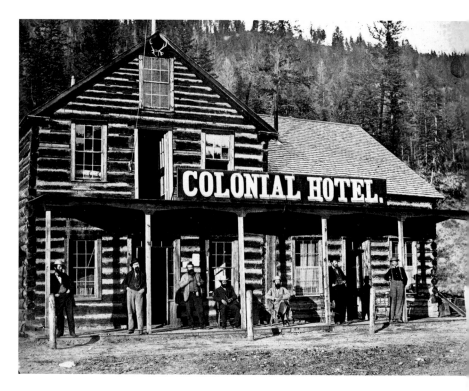

top The Colonial Hotel at Soda Creek in 1868. The man leaning against the post in front of the doorway on the left is Peter Dunlevy, who led the first party of miners up the Fraser in 1859. They found the first gold of Cariboo on the Horsefly River. Although they were Americans, most of them settled in the Cariboo and raised families. Dunlevy is buried at San Jose Mission cemetery near Williams Lake. HERITAGE HOUSE ARCHIVES

bottom The 164 Mile House at Deep Creek and, on the opposite page, the Cottonwood House between Quesnel and Barkerville in 1868. Dr. Cheadle gave the following description of the accommodation at the house just east of Cottonwood: "The wind blew thru [sic.] cracks in walls and floor, only one blanket apiece, 20 men in the room. One affected with cramp in his leg which brought him to his feet swearing every half hour."

At the next place, he was charged a half dollar for a cup of coffee but at the one further along, having "a capital dinner of beefsteak pie, and beefsteak and onions, and pancakes." UBC LIBRARY. RBSC. UNO LANGMANN FAMILY COLLECTION OF BC PHOTOGRAPHS. UL_1001_0056

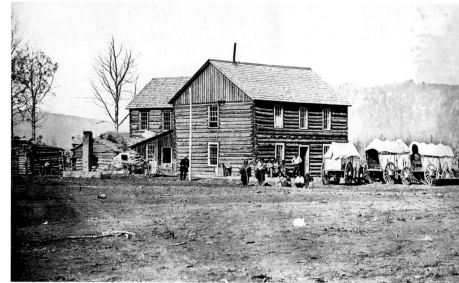

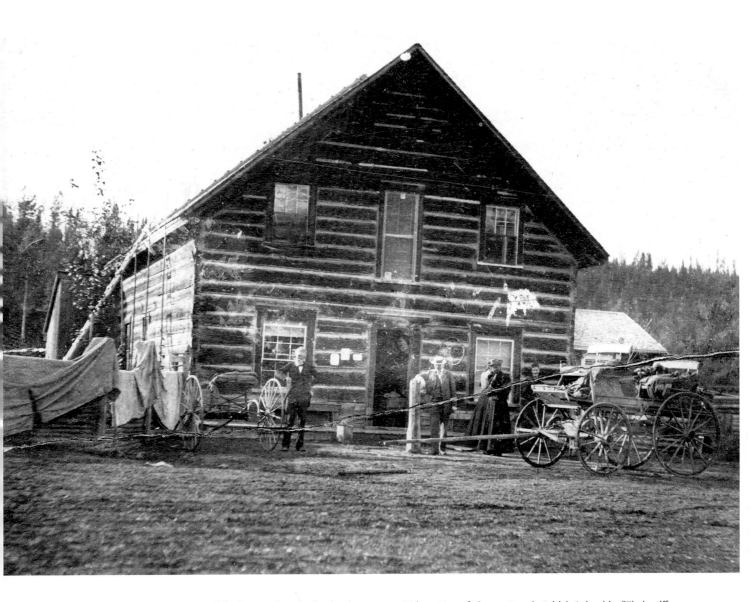

Cottonwood House was one of the few roadhouses destined to survive. It was completed in 1865 by John Ryder and Allen Smith but purchased in 1874 by John Boyd, who owned nearby Cold Spring House. The Boyd family then operated Cottonwood continuously until the fall of 1951. Mrs. Boyd arrived as a bride in 1868, remaining until her death at 89 in 1940. She raised ten children and became known as the "Grand Old Woman of Cariboo."

From 1863 until he died in 1909, John Boyd kept a set of daybooks and ledgers. Of them, Emelene Thomas wrote in Volume Two of *Pioneer Days in British Columbia*: "Their stiff yellowed pages... are a fascinating window into the romantic years when the dust, mire, and snow of the Cariboo Road was churned by countless travelers..."

In 1963 the stopping place was purchased by the BC government. Today, as part of Cottonwood House Historic Park, it remains a familiar landmark. CITY OF VANCOUVER ARCHIVES. AM54-S4-: OUT P436

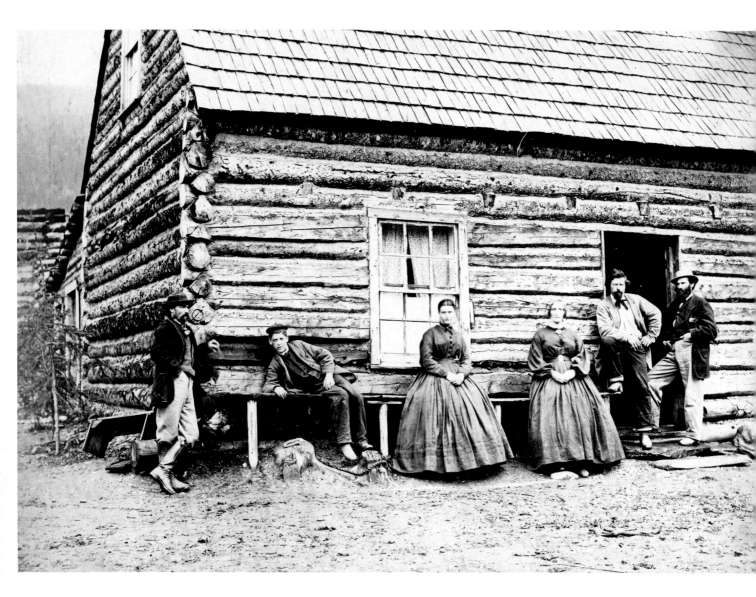

This stopping place on Lightning Creek between Quesnel and Barkerville was built by an Englishman named "Bloody" Edwards in 1862. He earned his nickname not because he was a ruffian but because he was a Cockney and spoke in language such as "three bloody good cheers for the Queen," "a bloody fine day," and so forth. Meals, chiefly beans, bacon, bread, and tea, were $2.50.

In 1868 he sold the place to a freighter named John Hamilton, shown in this photo with his family, who changed the name to Pine Grove. The place eventually burned down, and for years all that remained was a pile of stones from the chimney. UBC LIBRARY. RBSC. UNO LANGMANN FAMILY COLLECTION OF BC PHOTOGRAPHS. UL_1001_0065

Indigenous People in the Gold Rush

ONTRARY TO SOME preconceived ideas that the Indigenous Peoples of British Columbia were primitive humans living in Stone-Age surroundings before Europeans arrived, the First Nations of what would become the province of BC had, by the time of first contact, developed a rich, vibrant culture. They lived in relative comfort, thanks to the abundance of salmon and game. The route to the goldfields ran through the traditional territories of the Sto:lo, Nlaka'pamux (Thompson), St'at'imc (Lillooet), Secwépemc (Shuswap), and Dakelh (Carrier), following trails that had been used by these communities for thousands of years.

The Sto:lo territory extended from Fort Langley to Yale on the Lower Fraser River. It is not surprising that the first steamship to ascend the Fraser River to Fort Hope could only navigate the treacherous river currents and shoals with the help of a Sto:lo pilot, named Speel-est. The *Surprise* took Speel-est aboard at Fort Langley and proceeded sixteen miles above the fort, where it stopped for the night. The next day it arrived at Fort Hope at 2:00 PM. This was a fortuitous engagement for Speel-est who, after his successful mission, was paid in kind with "a pilot-cloth suit, white hat, and calfskin boots." He was also paid $160 for his services and, henceforth, he was known as Captain John. Other Sto:lo people saw Speel-est's success and charged to transport miners and supplies by canoe up and down the Lower Fraser.

Encounters between the miners and Indigenous people were not always without incident. The Nlaka'pamux resisted intrusions into their territory and were every bit as interested in mining the gravel bars of the Fraser as the White intruders. For the Nlaka'pamux, the potential income from gold mining was an important

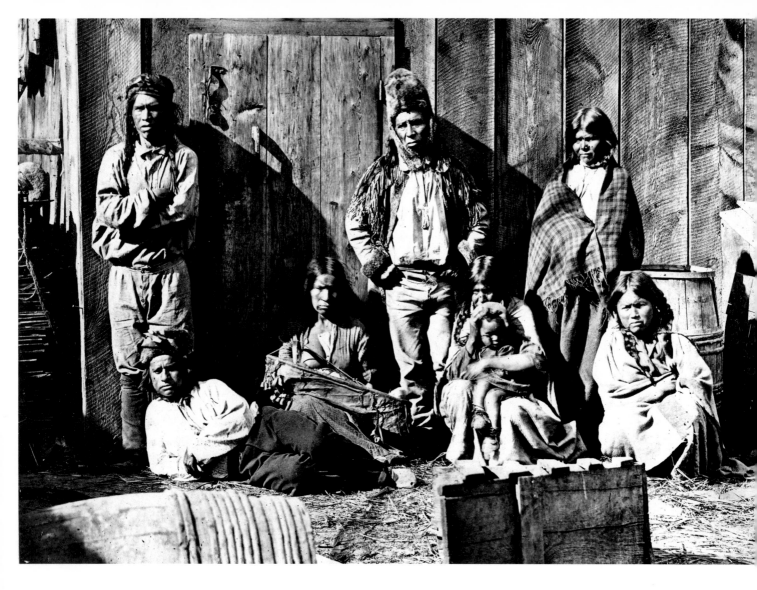

above Nlaka'pamux people at Lytton on the Fraser River. Left to right: Thos-mets-ko, Sha-op-e-salt (lying down) Sheenjuto (chief of the Shutswates Band), Pukelax (woman standing). The Nlaka'pamux were not afraid to stand up to the White miners. UBC LIBRARY. RBSC. UNO LANGMANN FAMILY COLLECTION OF BC PHOTOGRAPHS. UL_0001_0030

opposite, top Group of Secwépemc people on the Thompson River. The Secwépemc territory extended on the east side of the Fraser River as far north as the Quesnel River. UBC LIBRARY. RBSC. UNO LANGMANN FAMILY COLLECTION OF BC PHOTOGRAPHS. UL_0019_0017

opposite, middle A Nkla'pamux family mining near the "Forks," the confluence of the Fraser and Thompson Rivers. Indigenous people actively mined on the Fraser and Thompson Rivers using the techniques and equipment that had been brought in by the miners. In 1873, the superintendent of Indian Affairs, J.W. Powell, wrote with admiration that the Indigenous miners could

be seen "during the coldest weather working their cradles."
IMAGE D-06815 COURTESY OF ROYAL BC MUSEUM AND ARCHIVES

opposite, bottom An Indigenous pack train. Judge Begbie wrote in an 1872 report that "no supplies were taken in except by Indians ... Without them ... the country could not have been entered or supplied in 1858–1860."

As prospectors proceeded up beyond the Forks, they encountered the Secwépemc and St'at'imc Nations. The prospectors struggled to carry enough supplies to survive while they explored upriver, and the Indigenous people saw opportunities to make some money transporting the miners' precious provisions; they had large numbers of horses and were able to move supplies efficiently. Packing goods by horse or mule became the most effective way of transporting freight in the spring, summer, and fall. Indigenous packers learned the most effective ways of loading pack horses from the Mexican packers who had come to BC from the south. PENTICTON MUSEUM

aspect of their economy. After peace was established on the Fraser, Indigenous people mined alongside European miners.

When Barkerville became the heart of the Cariboo goldfields, many enterprising Indigenous people from all over the lower half of the Colony of British Columbia came to take advantage of the opportunities for income. Some Indigenous men worked for mining companies during the summer but, for most of the people, the potential for supplying much-needed food supplies was more attractive. Their centuries of experience in the area meant that they knew where food of every sort could be obtained. Bear (Bowron) Lake to the east of Barkerville had long been a site occupied by Indigenous people, evident from the numerous pit house and storage pit sites confirming that the area was their year-round home. The lake was on the border between the Secwépemc and Dakelh territories and was used by both nations. Indigenous people fished in the lake and in Bear (Cariboo) River and sold their surplus to miners on the creeks. The same applied for the salmon caught by in the Fraser and Quesnel Rivers, which were happily purchased by miners and merchants. The *Cariboo Sentinel* reported that Indigenous people were selling fish "at the rate of three bucketfuls for one bit." According to the newspaper, their main market was Chinese miners "who are always ready with the cash for good cheap grub."

The opportunities for income were not limited to the local Indigenous people. A large number of St'at'imc people travelled from the Lillooet area to Barkerville every year for the summer months, primarily to pick Olalla berries in June and huckleberries later in the summer. These were dried and sold in the gold camps and towns. The Indigenous Peoples in the Cariboo were, of course, excellent hunters and trappers. James Duffy, an Indigenous resident of Barkerville, trapped enough marten, mink, otter, bear, weasel, and lynx to support himself quite well. Indigenous people also rented out saddle horses from their large herds, and Indigenous women provided laundry services for the miners. Two of these may have been Lucy Bones, who had a cabin directly across from St. Saviour's Church, and

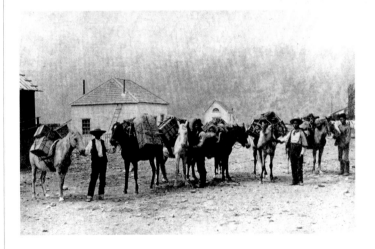

Miners followed the trails from the Fraser River to the Cariboo mountains that had been used by Indigenous Peoples for centuries. Indigenous women carried packs and pulled loaded sleighs full of provisions from Quesnelle Forks up through Keithley Creek and over the Snowshoe Plateau to Antler Creek, the first of the rich Cariboo creeks. Michael Costin Brown, one of the early miners on Williams Creek, reported that he had purchased a pair of snowshoes from Indigenous people at Fort George to make his way through the deep snow. IMAGE I-33342 COURTESY OF ROYAL BC MUSEUM AND ARCHIVES

"Indian Mary," who lived in a cabin in Stanley. The death of an Indigenous woman from Victoria, who had lived in Barkerville for two years, was reported in the *Cariboo Sentinel*, as well as a court case against "two Indians, a Lillooet and a Hyda [Haida]" in the assault against "Full Moon," another Indigenous woman.

Throughout the gold-rush years and after, the Indigenous population of British Columbia was far greater than the European and Chinese inhabitants. The 1871 census shows that there were an estimated 25,661 Indigenous people in BC compared with 8,576 of European origin and 1,548 of Chinese origin. This majority of Indigenous people at the time existed even though their people had been devastated by measles and influenza epidemics in 1848 and 1849, followed by a smallpox epidemic in 1862. Because of their great numbers, they provided a significant labour pool for the mining, packing, canoe and boat transport, roadbuilding, firefighting, and commercial fishing industries. The darker side of this majority population could be seen in the large number of Indigenous prostitutes.

The colonial governments of Vancouver Island and British Columbia were well aware of this population imbalance. Some officials, notably Governor James Douglas and Judge Matthew Baillie Begbie, were concerned that the various Indigenous groups be treated equitably and fairly by setting aside land for their use and making them equal before the law. During Douglas's time as governor, allotments of land were set out and agreements made with many of the First Nations. Unfortunately, these agreements were never officially recognized and subsequent governors and colonial administrations reduced the allotments and failed to live up to agreements. The resulting damage to the Indigenous people who, for the most part, welcomed the newcomers and trusted them before being betrayed by them, has left a sad legacy in the province.

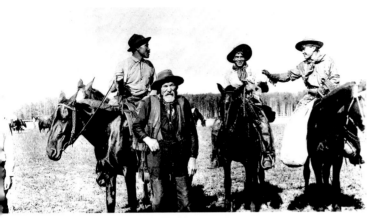

top The famous packer, Jean-Jacques Caux, known as "Cataline," with three Indigenous men who worked as his packers. Once the Cariboo Road (the Wagon Road) was completed to Barkerville in 1868, the mining towns were less dependent upon packed in supplies. But Indigenous packers would continue to be a vital link in the supply chain to the gold creeks of the Cariboo, especially in the spring, when melting snow made the roads impassable for wagons or sleighs. In the spring of 1868, the *Cariboo Sentinel* wrote that supplies for the mining town of Antler Creek "were only obtained by being packed by Indians from Barkerville." The report went on to say that the same applied for Mosquito Creek, Willow River, Sugar Creek, and Mustang Creek. Indigenous packers charged eight cents a pound to bring in supplies. IMAGE I-51525 COURTESY OF ROYAL BC MUSEUM AND ARCHIVES

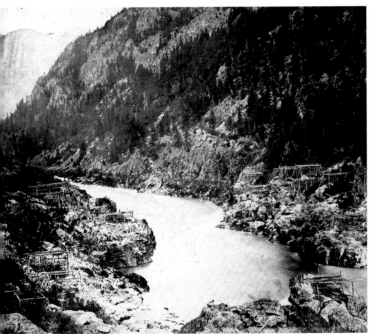

middle Salmon drying racks on the Little Fraser River. Indigenous fishers would stand on a platform that extended out over the river and spear salmon as they went by. UBC LIBRARY RBSC. UNO LANGMANN FAMILY COLLECTION OF BC PHOTOGRAPHS. UL_1001_0019

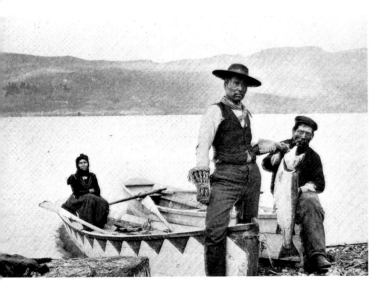

bottom During the winter, Dakelh fisherman caught whitefish in two large lakes, one on the west side of the Fraser and the other east of Quesnel, where it was reported that "they obtain their supply of white fish through the winter months." The *Cariboo Sentinel* reported in 1865 that the Indigenous people "go off to the mountains in winter, where they hunt for bear and moose, which they kill in large numbers sufficient to live on in the summer, besides selling large quantities of meat to the Hudson Bay forts." They soon learned that the hungry miners would pay even more for fresh fish and game. PUBLIC DOMAIN

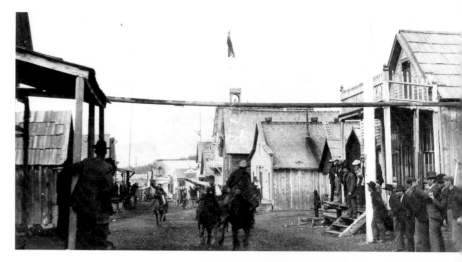

top The significant Indigenous population of Barkerville was regularly involved in the annual Dominion Day celebrations. In 1874, the *Cariboo Sentinel* reported that Indigenous people would be gathering "from all parts of the province to witness the [Dominion Day] amusements." There were specific events in the competitions that day, such as an "Indian" two-hundred-yard handicap race, a wheelbarrow race, a sack race, and a children's race. There were also separate races for "Siwash" horses. As the derogatory term "Siwash" was used to describe Indigenous people from various nations, it can be seen that the integration of Indigenous people into the general population was far from complete. In fact, most of the Indigenous people in the 1870s lived in a "shantytown" on the outskirts of Barkerville. BARKERVILLE MUSEUM P0657

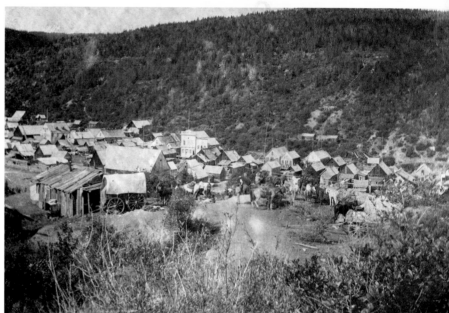

middle This image in the Barkerville photograph collection, labelled "Indian Encampment, Barkerville, Aug. '99," shows a distinct collection of shanties on the north end of the main street in town. BARKERVILLE MUSEUM P1479

bottom Governor Seymour addressing the Lillooet Indigenous people. Under Seymour's governorship, reserves for Indigenous people were drastically reduced. Seymour had little interest in the plight of Indigenous peoples and left the "readjustment" of their reserves to Joseph Trutch, who concluded, "the Indians have really no right to the lands they claim, nor are they of any actual value or utility to them." UBC LIBRARY. RBSC. UNO LANGMANN FAMILY COLLECTION OF BC PHOTOGRAPHS. UL_1019_0027

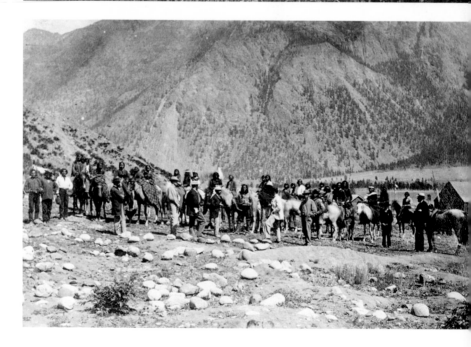

SIX

Chinese Sojourners

O N APRIL 25, 1858, when the steamship *Commodore* arrived in Victoria from San Francisco with the first group of 450 miners, it included about thirty Chinese people. These miners were from the estimated 24,000 Chinese people, mostly young men, who had come to California in search of gold. While a great number of them came north from California, even more came directly from China to British Columbia. Most came from the Pearl River Delta, a rice-growing area of Guangdong Province in China. They left their home and families to seek their fortunes in the goldfields of North America, which they referred to as the "Gold Mountain" (*Jinshan*). They embarked on small vessels from the nearby British colony of Hong Kong and were packed tightly in the lower decks. The journey across the Pacific took from sixty to sixty-five days, during which they lived on two meals a day of rice and tea. Many of them were paid for by large companies that required them to work off the cost of their passage when they got to BC. By the end of 1860, an estimated two thousand Chinese people had come to the colony, and within a few years more than twice that number had arrived. But the prospective Chinese miners never intended to stay. They considered themselves to be "sojourners" who left home only for the short period of time, enough to make enough money to return home and live comfortably.

The Chinese miners, along with the thousands of white miners, had to make their way across the Strait of Georgia to the mainland. Although the strait is only seventeen miles wide, it is subject to extreme weather and large waves. Victoria's *Colonist* newspaper reported in July 1860 that four canoes had headed to New Westminster, one of them carrying Chinese miners. Many miners were drowned in crossing the strait and, once they arrived at the first

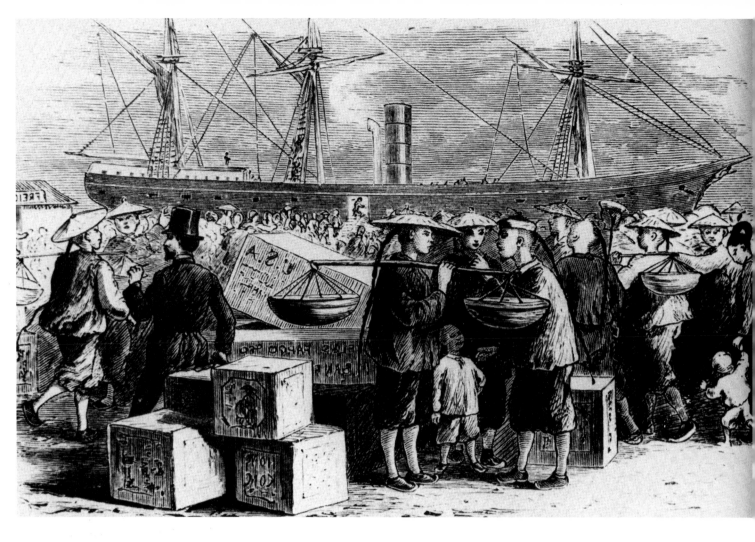

above Chinese people preparing to board a ship for British Columbia from Hong Kong. Most were from Guangdong Province and had to borrow money from large companies for their passage. They then spent years paying off their debt before being able to work for themselves. UBC UL_1019_0027

opposite Chinese prospectors carried their belongings on a pole over their shoulders. On one side was a box or bundle containing their blankets, clothing, and mining equipment, such as pans. On the other was a basket or box containing their basic provisions, such as rice and tea, along with basic cooking utensils. This miner is using a rocker box or cradle, first developed in the California goldfields and brought north to British Columbia. The rocker could be dismantled to be carried from one site to another on the end of a pole. After staking a claim that proved to be promising, miners would construct flumes to deliver more water to a series of riffles, allowing for much more gravel to be processed in a shorter time. IMAGE C-01274 COURTESY OF ROYAL BC MUSEUM AND ARCHIVES

gold-bearing gravel bars on the Fraser River around Hope, they would have travelled over 150 miles. From there, the going got even tougher. The Fraser Canyon was a challenge to the hardiest miners, and the Chinese showed their perseverance. They made their way along the precipitous trails, carrying their equipment and supplies. While many miners employed Indigenous packers, the Chinese miners carried their own possessions on a pole over their shoulders.

By 1862, there were 2,100 Chinese people in the Colony of Vancouver Island and 2,400 in the Colony of British Columbia. Those in the mainland colony (the two colonies did not unite until 1866) included 300 between the mouth of the Harrison River and Yale, 200 between Yale and Lytton, 100 on the Thompson River between Lytton and Kamloops, and another 400 to 500 in the vanguard between Lillooet and Cottonwood and on the Quesnelle River. Some had advanced up the Fraser River as far as Fort George. In the new area known as the Cariboo, there were Chinese miners at Quesnelle Forks, Antler, Keithley, Lightning Creek, and Williams Creek. Some were in Hope and Similkameen.

As Williams Creek and surrounding areas became the heart of the Cariboo goldfields, Chinese miners were quick to arrive on the scene. In 1861, the Gold Commissioner in Richfield noted that twenty-seven Chinese miners had been issued free miner's licences, and Chinese miners were working on Williams Creek. As even more Chinese miners began to arrive, the larger mining companies, always looking for more labour, began hiring them. By 1870,

Barkerville was home to 250 miners of Chinese origin and 975 Europeans.

Barkerville continued to attract Chinese miners and businessmen. By 1866, there were 444 White men, women, and children in Barkerville and 258 Chinese. The extent to which the Chinese had settled at Barkerville can be seen in records of he 1868 fire that destroyed the town, including buildings owned by Chinese people worth $26,000. Two years later, a work party of fifty men, mostly Chinese, worked on one hundred-foot-wide tunnel running through the Prairie Flower claim to the meadows. The Chinese miners, aware that they supplied much of the labour for the project, went on strike for an extra fifty cents a day. When the mine owners refused, they went back to work.

By 1872, the Chinese population of Barkerville totalled 250, and by 1884, John Bowron reported that the decline in white miners had been matched by an increase in Chinese who, by that time, produced three-quarters of the gold coming out of the Cariboo.

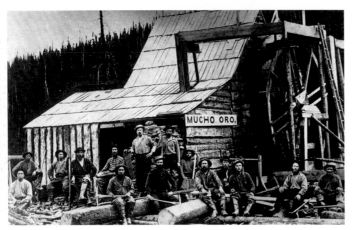

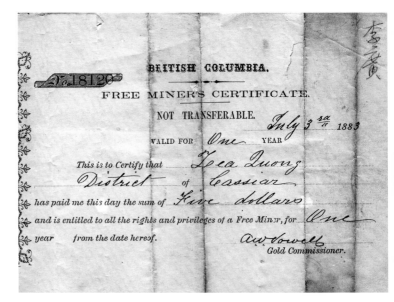

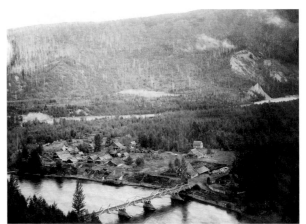

above, top, left Chinese miners washing gold in the Fraser Canyon using a rocker box. As was the case with the European miners, the gold pan was only used for testing a site to see what amount of gold could be found. Then the rocker box was the favourite tool for separating gold from the gravel. A good rocker box could process a large amount of fine gravel, the type of pay dirt found along the Fraser. The gold-bearing gravel was loaded into the top tray or hopper using a shovel or scoop like the ones visible in the photo. Then water would be poured in on top of it and the box rocked back and forth, separating the lumps of pay dirt so that the fine material passed through a coarse screen or half-inch holes punched in the tin bottom of the tray. The larger rocks were removed, allowing the sand and gold to flow through, and, as the gold and sand passed over the riffles, the heavier gold would be caught behind the riffles and lighter material would pass through. Often, carpeting was placed beneath the riffles to catch the very fine gold. UBC LIBRARY RBSC. THE CHUNG COLLECTION. CC-TX-278-9

above, bottom, left Seen on the left are four Chinese miners. In 1866 the Raby Company had three shafts sunk and were bringing out 450 ounces of gold per day. They employed sixty Chinese workers. Photographs taken by Frederick Dally in 1868 of some of the claims show that Chinese workers were common. HERITAGE HOUSE ARCHIVES

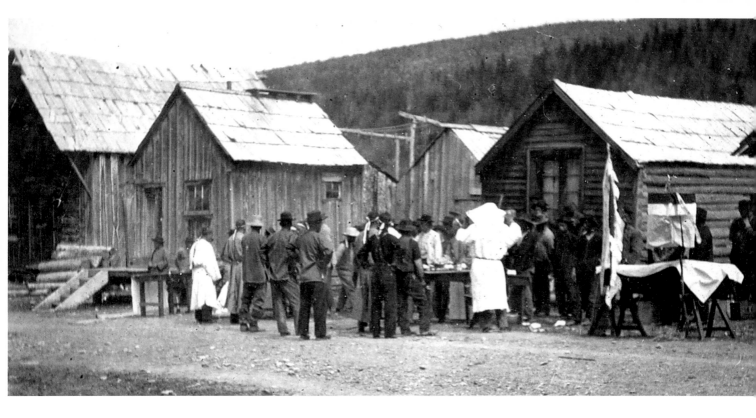

opposite, top, right A Free Miner's Certificate for Lee Quong, issued in the Cassiar region in 1883. As had been the case from the beginning of the gold rush to British Columbia, discrimination was quick to follow the Chinese. In 1865, eighty-seven Cariboo miners signed a petition demanding that "... all Chinamen found mining in any part of British Columbia, whether on the bars and banks of the Fraser or elsewhere, be required to pay a tax of one pound a year for each privilege." The response from Colonial Secretary Arthur Birch reveals the government's attitude toward the Chinese. He first noted that, "this petition is a very good specimen of the case with which a host of signatures can be obtained from persons utterly unacquainted with what they are signing. I think we have done enough for the present in taxing the Chinese." He went on to draft a reply to the petitioners: "You are mistaken in the impression that the law at present in any way favours the Chinese. Whenever they strike upon ground sufficiently rich to render it possibly attractive to the Free Miner they take out a licence for their own protection." IMAGE MS-0646 COURTESY OF ROYAL BC MUSEUM AND ARCHIVES

opposite, bottom, right Quesnelle Forks around 1900. The 300-foot bridge was built by Barry and Adler in 1861. After the main focus of activity became the creeks of the Cariboo around Barkerville, Quesnelle Forks attracted a large number of Chinese miners and businessmen. The 1873, the BC Directory lists numerous businesses there, including the Kwong Lee and E. Tie stores. The *Cariboo Sentinel* wrote in 1875 that "Chinese mining is in full blast on the South Fork and Kangaroo Creek, supposed to be paying well. Four or five new houses have been built lately at the Forks, so it seems the Celestials [a common term used to describe the Chinese people] have good faith in the district." The area became a centre of hydraulic mining late in the 1870s. By 1881, the census showed a population of 413 Chinese and only 102 white people in Quesnelle Forks. There were no Chinese women listed in the town until the 1891 census. During the period from 1890 to 1900, the region contained the third-largest group of Chinese residents after Victoria and Nanaimo. CITY OF VANCOUVER ARCHIVES. AM54-S4-: OUT P994

above Despite their increasing numbers, the Chinese continued to be treated as outsiders by the white mining community. Wherever they congregated, they would build their houses and businesses in the same part of town. These Chinese enclaves were inevitably called "Chinatowns," and there were dozens of them. There the Chinese, bound together by their common language and traditions, could live comfortably. During the gold-rush years, there were Chinatowns in Victoria, Yale, Ashcroft, Lillooet, Quesnel, Barkerville, Stanley, and Quesnelle Forks. The 1881 census listed the population of Barkerville as 444 white, 258 Chinese; Quesnelle Forks, 102 white, 413 Chinese; 150 Mile House to Quesnel, 198 white, 374 Chinese, and 717 Indigenous. BARKERVILLE MUSEUM PO662

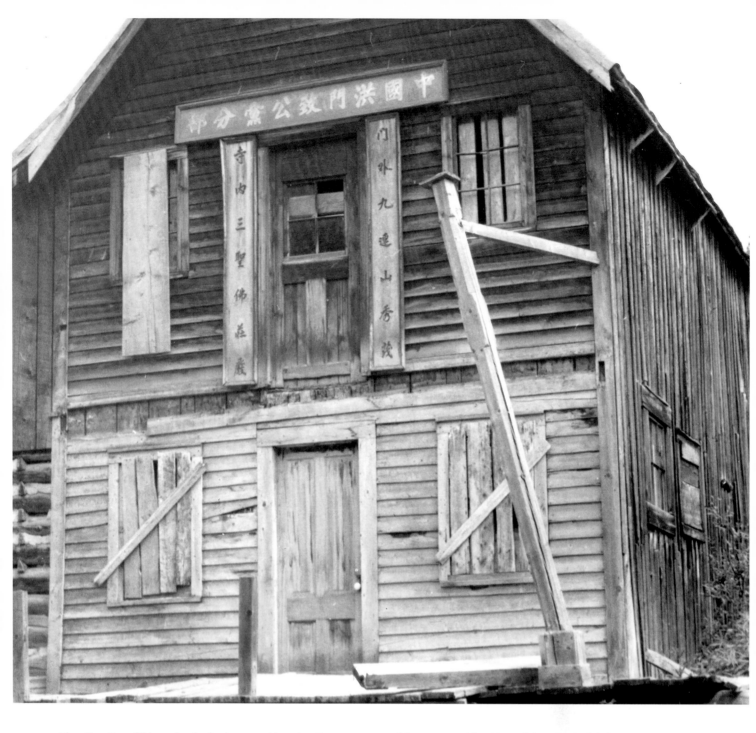

Chee Kung Tong (Zhigongdang), also known as Hongshun Tong (Tang) in Barkerville. Wherever they gathered in significant numbers, the Chinese people formed voluntary benevolent associations and political societies for support and protection. These focused around their originating districts in China, family names, clans, or sworn brotherhoods. They were called "tongs," meaning "hall" or "gathering place." Their objective was to assist members to find jobs and provide housing, recreation, and gambling opportunities. Many of the tongs had their own stores and sold produce to members and the public. The Chee Kung Tong in Barkerville started out just as a cabin before the 1868 fire, but this building, among the oldest surviving structures in the Barkerville, was constructed between 1874 and 1877. Its interior was divided into a hostel, kitchen, and socializing space on the ground floor, and a society hall and altar room on the second floor. HERITAGE HOUSE ARCHVIES

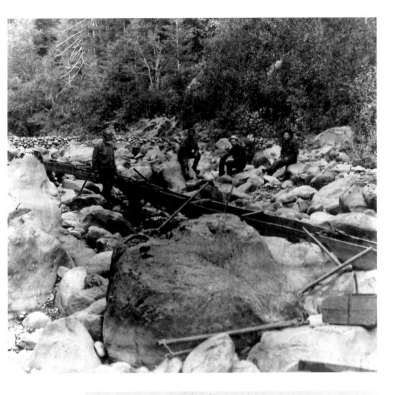

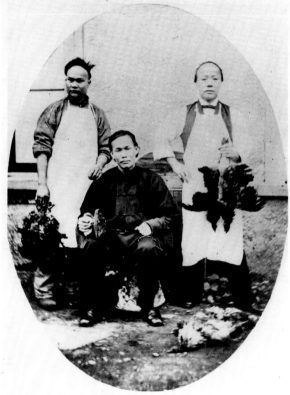

top Chinese miners soon earned a reputation for taking over mining areas that had been worked and abandoned, reworking them successfully to make a living from them. In his book *Very Far West*, published in London in 1872, R. Byron Johnson described this ability, which he had witnessed in British Columbia: "The much-enduring and industrious race are generally to be found in little clusters, at work upon diggings deserted by whites... and will, doubtless, at the end of the year, by means of their frugality, save more than their white brother is likely to, in spite of his higher gains... It is the fashion on the Pacific Coast to abuse and ill-treat the Chinaman [a derogatory word used at the time for Chinese people] in every possible way; and I really must tell my friends... they are hard-working, sober, and law-abiding—three scarce qualities among people of their station."

The Chinese reputation for gleaning gold out of abandoned claims grew over the years. In 1870, a Chinese miner who had bought an abandoned claim on Williams Creek obtained ten ounces of gold on the first day and another ten on the second day. Another Chinese company picked up from already worked ground sixteen nuggets of gold, one weighing three ounces, two of them between two and three ounces, and the rest no less than an ounce. Enterprising Chinese miners also did well on abandoned claims in the Similkameen River. The *Colonist*, reporting from Yale in 1861, noted that some were earning between ten and twenty dollars a day. HERITAGE HOUSE ARCHIVES

bottom Chinese domestic servants at Government House in Victoria.

Not all Chinese poeple who travelled up the Cariboo Road were gold seekers. In the early years of the gold rush, many members of the public welcomed the Chinese to BC because they were willing to provide laundry services and work as servants, barbers, tailors, cooks, market gardeners, cobblers, and in other trades. They also excelled in road building, a crucial necessity in the new colony. About 600 Chinese labourers worked on the road from Yale to Lytton, and about a hundred above Lytton. Royal Engineer sergeant John McMurphy, who supervised the construction of Gustavus Wright's road from Lillooet to Williams Lake, reported that he found Chinese men to be the most reliable labourers on the road. Unlike the white workers, who left their jobs at the news of the latest gold strike, the Chinese workers were not tempted to put down their shovels when gold excitement happened. As a result, they were the last workers to be discharged at the end of the contract. IMAGE D-09468 COURTESY OF ROYAL BC MUSEUM AND ARCHIVES

top Merchants such as Kwong Lee supplied food and other items to Chinese labourers, and he and other Chinese merchants delivered mail as well. Kwong Lee and Company was established in Victoria in 1858 by brothers Loo Chuck Fan and Loo Chew Fan. They hired as manager Lee Chong (or Chang), a well-known and respected merchant. Despite the fact that he was only a manager of the company, he was known as "Kwong Lee" to the non-Chinese public. On February 1, 1860, the *British Colonist* reported that "Mrs. Kwong Lee, accompanied by two children, arrived yesterday on the *Pacific*. This is the first Chinese female that has ever set foot in the Colony." Kwong Lee and Company also owned mining claims, employed Chinese miners, and owned shares in mining companies. In 1863, "At Long Bar, 9 miles above the mouth of Quesnelle, Wm. Ballou with Kwong Lee and others had a party of 120 Chinamen at work, which they expected to increase shortly to 500, and as soon as they could succeed in bringing water it was expected that great results would follow." The company also acquired a ranch one mile out of Quesnel, where it grew fresh produce. As the gold rush progressed, Kwong Lee and Company established locations in Yale, Lytton, Clinton, Lillooet, Quesnel (known then as Quesnel Mouth), Quesnelle Forks, Stanley, and Barkerville. *TIMES COLONIST* APRIL 6, 1864

bottom Nam Sing was one of the first Chinese miners to reach the Quesnel area around 1859 and stayed. Cariboo historian Louis Lebourdais wrote of him: "Nam Sing had poled a canoe up the Fraser from Yale . . . Clearing a little land above the river bar on the west bank, he used his gold-digging shovel to till the soil during the stages of high water when it did not pay to work on his rocker. He raised a few vegetables for himself and sold the surplus to neighouring miners. Gradually, he cleared more land, scowing his produce across to the Quesnel side where it always found a ready sale . . . Later he acquired more bush acreage on the east side." Nam Sing eventually turned to ranching and vegetable growing and operated freight teams to Barkerville. In 1880, he married Sue Cook, a Chinese woman who had travelled to Quesnel by stagecoach after her arrival from China. The couple had thirteen children. Nam Sing died in 1910 at the age of seventy-six. IMAGE G-03059 COURTESY OF ROYAL BC MUSEUM AND ARCHIVES

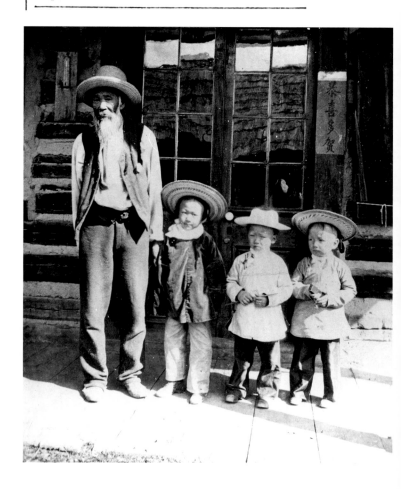

KWONG LEE & CO.,

LEE CHANG, Manager.

———

Commission Merchants,

IMPORTERS AND DEALERS

IN ALL KINDS OF

CHINESE GOODS,

Cormorant street, Victoria, V.I.

Branches....At FORT YALE, British Columbia
 LILLOOET " "
 MOUTH of QUESNELLE " "
 FORKS of QUESNELLE " "

San Francisco House...........Hop Kee & Co.
Also in China—Canton City.....Ye Tsan & Co.
Hong Kong...........Kwong Man Fung & Co.
 ap6 2m

Freighting to the Goldfields

DURING THE GOLD rush, freight was transported by methods from mules to oxen, sternwheel steamers to trundle-barrows, miners' backs, rafts, camels, or covered wagons. For many years, however, mules and ox-drawn freight wagons were the main means.

Oxen drivers were known as "bull punchers." One of the best was I.W. Strout, who once studied for the ministry but changed professions. Both he and his oxen were known throughout the Cariboo. On September 2, 1899, he closed an era when he left Ashcroft with twenty-four oxen and three wagons, the last freight trip made up the Cariboo Road by oxen.

Bill Bailey, who was a boy in Ashcroft when Strout was freighting, wrote the following account of a typical departure:

After loading, he would pull up and stop across the street from the Grand Central Hotel. At that point he would look over his outfit carefully and inspect everything from his wagons to the heavy wooden yokes on the necks of each span of oxen. When he was satisfied that all was in order the crucial moment for us kids would arrive. He would uncoil the long bull whip from around his neck and shouting out the names of several bulls, he would start them moving. Then the bull whip would be swung high above his head and lash out to its full length and a report like the blast of a cannon would ring through the air. Harry could lay that bull whip as close as he pleased to any of the bulls and never touch a hair. The bulls would strain forward, slowly placing one great hoof after another, as if there was all the time in the world and as if 200 miles didn't mean a thing.

The trundle-barrow was used by many trekking to Cariboo. It could carry about four hundred pounds and was far easier than backpacking. The man on the left demonstrating its use is Andrew Olsen, who in 1863 joined the rush northward but went ranching instead. He and three other miners staked land twenty-one miles south of Quesnel and started one of the Cariboo's first ranches. At front is John Yorston, a BX stagecoach driver who purchased the ranch about 1900. IMAGE A-00556 COURTESY OF ROYAL BC MUSEUM AND ARCHIVES

The most improbable method of freighting supplies to Cariboo were camels. It all started in 1862 when John C. Calbreath of Lillooet purchased twenty-three camels in San Francisco for three-hundred dollars each. Calbreath, however, was apparently only an agent for a syndicate that included Frank Laumeister, Adam Heffley, and Henry Ingram. In this he was fortunate.

In theory the project seemed sound. A camel could carry about eight hundred pounds compared to a mule's three hundred, could travel thirty to forty miles a day to a mule's fifteen, and could go for days without food and water, whereas a mule required both quite frequently. As a bonus, camels thrive in hot country and in summer, sections of the Cariboo are hot and dry.

In May 1862, the camels arrived at Port Douglas on a barge towed by the sternwheeler *Flying Dutchman*. Laumeister was apparently in charge since he was most frequently mentioned in the uproar that followed. The syndicate hoped to earn sixty thousand dollars the first season, but the camels soon proved the difference between hope and reality. They probably had good points, but these were effectively counterbalanced. One of their bad habits was attacking anything they didn't like—and they quickly showed their dislikes to be many.

As one beast came down the sternwheeler's gangway, it saw a prospector's mule and quickly bit and kicked it into oblivion. The camels, though, soon displayed a good point, possibly their only one. They were completely impartial, biting and kicking anything and everything from mules to oxen, from horses to men. Complementing their mean temperament was their odour—so potent that it alone caused pack animals to bolt. Even washing the camels in scented water didn't help. The "Dromedary Express," as it became known, soon was hated throughout the Cariboo.

Another shortcoming of the camels proved to be their hoofs. They were built for sand and were no match for the rocks and hardpan of the Fraser and Cariboo. Laumeister tried fitting them with shoes made of canvas and rawhide, but this was only part of his problems. The other packers now

above The last of the camels at Grande Prairie (now Westwold), with W.H. Smith holding the animal and A. MacPhail or Adam Heffley riding. The term "Dromedary Express" was wrong since the camels were not dromedaries, or Arabian camels, which have only one hump, but Bactrians from central Asia, which have two. IMAGE A-00347 COURTESY OF ROYAL BC MUSEUM AND ARCHIVES

left Frank Laumeister, one of those engaged in the ill-fated camel venture. IMAGE A-02269 COURTESY OF ROYAL BC MUSEUM AND ARCHIVES

unanimously disliked camels. Besides threatening to "sue for damages," they started a petition requesting that camels be banned.

In 1864, Laumeister disbanded his brigade, probably because the animal's hoofs couldn't stand the rocky terrain. The camels gradually vanished into history. According to historian Bruce Ramsey, some died in winter storms, others were shot for meat, and a few were kept as curiosity items. The last died near Grande Prairie (Westwold) in the north Okanagan in 1905.

While camels were an unexpected method of transportation to the goldfields, they were no more unusual than the fabled Red River carts of the long-grass prairie. These two-wheeled vehicles are as traditional to the prairies as the antelope, yet they also served in the Cariboo gold rush. They provided transportation for some two hundred gold seekers who trekked overland from Ontario and other eastern points.

There were several parties of Overlanders in 1862, numbering about 250 in all, but the main group, under the leadership of Thomas McMicking, consisted of about 150 who set out in the spring. From Ontario, they crossed the border for a journey by rail and steamboat across the American west and back into Canada at Fort Garry. From Fort Garry to Fort Edmonton, the route lay across nine hundred miles of prairie, and for this phase the Overlanders used Red River carts.

The Red River cart was an unusual vehicle in that it was built entirely of wood. It contained neither nails nor ironware; the entire cart was held together with wooden pegs and strips of buffalo hide called "shaganappi" that could be replaced when it wore out. The wooden wheels, revolving on wooden axles, creaked and groaned and could be heard for miles across the still prairie. At Fort Garry, the Overlanders paid $8 each for the carts, $40 a head for horses, $25 to $30 for oxen, and $4 a set for rawhide harnesses. For provisions, they bought flour at $3 for a hundred pounds, and pemmican, a mixture of dried buffalo meat and fat, at six cents a pound.

At first they looked at the pemmican with horror and as Thomas McMicking wrote, "Few of our party could eat it at first, its very appearance and the style in which it was put up being apt to prejudice one against it. But all by degrees cultivated a taste for it, so that before we reached the mountains it not only became palatable but was considered, by most of us, an absolute luxury."

Personal effects of many Overlanders were one good strong suit, from three to six changes of underwear, a pair of knee boots, and a pair of shoes, rubber coat, a pair of blankets, rifle or shotgun, revolver or bowie knife, soap and other toilet articles as fancy dictated, plus a few simple drugs and patent medicines.

The main party left Fort Garry on June 2, 1862. They travelled in 97 carts with 110 animals, most of them oxen, and the cavalcade stretched for half a mile over the plain. To keep order, leaders were elected and a schedule set. The camp was roused at 2:30 AM and moved off at 3:00 without breakfast. At 5:00 AM they halted for two hours, then travelled until 11:00, when another two-hour halt was called. They stopped for the night between 5:00 PM and 6:00 PM, depending on water supply. Their average speed was about two and a half miles an hour, and they travelled ten hours a day.

opposite A Métis family at their camp with a Red River Cart in Manitoba. LAC 3392788

above A man making a dugout canoe. This type of canoe, used by some of the Overlanders, was hand hewn from a single cottonwood tree. CITY OF VANCOUVER ARCHIVES. AM75-S1-: CVA 374-210

left Fort Edmonton as it looked to the Overlanders in 1862. LAC 3629668

They reached Fort Edmonton on July 21 and left on July 29, but since they were soon to enter the mountains, the supplies were now carried on the backs of 140 horses and oxen. Twenty-five of the party had remained at the Fort to mine on the North Saskatchewan River, and before long many others wished that they had also stayed behind.

When they reached the mountains, progress was cut to ten miles and even less a day, and their food gave out. They ate chipmunks, berries, squirrels, porcupines, and anything else they could find. For one Sunday dinner, Thomas McMicking wrote, "We dined on a dish so delicate and rare that it might have tempted the palate of Epicurus himself, so nice, indeed, was it that I have some little hesitation in naming it, lest we might be censured for living too luxuriously by the way." The dish that sounded so appetizing was roast skunk.

Fortunately, at a place called Tete Jaune Cache, they met some Indigenous people and were able to buy food that included dried skunk meat, salmon, berries, and mountain sheep. Here the group disbanded, some deciding to float down the Fraser River to Quesnel, others deciding to head southward to the Thompson River and Fort Kamloops. Included in the latter group were a woman, Catherine Schubert, and her three young children. Although several men

were drowned and the entire party suffered extreme hardship, she and her family reached Fort Kamloops safely. The next day, she gave birth to a daughter.

To those travelling the Fraser River to Quesnel, the most dangerous obstacle was the Grand Canyon. Here, the river is compressed to a fraction of its normal width with the water churning and boiling over a series of rocks and ledges. It finally writhes free from the rock enclosure, but a hundred yards downstream is compressed into a second canyon. At the end of this canyon, a foaming whirlpool extends some two hundred feet from shore to shore with a vortex six feet deep.

To challenge the river, some of the party built rafts about forty feet long by eighteen feet wide. These were loaded with oxen and supplies and were pushed into the current. They ran the canyon safely, but one raft was caught in the whirlpool and spun around and around, sinking lower and lower until those on shore could see only the horns of the oxen. Fortunately, the raft was too wide for the suction to pull it completely under and it emerged safely. Those on the following rafts also ran the rapids in safety, but others weren't so fortunate.

Some of the party decided that dugout canoes such as were used by Indigenous people were the safest method. It was a disastrous decision. One party of three made two dugout canoes and lashed them together, but they swamped. One man was a strong swimmer and struck for shore to bring aid. He was never seen again. His companions, who clung to the canoe, were washed ashore and survived. Three others made one big canoe, but it also swamped. Soaking wet, without food or fire, they were marooned for two days on an island. They were finally rescued but one, Eustace Pattison, was so weakened that he later died.

Another man who drowned running the canyon in two canoes lashed together was W. Carpenter. Before this party launched their canoe, they first explored the canyon on foot. During this time, Carpenter wrote something in a notebook, then left his coat and notebook on the riverbank. After he drowned, his sorrowing companions opened the

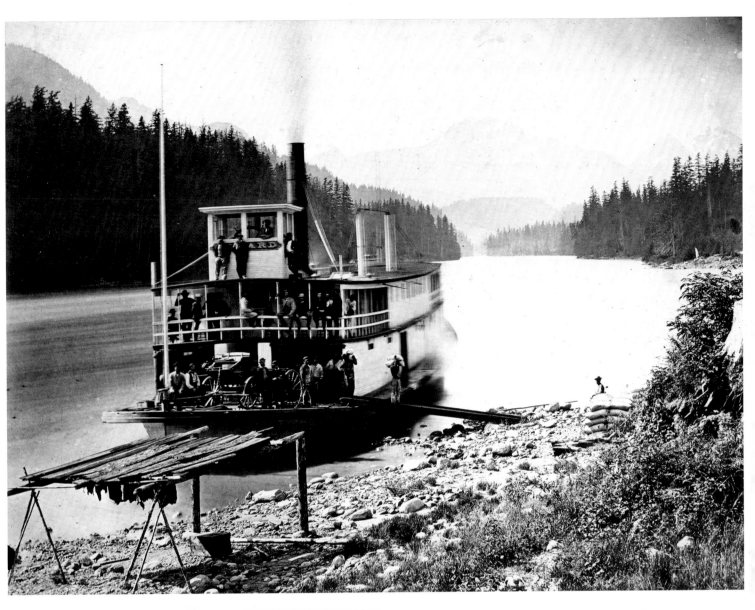

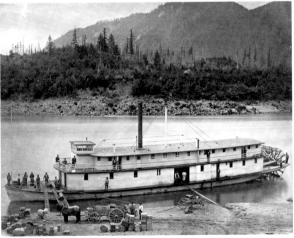

opposite Dugout canoes of the type used by some of the Overlanders. HERITAGE HOUSE ARCHIVES

above Typical of the sternwheelers on the Lower Fraser River during the early part of the gold rush was the *Onward*, shown above in 1868. Light, she could sail in thirteen inches of water. HERITAGE HOUSE ARCHIVES

left The *Reliance*, below at Yale about 1877, was well known to those travelling to Cariboo. HERITAGE HOUSE ARCHIVES

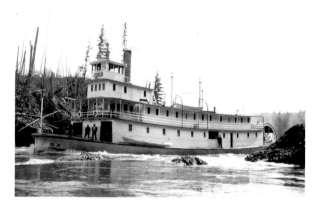

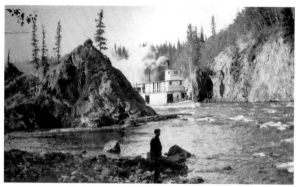

top The *B.X.* at Fort George Landing in 1910. PUBLIC DOMAIN

bottom The *Nechacco* (bottom) in rapids typical of those regularly challenged by the sternwheelers. The sternwheelers have long passed into history, remembered today only by the "Stop of Interest" plaque on the Cariboo Highway overlooking the Fraser River, just north of Soda Creek. HERITAGE HOUSE ARCHIVES

opposite One other, different method of transportation was the Cariboo gold escort. Formed in 1861 to ensure safety of gold shipments from the creeks to Victoria, it consisted of about a dozen men, smartly uniformed, heavily armed, and well mounted. The government, however, refused to guarantee safe delivery and miners were reluctant to use the service. After two trips, it was disbanded. In 1863, it was revived but again proved unsuccessful, and after three trips was disbanded permanently. This photo shows the escort at Barkerville in 1863.
HERITAGE HOUSE ARCHIVES

notebook and found this entry: "Arrived this day at the Canyon at 10 a.m. and drowned running the canoe down. God keep my poor wife."

The first of the Overlanders arrived at Quesnel on September 11, 1862. The distance they travelled in five months was some 3,500 miles, but others put the figure higher. When the Overlanders reached Quesnel, only a few continued on to the goldfields. The majority, although only sixty miles from Williams Creek, headed for Victoria, too exhausted and too discouraged to care about gold.

One of them summed up the trip with the words, "Our mining tools were the only articles that we found to be unnecessary."

Along with the Red River carts of the Overlanders and the camel caravans, another colorful transportation link to the goldfields was the sternwheel steamer. From the first discovery of gold on the Fraser River in 1858 and some sixty years thereafter, sternwheelers were familiar to travellers bound for the Cariboo. On the Lower Fraser River, they were for decades the only connection on the 185-mile section of water between Victoria and Yale. On the Upper Fraser, they plied between Soda Creek and Quesnel, then in later years provided a service over four hundred miles upstream to within sight of Mt. Robson in the Rockies.

The sternwheelers were ideal frontier craft. They could absorb fearful beatings from storms, rocks, ice, snags, gravel bars, and similar hazards of river and ocean travel. They could carry one hundred or more tons of freight in water little deeper than needed by a canoe, yet they regularly challenged canyons and rapids that swamped even the best of canoes and canoers.

The following background information on them is in the book *Paddlewheels on the Frontier—the Story of B.C. Sternwheel Steamers*:

Their success was due to a combination of factors, one of which was a flat bottom which enabled them to bob on the water like a duck. Another was that their wooden construction made them remarkably buoyant and fairly easy to

repair. On Upper Fraser River the BX once gouged a hole in her keel sixty feet long by three feet wide. She reached shore before sinking and a few weeks later was back in service.

Another asset was that their paddlewheel needed water only inches deep to supply its powerful thrust. On Thompson River the Kamloops worked in eight inches, the Spallumcheen could get by in six, while on Columbia River the Duchess sailed so close to the bottom that gravel ridged by spawning salmon was an obstacle. Because of this shallow draft, there is a story that one passenger who fell overboard raised a cloud of dust. Actually, the tale could be true. With a block and tackle device called a "grasshopper" rigged on the bow, vessels could hoist themselves over bars and shoals, and anyone then falling overboard would land with a thud rather than a splash.

Another story involves the captain of a sternwheeler stranded at the upper reaches of the Fraser by low water. As usually happens in Interior B.C., autumn rains caused the river to rise but not enough to cover the bar causing the trouble. The skipper curbed his impatience for a couple of days then could wait no longer. "Okay, boys, let's hit it. The sand's wet. She'll go over!"

During gold-rush days, passage on a sternwheeler was seldom dull. Even after paying his fare, a passenger could be called upon to cut firewood for the boiler and even help load it. He might suddenly have to fight a fire on board or surrender his blankets to plug a hole in the hull. During the Cariboo gold rush, a miner who boarded a sternwheeler at New Westminster for Yale recorded that one passenger had a "bell thrust into his hand, and he was instructed to ring the bell and bawl at the top of his voice the departure of the boat; this he did to perfection, being a powerful man with strong lungs. The work lasted half an hour and he was given $2.50 for his pains.

On his trip to the Cariboo in 1863, Dr. Cheadle met an engineer who related a trick that he and the captain used on passengers. The earliest vessels were underpowered and invariably overloaded, and frequently grounded on sand and gravel bars. If all regular means of freeing them failed, passengers and crew had to jump into the river and grab a tow line. Passengers would be somewhat reluctant, so to

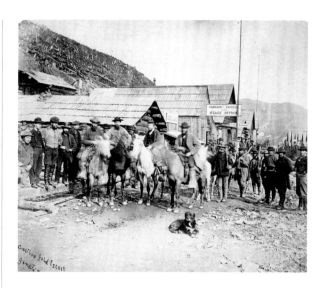

encourage them, the conversation between captain and engineer went as follows:

"All passengers overboard to haul at the tow line," the Captain shouted. Not a person stirred. "How much steam on, engineer?" he then asked.

"175 pounds, sir. Almost ready to explode," replied the engineer, in a serious tone.

"Then put on 25 more pounds and blow her to Hades," cried the Captain.

"Aye, aye, sir," responded the engineer. By then, however, passengers were invariably over the side sloshing toward the tow line.

In later years, however, travel by sternwheeler became not an ordeal but a pleasure. Tough laws were passed to prevent the boiler explosions that commonly occurred during the early gold-rush days, with heavy loss of life. Accommodation was improved and the vessels offered excellent passenger facilities. On the Upper Fraser River, the BX, for instance, was among the finest sternwheelers to sail inland waters. Her dining room could seat fifty and her staterooms had steam heat, reading lights, washstand, fan, and were finished with red velvet carpeting and green curtains. Fully laden with passengers and a hundred tons of freight, the vessel could work in water shallow enough for a man to wade.

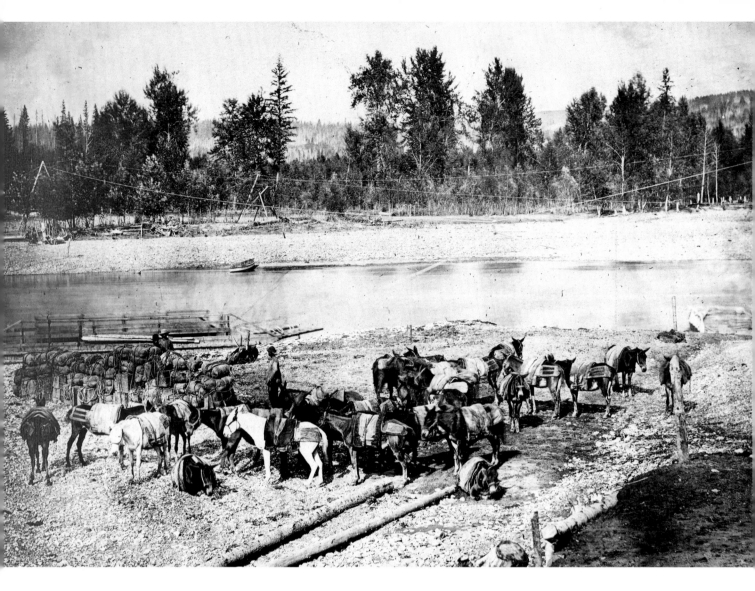

Other methods used for freighting to the gold-fields included horse-drawn outfits of three wagons coupled together, mule pack trains, and even road steamers. The horse-drawn outfits and mule pack trains served until the coming of the railway and trucks.

The following pages contain more information on freighting to Cariboo.

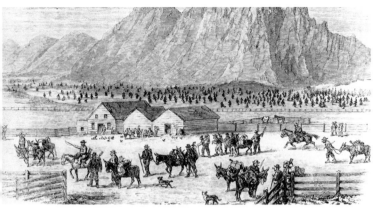

opposite Red-Headed Davis's mule pack train waits to cross the Quesnel River at Quesnel in 1868. A mule train consisted of from sixteen to forty-eight animals, with the average load per mule from 250 to 400 pounds. No packsaddles were used, instead a sort of leather sack, called an "aparejo" and filled with straw, was tied to the mule's back and freight lashed to it with the diamond hitch. A white mare usually led the train, but the mules weren't tied together in any way: each knew its place and kept it throughout the trip.

The crew usually consisted of a cook and a "cargodore," who had overall command, plus one man for every eight to ten animals. The train travelled about fifteen miles a day, but since they had to camp where there was feed and water, some days they would travel more than others.

A return trip from Yale to the goldfields took about two months with three trips usually made per season.

At the beginning, packing was very profitable. In early 1861, the rate from Yale to Quesnelle Forks was one dollar a pound, but as more packers entered the trade, prices soon dropped to forty cents a pound. The mule trains largely passed away with the completion of the Wagon Road, but individual outfits survived for many years. HERITAGE HOUSE ARCHIVES

top This sketch from the *London Illustrated News* of December 17, 1868, shows miners with their pack mules ready to leave for the Cariboo from a roadhouse near Fountain, a few miles from Lillooet. A correspondent wrote, "Although the soil here is light and sandy, the owner of the roadside inn manages to grow good crops of grain, vegetables and—what is more extraordinary in those high altitudes— water melons, a great boon to the traveller." HERITAGE HOUSE ARCHIVES

bottom The first attempt to haul freight to Cariboo by mechanical means was made by F.J. Barnard and Josiah Crosby Beedy. They brought in six of R.W. Thomson's patent India-rubber-tired "road steamers" from Scotland, (Thomson was the inventor of the pneumatic tire.) In spring 1871, the first of the vehicles left Yale. Pulling nine tons of freight, it reached Spuzzum the first day, Boston Bar the second, and Jackass Mountain the third. Here the journey to the Cariboo ended, as the links that held the rubber tires kept breaking. Horse-drawn freight wagons were just as fast and far less trouble and expense. This advertisement appeared in a Victoria newspaper on March 23, 1871. PUBLIC DOMAIN

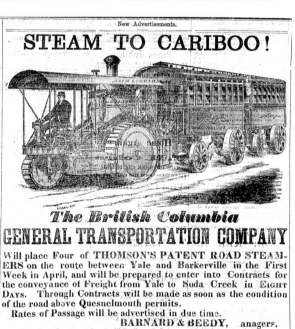

New Advertisements.

STEAM TO CARIBOO!

The British Columbia
GENERAL TRANSPORTATION COMPANY

Will place Four of THOMSON'S PATENT ROAD STEAMERS on the route between Yale and Barkerville in the First Week in April, and will be prepared to enter into Contracts for the conveyance of Freight from Yale to Soda Creek in EIGHT DAYS. Through Contracts will be made as soon as the condition of the road above Quesnelmouth permits.

Rates of Passage will be advertised in due time.

BARNARD & BEEDY, anagers.

OFFICE—Yates Street, next door to Wells, Fargo & Co.'s

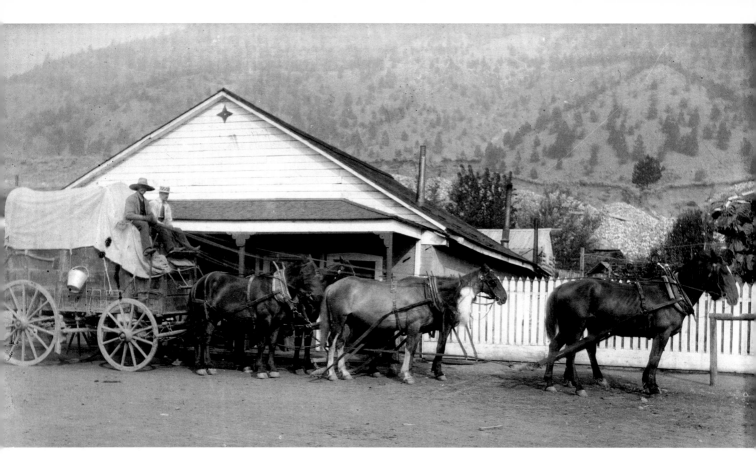

above Another freight wagon leaving Lillooet on the long haul up the Cariboo Road. CITY OF VANCOUVER ARCHIVES. AM1630-: CVA 10-08

right, top Freight wagons at Ashcroft outside the store and warehouse of F.W. Foster, a pioneer businessman who started in Clinton in 1864 and expanded to become one of the southern Cariboo's leading merchants. CITY OF VANCOUVER ARCHIVES. AM54-S4-: OUT P47

right, bottom Freight wagons transporting supplies from Clinton to Barkerville.

Wagons with seats were a later development. In the early days the teamsters either rode one of the horses or walked along beside the outfit.

Sometimes there were so many horses or mules hitched to a freight wagon that the use of reins was impracticable. Under these circumstances, a "jerk-line" was used. This was a single line connected to the bridles of the lead horses. The teamsters then "telegraphed" directions to the trained leaders, who would turn left or right according to the number of jerks on the line. HERITAGE HOUSE ARCHIVES

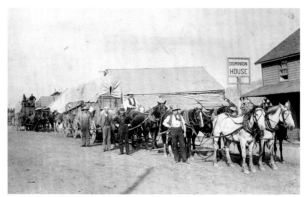

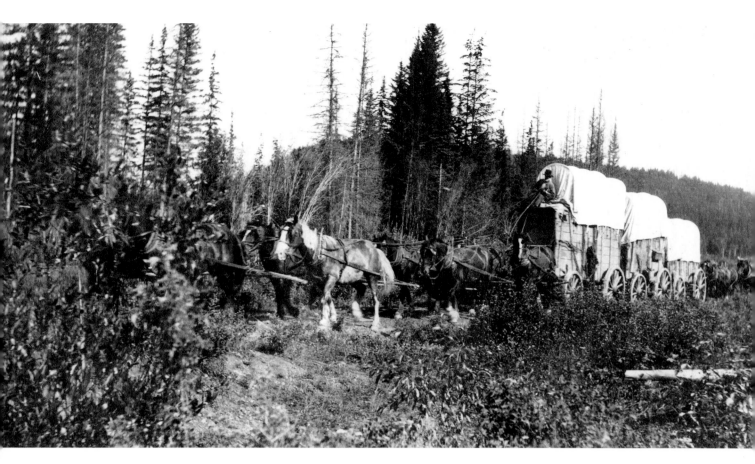

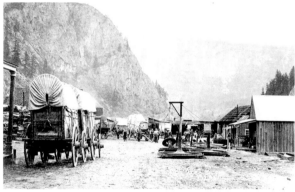

above Freight wagons on the Cariboo Raod. Many drivers were accompanied by a swamper," usually someone apprenticed to the teaming business. The swamper looked after the horses, rounded them up in the morning about four o'clock, and in general assisted the teamster with the overall duties of freighting. CITY OF VANCOUVER ARCHIVES. AM54-S4-: OUT P895

left Freight wagons and tire shrinkers at Yale in the early 1880s when the community was the supply point for the Cariboo. The tire shrinkers were necessary because the constant pounding over rocky roads caused the rims on the wheels to expand and fall off. IMAGE A-03616 COURTESY OF ROYAL BC MUSEUM AND ARCHIVES

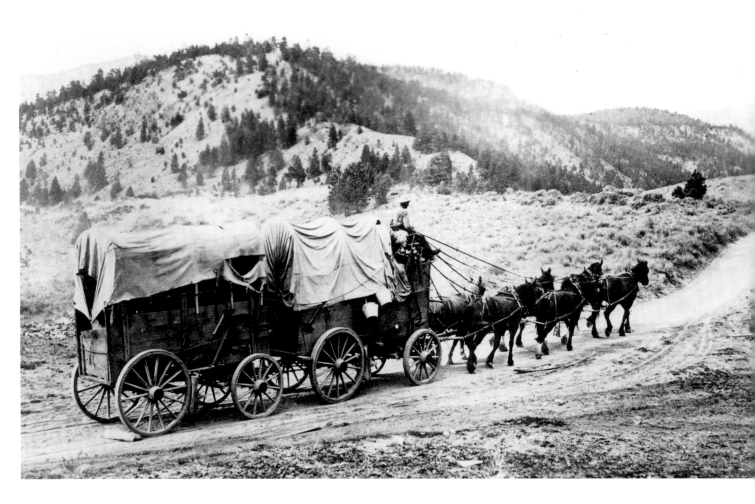

above Freight wagons on the Cariboo Road in the Ashcroft-Cache Creek area about 130 years ago.

Sam Kirkpatrick, a Cariboo old-timer, left the following description of the clothing worn by drivers:

The standard in head gear for the "skinners" was a stiff-brimmed hat, similar to the big stiff cowboy hats of today, with a narrower brim and a little darker.

The footwear used by all teamsters was a high-topped calfskin boot patterned after the cowboy riding boot, but made with a low flat heel. The boot top was worn under the pants. If you drove two horses, you turned the bottoms of your pants up one roll; if you drove four horses you were entitled to two rolls, and so on. The elevation of your pant-bottoms was an indication of your ability as a skinner.

opposite, top Oxen and freight wagons at Boston Bar in the Fraser Canyon in 1882. The average ox team consisted of a ten-yoke span with up to a ton of freight per animal. While oxen could easily outpull horses, they were very slow, averaging from six to twelve miles a day and making only two or three trips from Yale to the goldfields a season. To protect their hoofs the oxen wore a specially made steel shoe which, unlike a horseshoe, was in two pieces. Although bull teams were much slower than horse teams, they were common on the Cariboo Road from 1863 to 1899.

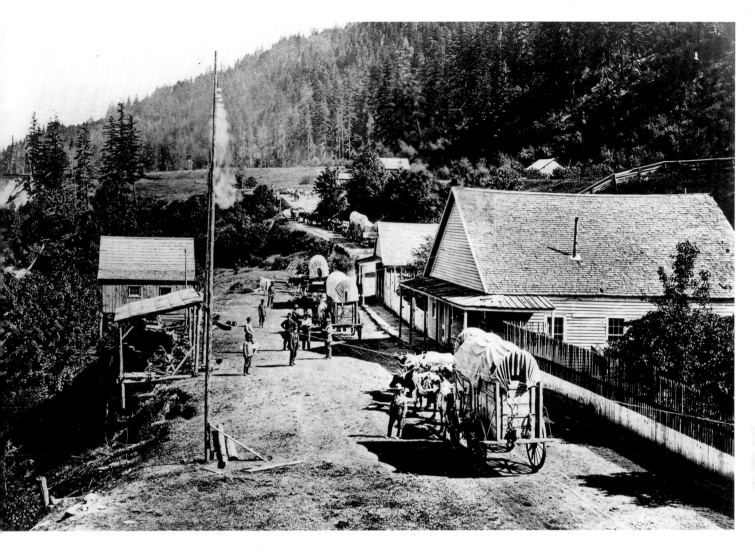

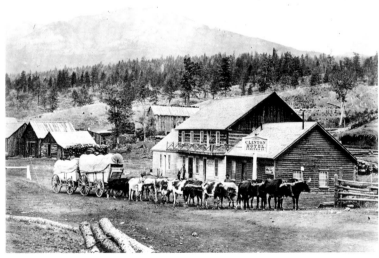

left Ox teams at Clinton, nearly 175 miles from Yale. The "bull-puncher," as the driver was called, walked all day beside his team. Instead of reins or a similar method of control, he used a "goad stick" or a blacksnake whip. During the early years of the gold rush, freight wagons were imported from California, but freighting soon became an industry large enough to support a wagon-building plant at Yale. CITY OF VANCOUVER ARCHIVES. AM54-S4-: OUT P164.2

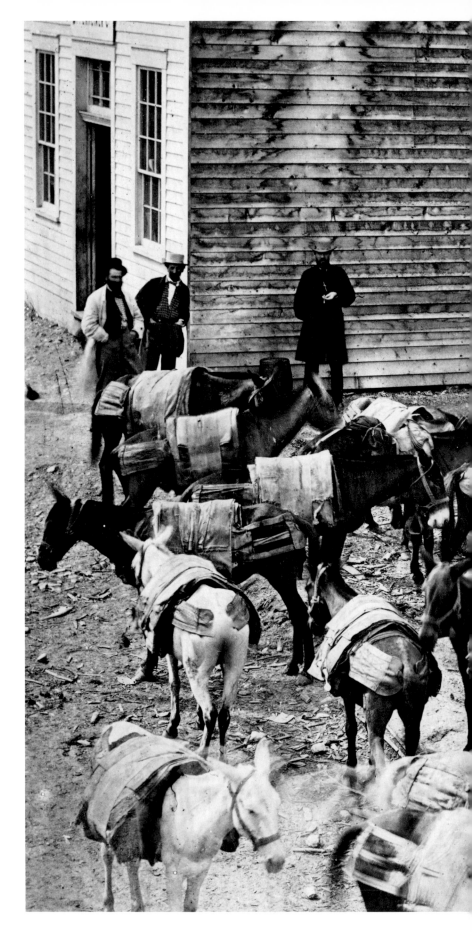

A mule pack train at Barkerville in 1868. While packing to the mines was profitable in the early days of the rush, it was also hazardous. In 1861, one miner wrote, "At Quesnelle Forks we saw two packers return from the mines. One of them carried a bell, such as is fastened to the foremost mule of a pack. They told us that they had started from here to Antler Creek with a train of thirty animals but every one en-route had fallen in the precipitous ravines..."

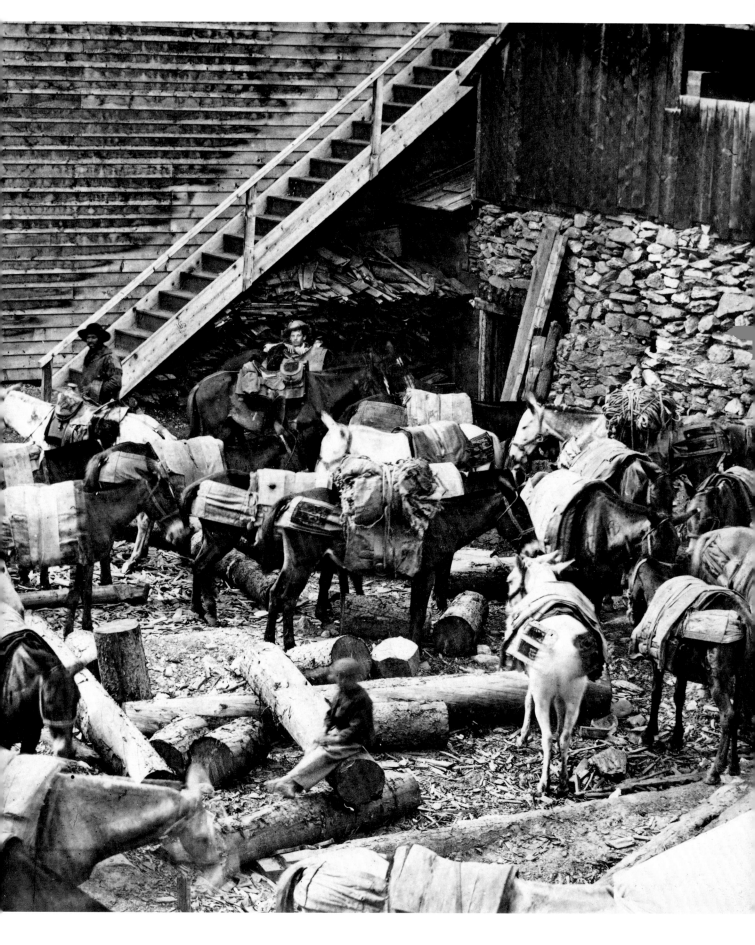

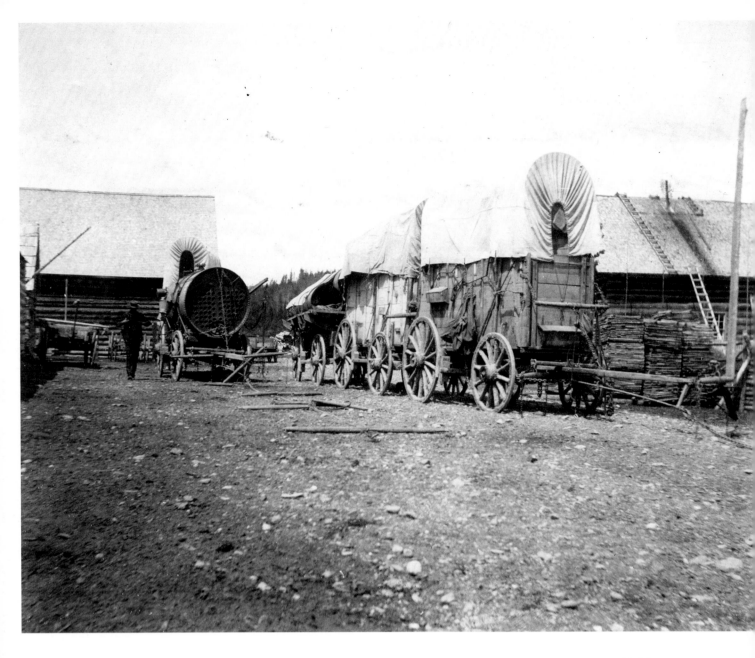

These wagons at Cottonwood indicate the variety of freight that was carried. The drivers boasted that they could haul anything from mining machinery weighing tons to a dozen eggs, from champagne to panes of glass, without damage to anything—and all in the same wagon. Among the heaviest pieces of freight to come over the Wagon Road was a 40,000-pound boiler brought in by Al Foucault with a sixteen-horse outfit. CITY OF VANCOUVER ARCHIVES. AM54-S4-: OUT P435

Stagecoaches on the Cariboo Road

THE STORY OF stagecoaches on the Cariboo Wagon Road is the story of Francis Jones Barnard, a native of Quebec who founded the service by carrying letters on foot to the goldfields. From this beginning, he built a company famous for reliability and proud of the fact that, after railways had replaced the stagecoach in the US, it claimed the distinction of being the longest stagecoach run in North America. For over half a century, it served a frontier region and became known far and wide as simply the "BX"

The stage service began in 1863, when Barnard put two-horse wagons on the route from Lillooet to Soda Creek, at that time the terminus of the Wagon Road. These wagons carried three passengers and freight and made the trip every ten days. But as the Wagon Road was extended, Barnard increased his service, and by 1865, stages operated from Yale in the lower Fraser Canyon to Richfield and Barkerville.

The first four-horse stage from Yale to Soda Creek was run in the spring of 1864, driven by Charles G. Major. Among the nine passengers were James Orr, Florence Wilson, Robert Stevenson, and H.M. Steele. The latter were two of the most successful miners of the gold rush. On the return trip, Stephen Tingley was the driver. He continued driving for over thirty years, eventually buying the firm.

Although the stagecoaches carried great quantities of gold, there were only a few cases of holdups, and from the beginning, the miners had complete faith in the company. One stage brought $600,000 in gold on a single trip; another brought out a gold ingot that had been cast in the form of an artillery shell. It weighed 650 pounds and was worth $178,000. At the end of the first year of operation in 1865, the stages had carried $4.6 million

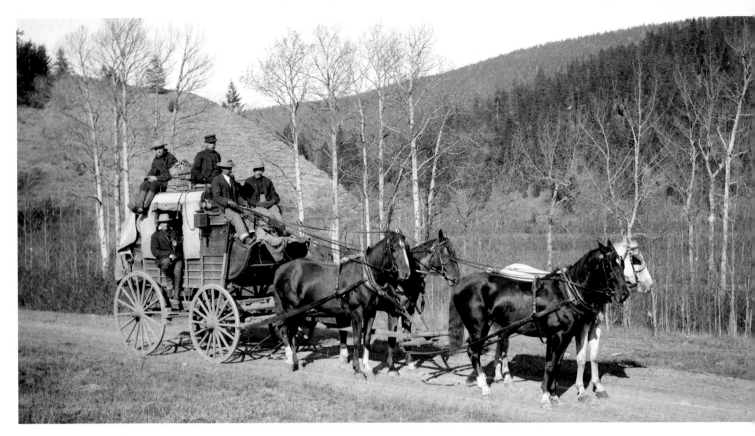

above A BX stage near Clinton on the Cariboo Road. The glossy coats and combed tails of the horses reflect the care and attention they were given. The horses were the finest that could be obtained and were a source of pride to the drivers and handlers. During the 1860s, the animals were obtained from Oregon, but in 1868 the BX Company bought three hundred head of breeding stock in Southern California, and "crack whip" Steve Tingley drove them all the way to the Nicola Valley in BC. A few years later, they established the famous BX horse ranch, which for many years provided the company with a large part of their requirements. They also bought animals from horse ranches in the Nicola and Kamloops regions of BC. CITY OF VANCOUVER ARCHIVES. AM54-S4-: SGN 433

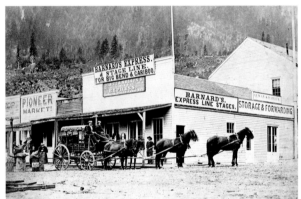

right A six-horse stage ready to leave for Cariboo from Barnard's Express Office at Yale in 1868. Horses were changed on an average of every eighteen miles, and passengers stopped for meals about every thirty-five. On level stretches, horses maintained a brisk trot with an average speed of about six miles an hour. This early coach had a canvas top, but later ones had solid roofs that would hold extra passengers and luggage.

On the following pages are additional photos of a colorful era in the history of the Cariboo Wagon Road. HERITAGE HOUSE ARCHIVES

worth of gold, 1,500 passengers, and travelled over 110,600 miles.

Although each driver carried a whip with which he could touch any horse of a six-horse outfit without the other horses being aware of it, the whip was used only in an emergency. The horses themselves soon acquired a pride in their job and seemed to know when to hold back on a hill, or to slow down on a dangerous curve, or when an extra burst of speed was required.

The following account of the horses was written by the late Willis J. West, for many years associated with the BX Company, and appeared originally in the *B.C. Historical Quarterly:*

These stage-horses were never really broken. They were trained for staging alone and had to be handled in a way they would understand. To illustrate this the custom observed in preparing a stage and its horses for leaving a station had to be carefully and expertly carried out to ensure a safe departure. When the mail, express matter, and baggage had been loaded and securely lashed onto the stage, the passengers were requested to take their places. Then the driver with his treasure-bag took his seat and all was in readiness for the horses to be brought from their stable. First the wheel team was led out by the hostler who backed it into position on either side of the stage-pole and passed the lines to the driver. After this team was ready with harness and rigging adjusted to the satisfaction of the driver, the swing team appeared and the same procedure was followed. Finally the two leaders, the freest and most spirited horses in the six-horse team, were brought out and after the horses had indulged in much restless prancing, the hostler would eventually succeed in completing the "hooking-up" of the team and would then quickly back out of the way. At this moment the driver released the brakes and the horses lunged forward, starting the stage on its way to the next station. Some teams when leaving a station at the beginning of their drive would behave in a most alarming manner and fill timid passengers with fear. The horses would stand on their hind legs and would seem to be so wildly entangled that a serious accident appeared inevitable. They would continue these antics until they had traveled 100 yards and then they would settle down to a brisk trot. In their natural health and vigour they could not refrain from these exuberant demonstrations."

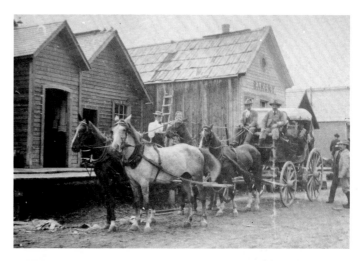

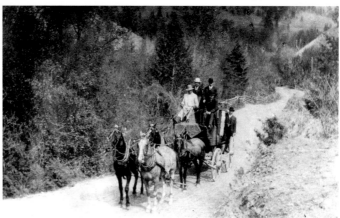

top For its many services, the BX used vehicles ranging from a two-horse thorobrace to six-horse mail coaches. There were also four-horse covered and open thorobrace stages, and for winter travel, sleighs of all sizes, including those that carried fifteen passengers. This is a coach known as the Dufferin, at Barkerville in 1877. It was specially built in 1876 for the visit of the Governor General, Lord Dufferin. Afterward, it was in use some fifty years and is today on display at Irving House Museum in New Westminster. BARKERVILLE MUSEUM P2790

bottom A regular Concord stagecoach, which was built with thorobraces, or what may best be called "leather springs." These springs were built of layers of leather and extended the length of the stage, the number of layers depending on the purpose of the stage. The body of the stage had rockers on each side that fitted on the springs and gave the stage a rocking and swaying motion that, while comfortable enough, had the same effect on many passengers as a boat ride. CITY OF VANCOUVER ARCHIVES. AM54-S4-: TRANS P128

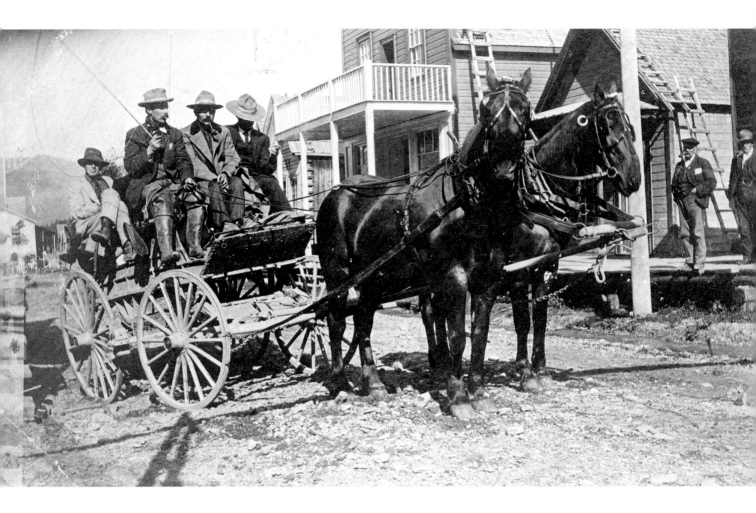

This photo is of a two-horse "jerky coach" at Barkerville. These were used for branch lines and when loads and passengers were light.

Women who travelled on the stages were given priority. This code was rigidly upheld whether the woman was rich or poor, a pillar of society, or an outcast of the creeks. Female passengers were always offered the choice seat on the stage, the most comfortable room at a stopping place, and during meals sat on the driver's right.

Originally, stagecoaches were purchased from carriage makers in Victoria, but later the BX built its own shops and made its own equipment. It also strengthened the Concord stages so that they would stand up to the rough road conditions and heavy loads characteristic of a region where they provided the main means of speedy, effective travel.

When the service started in 1864, the fare from Yale to Soda Creek was $130 and the journey took fifty-two hours. In 1872, the fare was reduced to $65. When headquarters for the Cariboo was changed from Yale to Ashcroft in 1886, the stage left at 4:00 AM and, under favorable conditions, arrived at the overnight stopping place at 84 Mile at 6:00 PM. It left at 4:00 AM the next morning and repeated the sequence. However, during periods of wet weather, when stages ran late, passengers usually got little sleep. Under the terms of the BX's mail contract, stages had to maintain a set schedule. If the stage arrived five hours late, it left almost immediately and passengers had to sleep as best they could in the swaying coach.

CITY OF VANCOUVER ARCHIVES. AM54-S4-: OUT N561

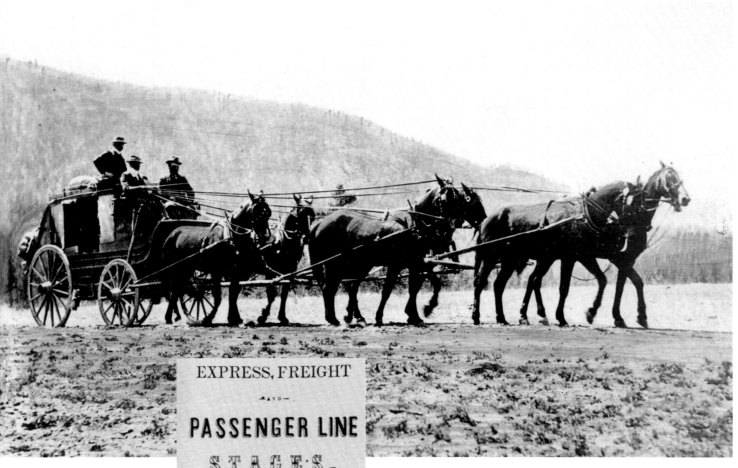

above A Barnard's Express stagecoach carrying the mail to Barkerville, circa 1865. CITY OF VANCOUVER ARCHIVES. AM54-S4-: TRANS P170

left The advertisement below from the *British Columbian* newspaper, May 4, 1864, announced the opening of the stagecoach era. HERITAGE HOUSE ARCHIVES

top A stagecoach arriving at Quesnel. Stagecoaches were the aristocrats of the road. All traffic yielded to them, and drivers entered and left all establishments in a galloping flourish.

In an era when a driver was judged by his ability to drive two-, four-, and six-horse outfits, the stage drivers were unexcelled. They were trusted with a stagecoach only after extensive training and after proving themselves outstanding horsemen. Driving was an arduous job, with long hours and exposure to all weather extremes. In summer, these extremes ranged from alkali dust to drenching storms, and in winter, from snow twenty feet deep to temperatures forty degrees below and lower for weeks at a time.

The driver was responsible not only for the stage and mail, but also for his passengers. At stopping places, for instance, he always sat at the head of the table to ensure that passengers were properly cared for. Drivers were not the hard-drinking, hard-driving men of legend, but temperate men who thought of passengers and horses before themselves. CITY OF VANCOUVER ARCHIVES. AM54-54 SGN 434

middle In winter, sleighs replaced the stagecoaches. In this photo, a BC Express sleigh navigates huge snow drifts on the way to Barkerville. LEONARD FRANK PHOTOGRAPH, VANCOUVER PUBLIC LIBRARY 9348

bottom Passengers prepare for the 55-mile journey from Quesnel to Barkerville. Winter service was maintained on the Cariboo Road even when temperatures dropped to fifty degrees below zero or lower. Passengers wrapped themselves in robes, fur coats, and thick, woollen garments, and heated thirty- to forty-pound stones helped to keep their feet warm. They arrived at stopping places with the stars shining at night and left with them still shining in the morning.

All BX equipment was painted a standard color, the body of the stage red and the running gear yellow. Harnesses were handmade from the finest leather, and it was a standing rule that it had to be cleaned every time it was removed from a horse.

From its origin as Barnard's Express, the BC Express Company served the Cariboo for fifty years. In 1913, the company lost the mail contract, but by then, stagecoach days were ending. Completion of the Pacific Great Eastern Railway and improvements in motor transportation opened a new era. In 1915, the stagecoach service ceased. IMAGE D-00746 COURTESY OF ROYAL BC MUSEUM AND ARCHIVES

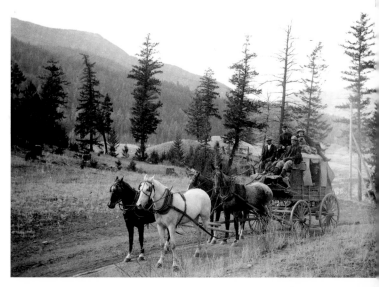

NINE

Women of the Cariboo

IN MID-1859, it was estimated that of the more than five thousand inhabitants in the booming mining town of Yale, no more than twenty were women. Some miners who flocked to the Lower Fraser did bring wives with them. An August 1858 report in the *Daily Alta* in California mentioned a man named Newton: "His wife rocks the cradle and cooks, while he picks and shovels and does the hard work." Nonetheless, this was an exception. The farther one went up the Fraser River into the region soon to be known as the Cariboo, the fewer women there were among the miners. In the winter of 1862–63, after Billy Barker's famous strike, there remained ninety people in Barkerville, seven of whom were women.

Two important facts must be noted in these estimates. First, neither Indigenous nor Chinese people were counted in the figures, betraying a distinct prejudice toward these two groups. There is no question that, among the Chinese, the ratios of men to women were even less balanced, but among the Indigenous people, women were equally numbered with the men. Not surprisingly, many miners took Indigenous wives. but this was not always appreciated by the Indigenous men.

Second, the disparity in numbers between men and women in the Cariboo does not account for the distinct lack of information on women in historical accounts. This tendency to make history the account of what white men were doing has finally changed in recent years, and the stories of the Indigenous people, the Chinese people, and above all, of women, are now being told. Even though there were few women in the Cariboo, their impact was significant beyond their numbers.

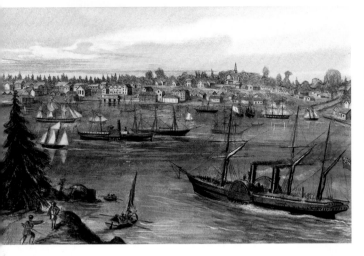

The colonial governments of British Columbia and Vancouver Island were well aware of this gender disparity and before long, a Female Immigration Board was set up in Britain. An appeal was made to the "deserving poor"—those women who worked hard, worshipped regularly, and knew their place in society—who would be given one-way passage to Vancouver Island. The Anglican Church in Britain set up the Columbia Mission Society to interview and screen prospective women.

The first two "bride ships," as they came to be called, were a distinct failure. The first was the *Marcella*, which took 192 days to sail around Cape Horn in September 1862, with twenty women on board who had been convicted of various offences, mostly prostitution. Unfortunately, when the ship docked in San Francisco for supplies, the unescorted women jumped ship and were never heard of again.

Yet a third attempt was made to bring prospective brides to the colony. The *Tynemouth*, a three-masted barque equipped with a steam engine, left England on June 9, 1862. Despite three crew mutinies, fierce storms in the Atlantic, a tropical hurricane, and the usual privations of scurvy, lack of water, and smallpox, the ship arrived in Victoria with three hundred passengers, sixty of whom were "marriageable lasses" from the London area. About six hundred men greeted the ship, and the women were escorted to marine barracks behind the legislative buildings. Within a few days, they were all taken on as domestic servants or brides.

The *British Colonist* later reported on one of the women, Sophia. As the women were leaving the ship, a Cariboo miner named Poineer, who had made a fortune in the diggings, offered her a staggering two thousand dollars in cash on the spot. After some hesitation, she smiled and tucked the money into her apron as the crowd roared in approval. A lavish wedding was held, and the couple disappeared from history.

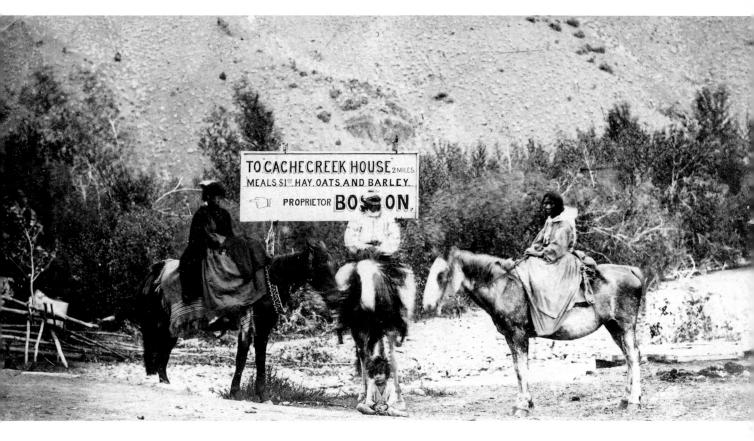

To Cache Creek House 2 Miles. Meals $1.⁰⁰ Hay. Oats and Barley. Proprietor Boston.

opposite, top Victoria Harbour in 1862 at the time of the arrival of the bride ship *Tynemouth*. COURTESY OF TORONTO PUBLIC LIBRARY

opposite, middle Tsang Quon family ca. 1912. Left to right: Ho Shee, Foo Ying (Florence), Pat Low, and Tsang How Quon.

Tsang Quon was manager and bookkeeper for the Kwong Lee Wing Kee Company. He was one of the Chinese men in British Columbia who was able to bring his wife to join him. In 1901, he brought his wife, Ho Shee, and daughter, Foo Ying, to Barkerville from China. Foo Ling was six years old. Her brother, Pat Low, was born in Barkerville in 1902. Florence told her son, Dick Mah that one of her winter chores as a child was to chop the ice away from the frozen drain of the kitchen sink. BARKERVILLE MUSEUM P6376

opposite, bottom Mary Louise Pringle, the granddaughter of a Scottish Highland chief, married the Reverend Alexander St. Davis Francis Pringle, who had arrived in Fort Hope in late fall of 1859 to establish an Anglican church. Mary Louise joined him in the fall of 1860 with their two children and wrote to her father-in-law that "I feel convinced that it is His will that I should go there." The couple stayed in Fort Hope for the next four years and Mary Louise, in addition to bearing and raising two sons, taught Sunday school, kept a large garden, and looked after a milk cow and chickens. She also helped raise money for the construction of Christ Church, which was consecrated by Bishop George Hills in November 8, 1861. The church is still holding services and is the oldest church in the Lower Mainland of British Columbia. IMAGE A-02417 COURTESY OF ROYAL BC MUSEUM AND ARCHIVES

above Indigenous women on horseback. Indigenous women played a major role in the Cariboo gold rush. During the winter of 1860–61, they were hired to carry heavy loads on their backs over the Snowshoe Plateau to Antler Creek, the first of the famous Cariboo creeks. That winter, "Red-Headed Davis" and his Indigenous wife operated a roadhouse, store, and saloon on Keithley Creek.

Two men who were present at that time were Peter Dunlevy and James Sellars, who also married Indigenous women. Dunlevy, Sellars, and, their wives owned and operated the Mud (later McLeese) Lake ranch and stopping house. Dunlevy ended up also part owner of the Exchange Hotel at Soda Creek. He and his Indigenous wife had several children but, as is the case of so many of the early miners who married Indigenous women, he parted with his wife in 1873, and married a white woman, Jennie Huston of Victoria. Sadly, this abandonment of Indigenous wives was very common in early British Columbia. UBC LIBRARY. RBSC. UNO LANGMANN FAMILY COLLECTION OF BC PHOTOGRAPHS. UL_1001_0047

top Denis Murphy came with his brother Michael from County Cork in Ireland and, along with three partners, pre-empted land at the 141 Mile post on the Cariboo Road. Denis, who had no desire to be a miner, decided to settle down and run the stopping house with a woman he had met while mining in California. He married Ellen White, a farm girl from New York State and by 1865, the couple had two sons. When he had first arrived in British Columbia, he had shared a mining claim with Frank Barnard, who later established Barnard's Express Company. When he started his stagecoach line in 1864, Barnard reconnected with his old friend and made the 141 Mile House a regular stop for the stage line. The 141 Mile, under the Murphys' guiding hands, advertised in 1865 "good food and good beds" for all guests. By 1870 the log building that had served as the stopping house was replaced by a large two-storey log building that had fourteen rooms. While Ellen had not had the opportunity for advanced schooling, she insisted that her five children have the best education available. To help this along, the Murphys, both devout Catholics, helped the Oblate priests establish the St. Joseph's Mission school at Williams Lake. One of their sons, Denis, became a Justice in the BC Supreme Court. IMAGE G-02443 COURTESY OF ROYAL BC MUSEUM AND ARCHIVES

bottom Adelaide Victoria (née Ogden) Manson was the mixed-blood granddaughter of fur trader Peter Skene Ogden. She was born at the fur trade post Fort Fraser in 1848 and married Hudson's Bay Company clerk William Manson on May 29, 1861. Manson was chief clerk at Fort Alexandria on the Fraser from 1863 to 1856, in the height of the Cariboo gold rush. When the conflict between the Tsilhqot'in (Chilcotin) people and the colonial government took place in 1864, the Mansons accommodated sixty miners and guides hired by gold commissioner William George Cox to deal with the uprising. That August, the new governor of British Columbia, Frederick Seymour, arrived on his way to visit Quesnelle Mouth and Williams Creek. After the trial of the Tsilhqot'in men for the uprising, Judge Begbie asked the Mansons to look after the two Tsilhqot'in women who had testified in the case, Nancie and Il-se-dart-nell. The couple had a number of children including Lizzie, William, Martha, Peter, Sarah, and Margaret. After retiring as an HBC officer, William moved the family to his ranch at 111 Mile House, where he lived until the death of Adelaide in 1880. IMAGE I-68892 COURTESY OF ROYAL BC MUSEUM AND ARCHIVES

Janet (née Fleming) Boyd (right) with her daughter Alice (left) and Mrs. and Mr. Norman Fraser.

Janet Fleming was the daughter of Thomas and Mary Fleming, who had emigrated from the British Isles to San Juan Island in the late 1840s. She was sixteen years old when she met widower John Boyd, part owner of Cold Spring House on the road between Quesnelle Mouth and Barkerville. They were married April 18, 1868, after which Boyd returned to Cold Spring and Janet remained in Victoria until June, when she took a stagecoach up the Cariboo Road with six laying hens "to keep her busy." The couple had ten children and eventually moved to the recently acquired Cottonwood House in 1886. Both stopping houses were successful financially and Janet lived comfortably, making frequent visits to her family on the coast. All ten of her children were well educated and attended secondary schools in Vancouver and Victoria. John Boyd died in 1909, but Janet lived on at Cottonwood and became known as the "Grand Old Woman of the Cariboo." She died the age of eighty-eight in 1940. IMAGE A-01133 COURTESY OF THE ROYAL BC MUSEUM AND ARCHIVES

This photograph by Carlo "Charles" Gentile of four Hurdy Gurdies posed on a sidewalk in Barkerville was taken in 1865, the first year they appeared on the creek.

A dance with a Hurdy Gurdy cost one dollar, and for a miner desperate for any female contact, it was money well spent. The women also got a percentage of the money a miner spent on drinks. The dancing lasted for five minutes, and the women were expected to dance until the last miner was exhausted at four or six in the morning.

In 1866, a letter to the *Cariboo Sentinel* described the "Hurdy Gurdy Damsels":

There are three descriptions of the above named "Ladies" here, they are unsophisticated maidens of Dutch [German, mostly] extraction, from "poor but honest parents" and morally speaking, they really are not what they are generally put down for. They are generally brought to America by some speculating, conscienceless scoundrel of a being called a "Boss Hurdy." This man binds them in his service until he has received about a thousand per cent for his outlay. The girls receive a few lessons in the terpsichorean art, are put into a kind of uniform, generally consisting of a red waist, cotton print skirt and a half mourning headdress resembling somewhat in shape the top knot of a male turkey, this uniform gives them quite a grotesque appearance. Few of them speak English, but they soon pick up a few popular vulgarisms . . . The hurdy style of dancing differs from all other schools. If you ever saw a ring of bells in motion, you have seen the exact positions these young ladies are put through during the dance, the more muscular the partner, the nearer the approximation of the ladies' pedal extremities to the ceiling, and the gent who can hoist his "gal" the highest is considered the best dancer; the poor girls as a general thing earn their money very hardly.

The account goes on to describe the "Hurdy Gurdy fiddlers":

This class of musician (pardon the misnomer) have also a school of their own, in which melody and euphony have no part. Noise is the grand object. The one who can make the most noise on the fiddle, and shout his calls the loudest, is (amongst the hurdy artists) considered the most talented. Sometimes, to increase the power of the orchestra (which seldom consists of more than two violins—more properly Fiddlers in this case), they sing and play, and in passing up Broadway, Barkerville, in the evening, you may hear them letting off steam as if their lungs were made of cast iron, and the notes forged with a hammer.

The "Bard of Barkerville," James Anderson, wrote a song about the Hurdy Gurdies that was sung in his Scots dialect to the tune of the popular song "Green Grow the Rushes Oh!"

Last summer we had lassies here
Frae Germany—the Hurdies, O!
And troth I wot, as I'm a Scot
They were bonnie hurdies, O!

Chorus: Bonnie are the hurdies, O!
The German hurdy-gurdies, O!
The daftest hour that e'er I spent
Was dancin' wi' the hurdies, O!

They left the creek wi' lots o' gold,
Danced frae orr lads sae clever, O!
My blessin's on their "sour krout" heads.
Gif they stay awa' forever, O!

The Hurdies usually left Barkerville for the warmer climate of Victoria and returned each spring to renew their dancing. They were still present through the summer of 1869, but by then, the days of free spending were starting to wane. There is no evidence that the Hurdies were prostitutes, as they were able to make good money simply by dancing. But many of them married rich miners and stayed in BC. The next pages tell the stories of some of them. UBC LIBRARY. RBSC. UNO LANGMANN FAMILY COLLECTION OF BC PHOTOGRAPHS. UL_1001_0081

top Elizabeth Ebert was born in the Grand Duchy Baden, part of the German Confederation. She arrived with her family in Barkerville in 1868 at the age of seventeen and found work as a Hurdy. In Barkerville, Elizabeth met Edward Doherty and the two married on December 16, 1871. Edward had acquired an abandoned pre-emption of 160 acres on Grave (Maiden) Creek at the 126-mile post from Yale, and the couple operated a roadhouse there. Like so many other families along the Cariboo Road, the Dohertys had a large family, consisting of five boys and four girls. The roadhouse gained a reputation for serving sumptuous meals costing only fifty cents. According to Willis West, manager of the BC Express, the meals "always included three kinds of hot meat for a mid-day meal, with vegetables and at least three kinds of pie and pudding, two kinds of cake, relish, cookies, and stewed fruit." Not surprisingly, Elizabeth and her daughters were excellent dancers and were always welcomed to the annual Clinton Ball. A hit of the ball was always when Edward and Elizabeth would dance the polka to the tune of "The Flying Dutchman." Edward died of pneumonia in 1897, but Elizabeth stayed to help her son run the roadhouse, dying in 1944 at the age of ninety-two. IMAGE G-06778 COURTESY OF ROYAL BC MUSEUM AND ARCHIVES

bottom Jeanette Ceise (left) left her home in Langheim, Germany, and came to Barkerville as a Hurdy. After a few years, she returned to Germany and convinced her sister Margaret (right) to come to America. When the sisters were in San Francisco, Jeanette married John Houser in 1870, whom she may have met earlier in Barkerville. In 1871, the Housers, now including a son, William, went to Barkerville but only stayed a year. They returned in 1875, along with Margaret, who married Charlie House of Syracuse, New York; he had been in Barkerville since the late 1860s. Both couples settled into Barkerville where, in 1884, the Houses bought a hotel and the Housers operated a saloon at Stout's Gulch.

The Housers had eight children, and John Houser, who worked in various mining claims, was a talented musician who taught his children to play instruments in his band. John died in 1909, but Jeanette lived in her house in Barkerville until her death in 1933.

The Houses had four children and continued to run the hotel as a favourite stopping place for miners; many miners boarded there as well. Charlie died in 1913, but Margaret was still running the hotel in 1939 when she died. BARKERVILLE MUSEUM PO331

top Rosa Haub came from Nieder-Weisel, Germany, and worked as a Hurdy in Barkerville in 1869. By then, the Hurdies were given more freedom to sell drinks and circulate among the miners. After leaving Barkerville in July, Rosa returned a few months later to sponsor a dance at the Theatre Royal for five dollars' admission. In November, she was back on the creek with a group of Hurdies and a fiddler to play at Sterling's Saloon. The young women were advertised as "Baden Terpsichorean Dance School." In 1874, at the age of twenty-six, Rosa married Ephraim Langell (Langille) from Nova Scotia, and the two settled in the small town of Eastsound on Orcas Island, one of the San Juan Islands in Washington Territory. The couple raised a family of fourteen children. IMAGE I-60884 COURTESY OF ROYAL BC MUSEUM AND ARCHIVES

bottom A closeup of the Cariboo Amateur Dramatic Society showing Emily Edwards (left) and Florence Wilson, with an unidentified man in between. Emily Penberthy Edwards was born in 1850 in Clifton, Michigan, daughter of Thomas Edwards and Jane Penberthy. Her father was involved in the Cliff mine, which was the first successful mine in the Michigan Copper District. Emily was educated in Clifton and the Young Ladies' Seminary in Detroit. In 1867, she accompanied her mother to the Pacific Northwest and ended up in Barkerville, where they decided to take up residence. Mrs. Penberthy, as she was known, purchased the Richfield Hotel, and Emily became involved in the Cariboo Amateur Dramatic Society, where she met the tall and handsome John Bowron. The couple moved into the building that housed the library, post office, and family living quarters, hastily constructed after the fire the previous September. This house became the centre of social activity in post-fire Barkerville, and Emily hosted all visitors, whether political bigwigs or miners down on their luck. She was prominent in the Church of England and was the Sunday school teacher and event organizer for St. Saviour's Church, which still stands at the bottom of the long street in Barkerville. When she died at the young age of forty-five, her obituary described her as follows: "Mrs. Bowron, by her agent and capacity for organization and training, contributed more perhaps than any other single person to the advancement and well-being of the community in which she so long played an active and important part." BARKERVILLE MUSEUM P0039

What is unique in the Cariboo gold-rush years is that despite their small numbers, a large percentage of women successfully ran their own businesses. Even as the mining frontier advanced, women were in the vanguard. In Keithey Creek, during the summer of 1861, there were six women at Antler Creek: "Red Headed" Davis's Indigenous wife as well as Mrs. Bailey, Mary Ann Webster, and Everina Rice, along with Mrs. Cusheon, her daughter, and her mother. When Barkerville sprang into being on Williams Creek, female business owners were quick to follow, even though the final stretch involved travelling on foot or riding horseback along the narrow mountain trail to Richfield, Barkerville, Grouse Creek, Mosquito Creek, and wherever gold was found. Boarding houses, laundries, hotels, and most of all, saloons were all businesses where women could succeed. Many were operated by married women whose husbands were busy mining, but an increasing number were owned by independent women who welcomed the opportunity to run their own establishments. The list of businesswomen in post-fire Barkerville is significant and includes the following:

Fanny Bendixon, saloon and hotel;
Madam Coulon, laundry;
Mary Dupret, saloon keeper;
Eliza Ebert, dancing saloon;
Mrs. Funck and her daughter, purchased Mrs. Tracey's
 boarding house in 1869;
Rebecca Gibbs, laundry;
Ann (Jane) Hickman, New Dominion Boarding House;
Madam Laurent, saloon keeper;
Mary Nathan, saloon keeper;
Eliza Ord, saloon keeper;
Catherine Parker, Miners' Boarding House;
Julia Picot, Hotel de France;
Ellen Price, wash house;
Kate and Emma Scwitzer, dance house employees;
Mary Sheldon, saloon keeper.

Of particular interest were Rebecca Gibbs and Ann Hickman, who were the only Black women in Barkerville. Rebecca and her husband, Richard, had been among the first group of Black immigrants

Elizabeth Hastie of Ayrshire, Scotland, met and married Andrew Kelly in Victoria in 1866. Andrew had established the Wake-Up Jake Bakeshop, Coffee Saloon, and Lunch House in Barkerville, and the couple made their way there in March. Years later, Elizabeth recalled the trip:

The only difficulty I experienced on that long walk, which was really my honeymoon trip, was during the last 12 miles. We struck a snow storm and my high heels sunk away down, and hoops would keep bobbing up to my shoulders. The latter being such a nuisance to let the six miners who were sharing the trail with us go ahead a bit. Then I took off my crinoline, and after folding it carried it on my arm. The Scotch plaid which was my mother's parting gift when I left home for California four years previously kept me warm.

The Kellys sold the Wake-Up Jake and opened a boarding house at Grouse Creek, but in 1871 bought the Hotel de France, which became the Kelly Hotel in Barkerville. They ran it until the 1920s. BARKERVILLE MUSEUM P1023

Mrs. Janet Allen, better known to the miners as "Big Jennie" or "Scotch Jeannie," and her boarding house on Mosquito Creek in 1868. With her are the Rankin brothers, owners of a very rich claim.

Janet Morris came from Fifeshire, Scotland, to Barkerville with her husband in 1862, and operated a small store. Her husband died in 1865 and, a few months later, she married William Allen. When she died tragically in 1870, the *Cariboo Sentinel* wrote:

Mrs. Allan came to Cariboo in 1862 and acquired the respect of every one by the numerous acts of kindness she performed in cases of sickness or distress. Whenever any accident occurred or any case of serious illness she volunteered her services and became the nurse and friend of the miner. She exhibited this human disposition at considerable inconvenience to herself. On one occasion of sickness at Lowhee Creek she left Camerontown, where she resided at the time, and walked to the bedside of the sick man for several days, although the road was rough and covered with snow... All the flags in Barkerville were hung at half-mast and all the circumstances and solemnity at an extraordinary funeral were exhibited.

BARKERVILLE MUSEUM P0073

to arrive in the colony in 1858. After Richard died, Rebecca moved to Barkerville to open a laundry. She was successful enough to purchase shares in the Reid Company and to buy a house in Barkerville. When her home was destroyed in the 1868 fire, she quickly rebuilt and carried on. Ann Hickman opened the Forest Hills Restaurant and boarding house in Richfield.

Rebecca was a published poet, and her poem "The Old Red Shirt" was published in the *Cariboo Sentinel*:

A miner came to my cabin door,
His clothes they were covered with dirt;
He held out a piece he desired me to wash,
Which I found was an old red shirt.

His cheeks were thin, and furrowed his brow,
His eyes they were sunk in his head;
He said that he had got work to do,
To be able to earn his bread.

He said that the "old red shirt" was torn
And asked me to give it a stitch;
But it was threadbare and sorely worn,
Which show'd he was far from rich.

O' miners with good paying claims,
O' traders who wish to do good
Have pity on men who earn your wealth
Grudge not the poor miner his food.

Far from these mountains a poor mother mourns
The darling that hung by her skirt,
When contentment and plenty surrounded the home
Of the miner that brought me the shirt.

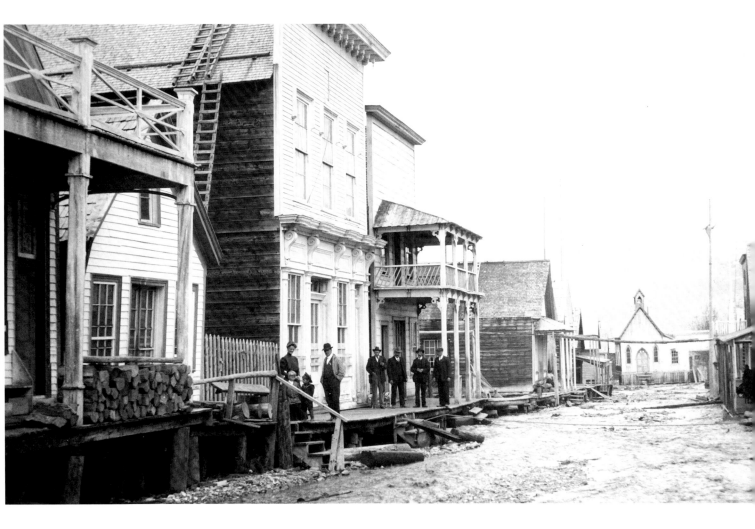

The Bendixen Hotel in Barkerville is the building with the covered balcony. Fanny (Frances) Perrier was born in France and arrived in California during the early 1850s. She later moved to New Orleans, where she met Louis Bendixen. After moving to San Francisco, they decided to go to British Columbia and arrived in Victoria in July 1862. They were married a few days later and had constructed the luxurious St. George Hotel. By 1865, their finances were in trouble, and Fanny travelled to Barkerville and spent the summer there. After returning to Victoria for the winter, she returned again to Barkerville and opened the renovated Parlour Saloon while her husband declared bankruptcy. Fanny stayed in Barkerville where, in 1867, she opened the Bella Union Saloon. The fire of September 1868 destroyed her saloon at a loss of five thousand dollars, a considerable sum at the time. After the fire, builders Bruce and Mann built her "a large saloon" that, according to the *Cariboo Sentinel*, wherein the "house belongs to Burdick but lot is owned by Madame Bendixen

with whom Burdick is in partnership. Mme Bendixen also owns the liquor license . . . House is also a boarding house—it has beds." During the 1870s, Fanny moved operations to Lightning Creek, where gold had recently been found. Her saloon at Van Winkle was declared to have "one of the finest reading rooms and picture galleries on the creek." In 1874, she sold this saloon and opened another called The Exchange in the town of Stanley. When the Lightning Creek excitement faded, she moved back to Barkerville and opened a small hotel she called the St. George. During the 1880s, she ran a two-storey hotel onto which she built a decorated roofed balcony. In his final trip to Barkerville, Judge Begbie, who had known her since her days in Victoria, described her "in great form; indeed enormous . . . though she was always of goodly diameter." Fanny died in 1899 in Barkerville and was buried in an unmarked grave in the Camerontown cemetery. BARKERVILLE MUSEUM P6041

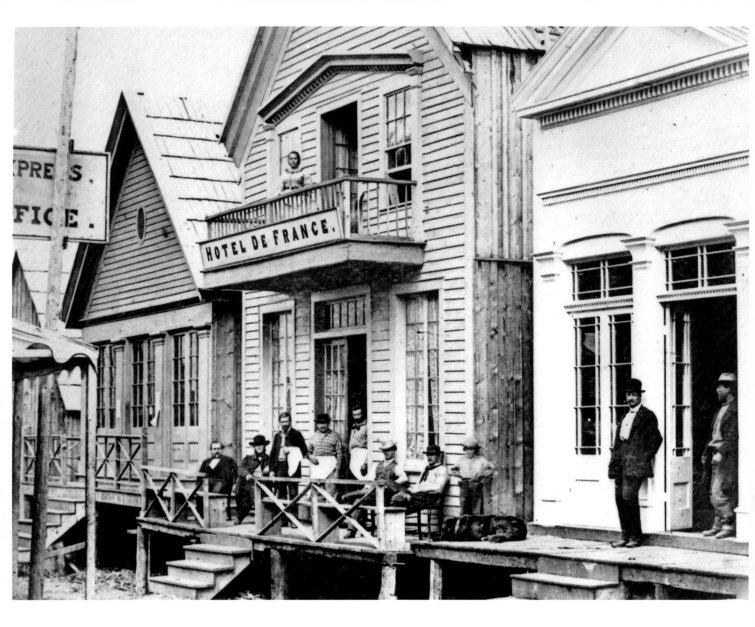

The Hotel de France with Julia Picot standing by herself in the balcony. Julia Picot first appears in Sacramento, California, in December 1860, where she was charged, along with several other women, with malicious mischief—a charge that was later dismissed. She next appears two years later in Umatilla, Oregon, with her father, mother, and brother, alongside the trail over which cattle were being driven to the Cariboo. It is possible she heard about the gold excitement in the Cariboo from passing cattle drovers as she travelled to Victoria in July 1861. By the mid-1860s she was living in Barkerville where, on June 3, 1868, it was recorded that she had bought "a piece of land . . . occupied by her house . . . presently occupied by Madame Bendixen." This house was destroyed by fire in 1868 at the cost of twelve thousand dollars. Despite this setback, she purchased the

rebuilt Hotel de France from A. Lecuyer and Jacques Le Brun in October 1869, just a month after they had finished construction. In June 1871, when Lightning Creek became the focus of gold mining, she sold the Hotel de France to Andrew Kelly "with all furniture, fixtures, and two first rate billiard tables in splendid order." From the proceeds, she purchased a boarding house in Stanley but did not stay there very long. The *Cariboo Sentinel* reported on September 2, "A house belonging to Julia Picot, at the upper end of Stanley, Lightning Creek, was burnt mysteriously on the night of 25th August. The proprietress had been there the same day and had removed her furniture to William Creek, and there can be little doubt but that the fire was the act of an incendiary [arson]." Julia Picot left the Cariboo for good the following month. HERITAGE HOUSE ARCHIVES

TEN

The Communities

ESTINED TO BECOME the largest and most flamboyant of all communities that were born and flourished on the Cariboo Wagon Road during the gold rush was a collection of shacks and shanties around the mine shaft belonging to Billy Barker. Named Barkerville in his honour, it clung to the bank of Williams Creek between Camerontown and Richfield. Its residents boasted that it was the largest community west of Chicago and north of San Francisco, a dubious claim. It also claimed to be the gold capital of the world, a much more legitimate title. Of the latter, there is ample proof. Miners, reaping gold tabulated not in thousands of dollars but in millions, trod the eighteen-foot-wide main street, leaving much of their treasure in the thirteen saloons and three breweries numbered among the business establishments.

In his book *Quesnel, Commercial Centre of the Cariboo Gold Rush*, Gordon Elliott describes the community in the following words:

Merchants came, and wooden buildings, generally of whipsawed lumber, were erected in an irregular fashion on an irregular street. Because the creek was subject to freshets and flash floods, most of the houses were on log posts, hardly two of the houses the same height. Consequently, the sidewalks in front were at varied elevations and made walking unsafe. Overhead the signs of various businesses protruded over the muddy, filth-strewn, hole-pitted eighteen-foot-wide street.

The town had everything necessary for community life; if not the best, then a good substitute. There were laundries, blacksmiths, butchers, bakers, pie-men-turned-masseurs, barbers, churches, saloons, and hotels; a theatre, a newspaper, and a cemetery. Wellington D. Moses, the Black barber who wrote such intriguing advertisements for his own brand of guaranteed hair

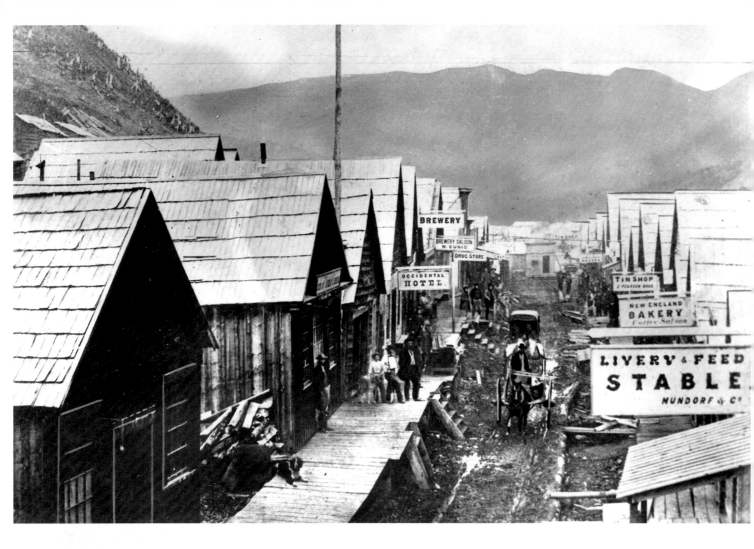

restorer, wrapped a bleached pine pole with red flannel in lieu of the traditional painted barber pole.

On September 16, 1868, Barkerville burned to the ground. In just one hour and twenty minutes, the entire business section and many homes were completely razed. In all, 116 buildings worth $700,000 were destroyed, with the heaviest loss suffered by a merchant named C. Strouss, whose store and house accounted for $100,000 of the damage.

Frederick Dally, the photographer who had opened a studio in Barkerville a few months before the fire, was among those burned out. He expected the fire, writing, "Stove-pipes very close together came through the wooden roofs of the buildings at every height and in every direction, and sent forth myriads of sparks and numbers of them were constantly alighting on the roofs where they would remain many seconds before going out. From the dryness of the season I came to the conclusion that unless we shortly had rain or snow to cover the roofs, the town was doomed."

Dally's description of the fire reads, in part:

The fire travelled at the same time up and down both sides of the street—and although my building was nearly fifty yards away from where the fire originated, in less than twenty minutes it, together with the whole of the lower part of the town, was a sheet of fire, hissing, crackling, and roaring furiously. There was, in a store not far from my place, fifty kegs of blasting powder and had that not been removed at the commencement of the fire, and put down a dry shaft, most likely not a soul would have been left alive of the number that was then present. Blankets and bedding were seen to be sent at least 200 feet high when a number of coal oil tins, 5 gallons, exploded, and the top of one of the tins was sent five miles and dropped at the saw-mill on Grouse Creek.

The fire was caused by a miner in Barry & Adler's Saloon trying to kiss one of the girls that was ironing and knocking against the stove, displaced the pipe that went through the canvas ceiling, and through the roof, which at once took fire. This information I got from an eye-witness who never made it generally known, thinking that it might result in a lynching scene.

Rebuilding started next morning. The *Cariboo Sentinel*, which began publishing in Barkerville on June 6, 1865, noted a week after the fire:

Already there are over thirty houses standing in symmetrical order on the old site, and the foundation of several others laid; and many more would yet have been in the course of erection were it possible to obtain carpenters and tools. The town when rebuilt will present a much more uniform and pleasant appearance. The main street has been increased in width fifteen feet and the sidewalks fixed at a regular and uniform grade. Vacancies which were originally intended for cross streets but occupied by sufferance, are now to be left open, and altogether the new town will be much more convenient for business, and will be a decided improvement on the old.

Barkerville was rebuilt, and as the paper predicted, did present a much more uniform and pleasant appearance. For over sixty years it served the outlying creeks—the creeks that had yielded some $100 million in gold and had been combed again and again by prospectors hoping to find treasure that the original argonauts missed. But they found nothing spectacular.

Then in the early 1920s appeared prospector Fred Wells. He knew that gold-bearing quartz veins had been found by miners in the 1860s but that no one had successfully established a hard-rock mine. After five frustrating years, he succeeded. In 1933, the Cariboo Gold Quartz mine came into production on Cow Mountain, about five miles from Barkerville. Then a second mine was established nearby, with eventual yield of the two over $40 million.

Established, too, was a new townsite, Wells, which overshadowed Barkerville. But the pioneer settlement refused to become a ghost town and has outlived many of the communities on the following pages.

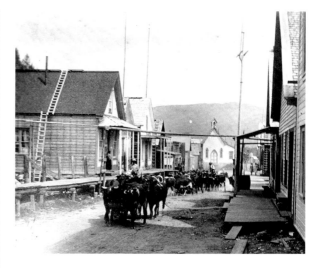

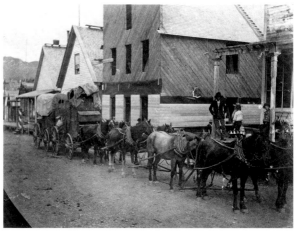

opposite This photo shows the lower end of Barkerville's narrow main street shortly before the all-consuming fire of September 1868. Among business buildings identifiable from signs are a stables, restaurant, drugstore, brewery, several bakeries, and a tin shop. The rebuilding of Barkerville started on the morning after the fire and, as shown in the post-fire photos on this page, the main street was soon flanked with buildings. HERITAGE HOUSE ARCHIVES

top An early street scene in Barkerville. HERITAGE HOUSE ARCHIVES

bottom Freight wagons arrive at Barkerville from Ashcroft. CITY OF VANCOUVER ARCHIVES. AM54-S4-: OUT CA N550

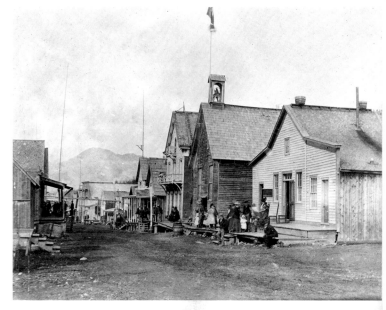

top A view of the street in Barkerville after the town had been re-built. From the right is the Cariboo Goldfields office, the fire-hall, and the Barkerville Hotel. By then, however, the community was already fading, since the miners had gleaned the creeks of their gold. Apart from brief flurries, Barkerville never regained its former glory. CITY OF VANCOUVER ARCHIVES. AM54-S4-: OUT P205

middle A name considered for the historic community was Springfield, a choice that led one miner to comment, "Some wish to call it Springfield; others, Barkerville. If we admire the trails which lead to it, and the different springs which help to keep the same in some places a complete puddle, I should say it was an appropriate name." BARKERVILLE MUSEUM P1596

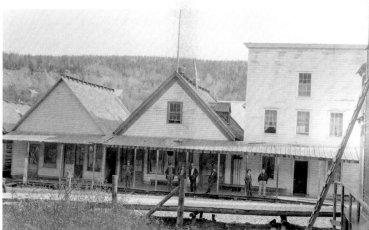

bottom Camerontown in September 1868. This community was just downstream from Barkerville on Williams Creek. In fact, Richfield, Barkerville, and Camerontown were virtually one street of buildings on the bank of Williams Creek. Because of this closeness, Barkerville was known also as Middletown. In 1863, Dr. Cheadle described the setting: "Our path was a difficult one over endless sluices, flumes, and ditches, across icy planks and logs, all getting tumbles, gumboots being very treacherous." UBC LIBRARY. RBSC. UNO LANGMANN FAMILY COLLECTION OF BC PHOTOGRAPHS. UL_1001_0093

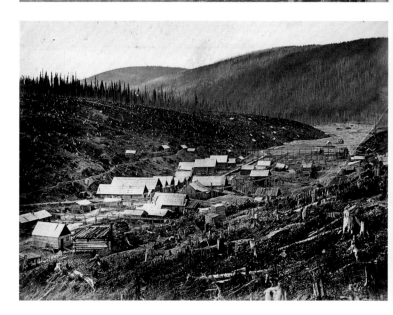

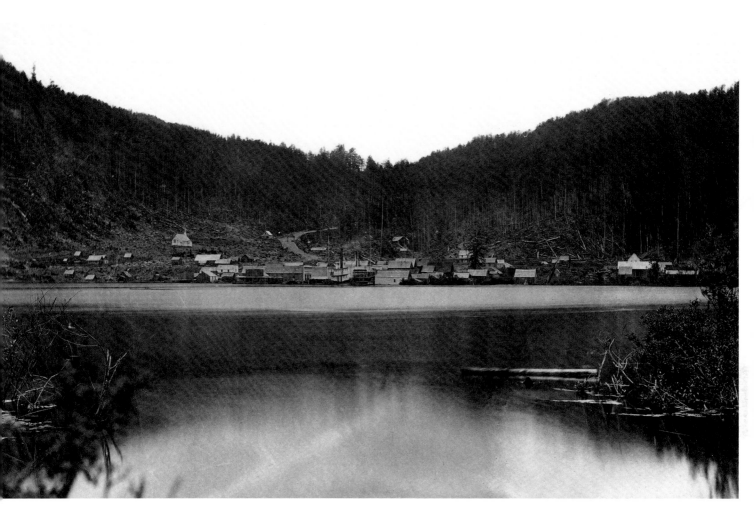

above The original portal to Cariboo was Port Douglas at the head of Harrison Lake. This photo shows the community in the early 1860s. With the completion of the Cariboo Wagon Road through the Fraser Canyon, however, Yale on the Fraser River quickly superseded Port Douglas. UBC LIBRARY. RBSC. UNO LANGMANN FAMILY COLLECTION OF BC PHOTOGRAPHS. UL_1019_0033

left Yale in 1868, when it had long since replaced Port Douglas as the entry point for the Cariboo, a position it held until the completion of the CPR twenty years later. One of the buildings, at left centre, is St. John the Divine Church. Built in 1860, the church was a familiar landmark to all those entering or leaving Cariboo. Today it is the oldest church in BC still on its original site. UBC LIBRARY. RBSC. UNO LANGMANN FAMILY COLLECTION OF BC PHOTOGRAPHS. UL_1019_0001

above New Westminster circa 1866. First called Queens-
borough, it was changed to New Westminster by Queen Victoria
on July 20, 1859. It was the capital of the Colony of British
Columbia until 1866, when the Colony of Vancouver Island
merged with the mainland Colony of British Columbia and
Victoria was named the capital. New Westminster was laid out
by the Royal Engineers on a site covered with giant fir, cedar,
and other conifers, some of them 250 feet high and over 25 feet
in circumference. For many years, the community was known
by the colourful and accurate title of "Stumpville." CITY OF
VANCOUVER ARCHIVES. AM54-S4-: OUT P171

right, top Hope in the 1870s. CITY OF VANCOUVER
ARCHIVES. AM54-S4-: OUT P48

right, bottom The Globe Hotel in Lytton in the early 1880s.
Despite its jerry-built appearance, the Globe was famous from
Yale to Barkerville for its comfortable rooms and excellent
meals prepared by owner Louis Hautier. In 1872, the Reverend
G.M. Grant was a guest, and noted, "The meat, fish, vegeta-
bles, and sweets on the table are all excellent." COURTESY OF
THE BRITISH COLUMBIA POSTCARDS COLLECTION. SIMON
FRASER UNIVERSITY LIBRARY

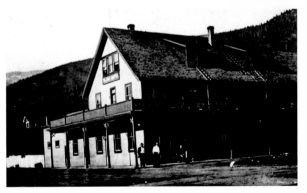

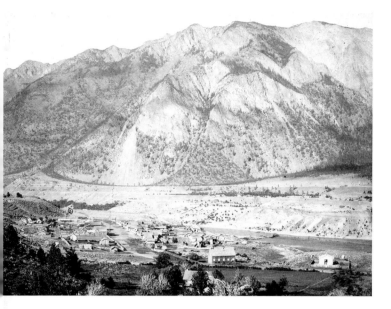

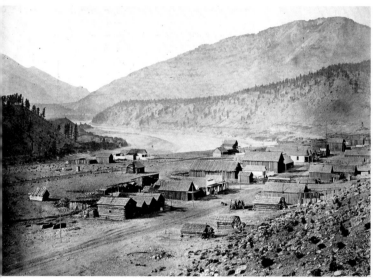

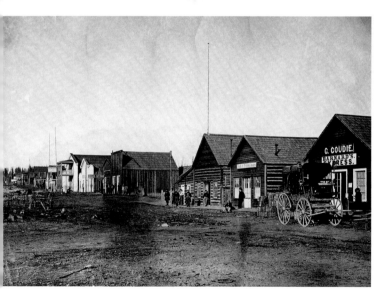

top A photo of Lillooet taken in 1894 by a photographer named J.H. Blome. Lillooet was the original Mile Zero on the Cariboo Wagon Road and the only community with a main street wide enough for a span of oxen to be turned in. Between 1860 and 1863, Lillooet supported thirteen saloons, with a total of twenty-five places licensed to sell liquor. St. Mary's Church, built in 1860, is still in active use here. CITY OF VANCOUVER ARCHIVES. CA AM54-S4-: OUT P778

middle Clinton in 1868, with the Cariboo Wagon Road running through the middle. LAC 3306879

bottom Below is the settlement of Quesnellemouth (so-named to distinguish it from Quesnelle Forks) at the junction of the Quesnel and Fraser Rivers in 1868. The Quesnel River was named in 1808 by Simon Fraser after his first lieutenant, Jules Maurice Quesnel.

The first shovel of gravel on the Quesnel River was spaded by Ben McDonald on June 3, 1859. On September 11, 1862, the first of the Overlanders arrived, and R.B. McMicking wrote, "Got to the mouth of Quesnel at 2:25 p.m. where there is abundance of provisions, there being two stores and eating houses and other little buildings, Indian huts, etc. Flour $50, salt $1 a pound, rice 55 cents, bacon .75 to $1, beans $1.75, tea $2 a pound."

In the spring of 1863, a *Victoria Colonist* correspondent wrote, "At mouth of Quesnel there is a town springing up which bids fair to be the largest interior town in B.C. The entire business of the present routes and of the projected coast routes must eventually centre here. A dozen buildings are in the process of erection and the machinery for a sawmill is on the way from Lillooet."

That summer, W. McColl of the Royal Engineers surveyed the surrounding lands for three townsites: Upper, Middle, and Lower.

That winter, the *Colonist* reporter noted, "What a change. The few scattered huts and shanties that in the month of June last collectively struggled for a name—for to call it a town or hamlet would be a libel on the language—have all disappeared and are replaced by excellent buildings, fronting on a good street." UBC LIBRARY. RBSC. UNO LANGMANN FAMILY COLLECTION OF BC PHOTOGRAPHS. UL_1019_0022

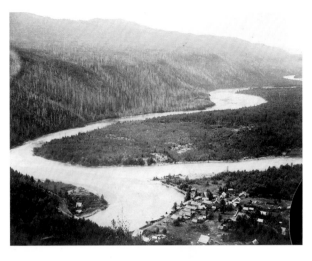

top Along the creeks on the goldfields, communities flared to life with each new strike but just as quickly passed into oblivion. Because of their temporary nature, and the carefree attitude of many miners, saloons were the most common buildings and usually the first. The first sermon on Antler Creek was held in a saloon; the back had been cleared for the occasion, but in front it was business as usual.

The first community to develop into a permanent camp was located on a ten-acre flat at the junction of the north and south forks of the Quesnel River. Shown here in the 1890s, it was known variously as Quesnel City, Quesnel Forks, the Forks, or Quesnelle. In 1860 it consisted of some twenty houses, a dozen stores, a variety of saloons, boarding houses, and a hodge-podge of cabins. River crossing was by ferry, until W.P. Barry and S. Adler built a two-hundred-foot bridge and charged a toll on miners and supplies coming to the goldfields. HERITAGE HOUSE ARCHIVES

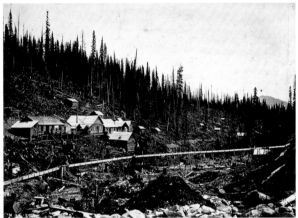

middle The community of Kellyville on Grouse Creek in 1868. UBC LIBRARY. RBSC. UNO LANGMANN FAMILY COLLECTION OF BC PHOTOGRAPHS. UL_1001_0101

bottom Van Winkle on the Cariboo Wagon Road at the junction of Van Winkle and Lightning Creeks in 1868.

For a time it appeared that Van Winkle would become the main supply point for many creeks. By the autumn of 1862, its business places included those of bakers, shoemakers, black-smiths, hotels, and a variety of saloons and gambling houses. The rosy predictions proved empty, however, and within a few years the community was virtually abandoned. UBC LIBRARY. RBSC. UNO LANGMANN FAMILY COLLECTION OF BC PHOTOGRAPHS. UL_1001_0067

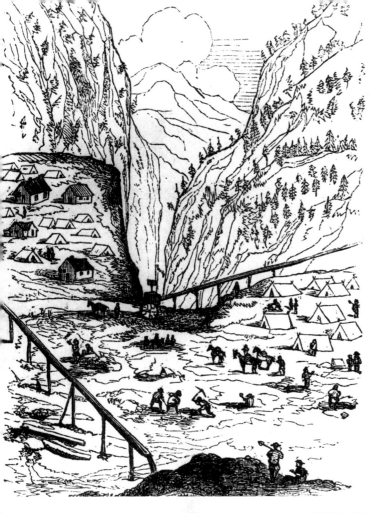

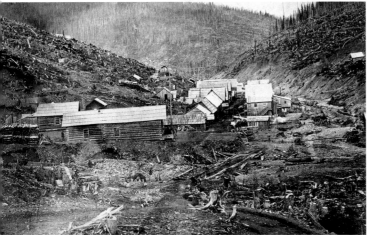

top The drawing shows cabins, tents, and stores at Antler on Antler Creek in 1861. One of the buildings was the first built of sawn lumber in the Cariboo. But Antler's flame was brief: by 1862 it was already waning and like most communities—including the one at right below on Mosquito Creek in 1868—was totally reclaimed by the forest. HERITAGE HOUSE ARCHIVES

middle The first major community on Williams Creek was Richfield, shown left in 1868. In 1863, a journalist wrote the following description:

The town comprised the ordinary series of rough wooden shanties, stores, restaurants, grog shops, and gambling saloons. On a little eminence was the official residence tenanted by the gold commissioner and his assistants and policemen.

In and out of this nest, the human ants poured all day and night, for in wet-sinking [of shafts], the labour must be kept up without ceasing all through the 24 hours, Sunday included. It was a curious sight to look down the creek at night, and see each shaft with its little fire and its lanterns, and the dim ghostly figures gliding about from darkness to light, while an occasional hut was illuminated by some weary labourer returning from his nightly toil.

UBC LIBRARY. RBSC. UNO LANGMANN FAMILY COLLECTION OF BC PHOTOGRAPHS. UL_1001_0068

bottom With the exception of the courthouse, shown in this photo, Richfield, too, has vanished. UBC LIBRARY. RBSC. UNO LANGMANN FAMILY COLLECTION OF BC PHOTOGRAPHS. UL_1001_0070

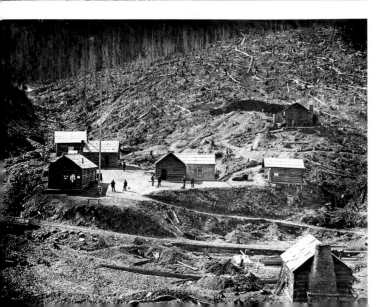

left The Barkerville Hotel in 1894. It was the finest building constructed in Barkerville after the fire, featuring cantilevered balconies supported only by brackets. The hotel was constructed by Johnny Nott, who is standing third from the left. He began construction in 1869 but took several years to complete it. It served as a home for a butcher shop, saloon, and boarding house and was known as the Brown Hotel before being renamed the "Barkerville Hotel" in 1890. BARKERVILLE MUSEUM PO720

right The Bank of British Columbia at Quesnel in 1864. It was described by the manager Walter Young as "a log house with a lot of bear skins tacked on the outside to dry, the owners of the skins putting them up without even asking permission. We treated our customers well, had a good fire, and furnished plug tobacco free, with a sharpened axe-head and a board to cut it on."

The Bank of British Columbia at Richfield, believed about 1863. There was another branch at Camerontown. Walter Young left the following description of it: "A two-roomed shack, built of boards and with many a chink through which the snow used to drift, until the walls were lined with cotton and paper. The safe was simply an iron box about three feet by two, and two and a half feet high. It had a lid with only one lock and no combination, and was often so full that there was difficulty in getting the lid closed." IMAGE A-00371 COURTESY OF ROYAL BC MUSEUM AND ARCHIVES

ELEVEN

BARKERVILLE CELEBRATES

THE EARLIEST DAYS of the Cariboo gold rush were largely an "American" phenomenon, as thousands of miners and would-be miners converged on the gravel bars of the Lower Fraser from California. It was these Californians, themselves representing many nationalities, who penetrated deep into the Cariboo highlands and discovered the legendary Cariboo creeks: Keithley, Antler, Grouse, Lightning, and, most famous of all, Williams Creek. Among this predominantly male population and the thousands who followed them into the Cariboo during the rush of 1862–65, any excuse for celebration was quickly seized upon and full advantage taken. "Striking it rich" was the most popular and perhaps legitimate cause for celebration. In the "champagne treat," the successful miner or miners staked everyone within walking distance to champagne as long as supplies held out. One of the annual celebrations was the Fourth of July, in which the Americans on the creek tried to outdo each other in making the day memorable. This fact was not unnoticed by the large Canadian contingent. (Just to be clear, "Canada," while actually referring to Upper and Lower Canada, today's Ontario and Quebec, was considered to include New Brunswick, Nova Scotia, and Prince Edward Island, at the time all independent British colonies.)

Imagine the Canadians' feelings of pride when the telegraph wires announced the formation of the Dominion of Canada in 1867. They, too, had an independent country to celebrate, and they were fully aware of the implications of the new Dominion's motto "From Sea to Sea." It only remained for them to demonstrate to their friends at home the willingness for joining their new home with their old. And one of the ways of demonstrating their fervour

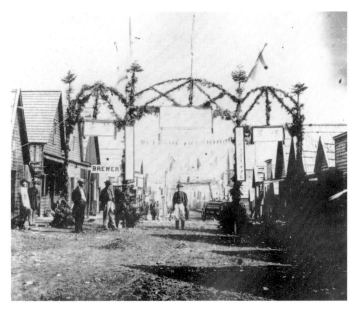

top A modern depiction of the Barkerville flag designed by William H. Hill in 1869. FRIENDS OF BARKERVILLE

bottom One of the four triumphal arches erected in celebration of Governor Anthony Musgrave's visit to Barkerville. This one, in the Chinese section of Barkerville, read "Welcome Excellency." The man in the white hat on the left is believed by historians to be Barkerville's barber, Wellington Delaney Moses. The Cariboo Sentinel reported, "The town was gaily decorated with flags. Every other house in Barkerville has its flag-staff and flag. Most prominent of all is the gigantic Dominion flag-staff, on which the Union Jack, with a beaver in the red ground, was hoisted. Stretched from the enormous pole to the house opposite was a large cloth on which appeared the words, 'Success to the Dominion' and at another part of the town hung the banner, 'Union for Ever.'" BARKERVILLE MUSEUM P1262

was through the tried-and-true method of celebrating. The results were guaranteed to make the wildest American on the creek stand up and take notice.

So it was that at one minute after midnight on July 1, 1868, the first anniversary of Confederation, the good people of Barkerville were startled out of their sleep by the thunderous roar of a twenty-one gun salute. But in the absence of cannons, the Canadians used the traditional "anvil chorus," consisting of putting one anvil on top of another and sandwiching between each a charge of black powder. When touched off, the resulting sound was deafening and did full credit to equalling the roar of the cannon. On that historic day, William B. Campbell, town blacksmith from Upper Canada, supplied the anvils and no doubt participated with glee in the furor. Of course, this was just the beginning.

The morning of July 1 dawned sunny and bright, and the festivities began in earnest. A full round of sports including horse races, athletic events, a greasy pole climb, and many more occupied the day, and in the evening the Theatre Royal gave a special performance, followed by a grand ball at Mrs. Tracey's boarding house. The grand finale was a fireworks display at 11:30 PM that was attended by over a thousand townspeople. Thus the first Dominion Day celebration in British Columbia, and perhaps in North America, passed into memory, not without a few large heads—no doubt the result of the anvil chorus.

The Americans on Williams Creek begrudgingly admitted that the Canadians had organized a real ripsnorter, but they were quick to point out that this fledgling Dominion had a long way to go before it equalled their glorious country to the south. Why, the new country didn't even have a flag! To further emphasize this, they placed their own flag, Old Glory, on top of a ninety-four-foot-high flagpole in front of Sterling's Saloon, better known as the Eldorado Billiard and Dancing Saloon and as American an institution as six-guns and Bowie knives.

As Dominion Day 1869 approached, the Canadians had had enough of this American symbol. Their country had been slow in adopting a flag, but they were not. Plans were begun in secret, and the local artist William W. Hill designed and painted a

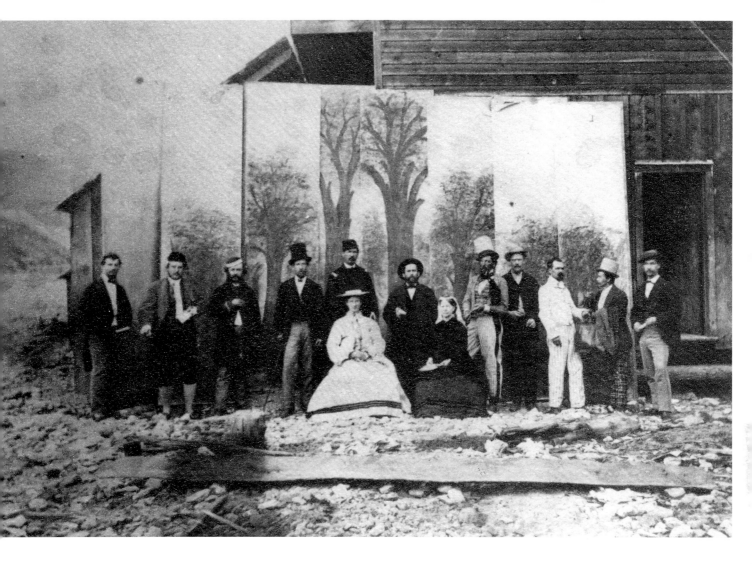

The Cariboo Amateur Dramatic Association actors. Left to right: Marcus Wolfe, J.B. Fisher, Joshua Spencer Thompson, William McColl, John Bowron, Emily Edwards, unidentified person, Florence Wilson, Dr. K.F. Foster, Gomer Johns, Frank Perret, Jack Hudson, Dixie Ross. For Governor Musgrave, the *Cariboo Sentinel* wrote that "the Cariboo Amateurs announce that they will give a performance tonight in honour of his Excellency the Governor, who has accepted an invitation to attend. Two splendid pieces have been prepared, and if the amateurs acquit themselves as well as usual the performance will prove extremely entertaining." BARKERVILLE MUSEUM P0038

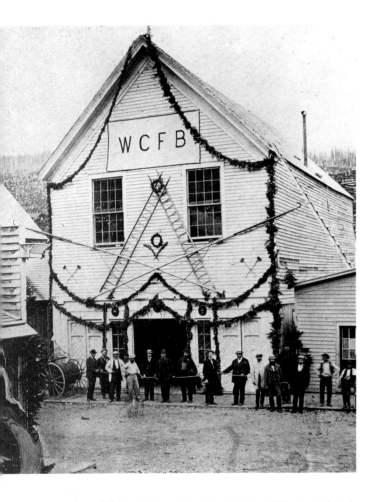

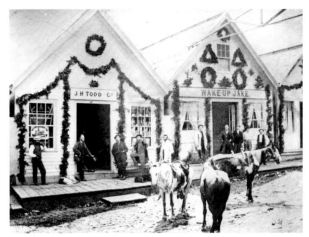

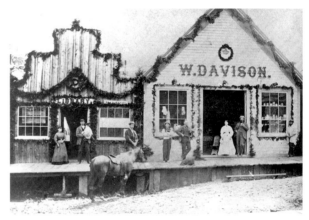

above, left The Williams Creek Fire Brigade building was shared with the Cariboo Amateur Dramatic Association, which occupied the upper floor and was where they performed in what was called the Theatre Royal. HERITAGE HOUSE ARCHIVES

above, top, right The J.H. Todd store and Wake-Up Jake restaurant. The restaurant was named for Jake Franklin, who repeatedly fell asleep at a table. HERITAGE HOUSE ARCHIVES

above, bottom, right On the left are John and Emily Bowron in front of their home and the library. On the right are Mr. and Mrs. William Davison in the doorway of their grocery store. BARKERVILLE MUSEUM P0726

opposite, top John Bibby, who came to the Cariboo with his brother James from Kingston, Canada West (formerly Upper Canada and now Ontario) in 1871, is leaning on the door of his tin shop. CITY OF VANCOUVER ARCHIVES. AM54-54-: OUT P334

opposite, middle The Assay Office was constructed by Denis Cain and finished at the end of June 1869. It housed businesses on either wing and a variety of rooms upstairs. HERITAGE HOUSE ARCHIVES

opposite, bottom Barkerville's enthusiasm did not go unnoticed, and it was with a not unjustified pride that the townspeople learned that one of their number, Dr. R.W.W. Carrall, had been called to the Canadian Senate, where he served until his death in 1879. The most significant contribution he made to Canadian legislation was his introduction of the bill on May 15, 1879, to celebrate July 1 as Dominion Day. The bill was passed and finally, some eleven years after the fact, the rest of Canada joined Barkerville in celebrating this great occasion. LAC 3479687

distinctly Canadian flag consisting of a beaver surrounded by a wreath of maple leaves on a white background in the middle of the British ensign. Under cover of night on June 30, 1869, the flag was placed on a pole and erected in Barkerville across from Sterling's Saloon. The people of Barkerville awoke on July 1 to view, not without some delight, the "new" Canadian flag fluttering proudly atop a flagpole 115 feet high, looking down on the American flag below.

The day began with the now traditional Anvil Chorus, followed by the usual speeches and sports, including the highlight, a velocipede race (bicycle, to the uninitiated). A further highlight of the day was the playing of the "Dominion March," written by the ever talented W.W. Hill. The evening saw balloons and fireworks displayed for the people's enjoyment.

As might be imagined, the residents of Barkerville did not miss any opportunity to celebrate, especially when it came to Canadian Confederation. It is no surprise that the proposed visit of Governor Anthony Musgrave in September that same year brought about a similar enthusiastic response. No less than four "triumphal arches" were constructed over Barkerville's single street.

It is not surprising that Barkerville became the most vocal town in the colony in arguing that British Columbia join the Canadian Confederation. The local representative to the Legislative Council was Dr. Robert William Weir Carrall, who hailed from Carrall's Grove, Upper Canada. He had been one of the prime movers in the early Dominion Day celebrations in Barkerville and was the strongest supporter of the pro-Confederation movement. Appropriately, he, along with William Trutch and J.S. Helmcken, was chosen to travel to Ottawa to negotiate the terms of Confederation. They returned victorious, and on July 20, 1871, British Columbia became part of the Dominion of Canada.

The celebrations that year took place on July 1 and July 20 and outdid every celebration that had gone before. The entire town of Barkerville was decorated with evergreen boughs, banners, and ribbons. Buildings were trimmed with greenery and

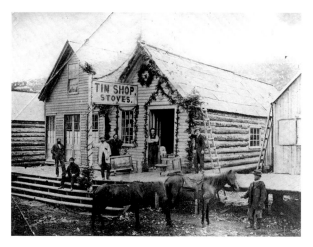

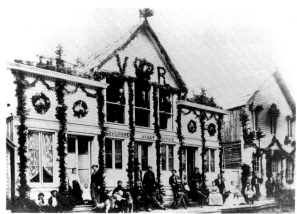

appropriate symbols appeared, such as V.R., for Victoria Royal, or crowns. The banners read "God Save The Queen," "Success to the Dominion" and "Union Forever." Festivities began at 10:00 AM with speeches from a platform decorated with evergreens and scarlet bannerettes wearing gilt maple leaves. Three cheers were given for Queen Victoria, three cheers for the Dominion, and the band played "God Save the Queen." The sports that day continued without interruption until 7:00 in the evening and included such events as "throwing the sledge," "merchants' race," sack and three-legged races, climbing the greasy pole, and a series of horse races right down the main street of Barkerville.

A royal salute was fired at noon using Mr. Campbell's tried-and-true anvils, and in the evening a special performance was given in the Theatre Royal by the Cariboo Amateur Dramatic Association. The evening was further highlighted by a "Grand Illumination" in which every household and business placed lighted candles in their windows until midnight. The day was accorded a complete success, and the town newspaper, the *Cariboo Sentinel* gushed that "we feel little hesitation in recording our belief that when the day has ended our little town of Barkerville will have fairly earned the title of Dominion Town . . . of the Colony."

TWELVE

James Anderson, Bard of Barkerville

JAMES ANDERSON came to Barkerville from Scotland in 1863. He was a talented songwriter and wrote verses that were presented at Barkerville's Theatre Royal. His poems, written in the Scottish dialect, appeared originally in the *Cariboo Sentinel*, then were published on a single sheet of paper called "Sawney's Letters, or Cariboo Rhymes." In 1895, they were collected and published in a slim volume.

Included among his poems were many that recorded the life of the "Poor but Honest Miner." The one overleaf describes a miner's cabin, typified by the accompanying photo taken on Williams Creek in 1868. Anderson, however, made no money from his poems or from the creeks. In November 1871, he returned to Scotland and died in 1923 at eighty-five years old.

"Farewell," his last poem, was printed in the November 25, 1871, issue of the *Cariboo Sentinel*. The paper noted: "Mr. Anderson has been a resident of Cariboo for the last eight years, during which time he has won the esteem of many friends, and we are certain has made no enemies. Fortune, we are sorry to say, has not smiled on him; and weary of wooing her embraces in the search for gold, he now returns to his old Scottish home, where a fond wife and family have long been mourning his absence. He was one of the original members of the Amateur Dramatic Association, and by his vocal talents rendered much assistance at their performances, his songs always much admired."

THE PROSPECTOR'S SHANTY

See yonder shanty on the hill,
'Tis but an humble biggin',
Some ten by six within the wa's—
Your head may touch the riggin'—

The door stands open to the south.
The fire, outside the door;
The logs are chinket close wi' fog—
And nocht but mud the floor—

A knife an' fork, a pewter plate,
An' cup o' the same metal,
A teaspoon an' a sugar bowl,
A frying pan an' kettle;

The bakin' board hangs on the wa',
Its purposes are twa-fold—
For mixing bread wi' yeast or dough
Or panning oot the braw gold!

A log or twa in place o' stools,
A bed withoot a hangin',
Are feckly a' the furnishin's
This little house belangin';

The laird and tennant o' this sty,
I canna name it finer,
Lives free an' easy as a lord,
Tho' but an "honest miner."

FAREWELL

Cold Cariboo, farewell!
I write it with a sad and heavy heart;
You've treated me so roughly that I feel,
'Tis hard to part.

'Twas all I asked of thee,
One handful of thy plenteous golden grain,
Had'st thou but yielded, I'd have sung "Farewell!"
And home again.

But, time on time, defeat!
Ah, cold and cruel, callous Cariboo!
Have eight years' honest persevering toil
No more of you?

Ah well, then since 'tis so—
Since Fate hath will'd I should no longer here—
I e'en submit, while disappointment starts
The hidden tear.

But still I'll picture thee
As some dear loved one in the days gone by,
And think what might have been, till dreaming
brings
The soothing sigh.

Farewell! a fond farewell
To all thy friendships, kindly Cariboo!
No other land hath hearts more warm than thine,
Nor friends more true.

James Anderson

THIRTEEN

Rest in Peace

"AND ONE OF Cariboo Cameron's men died so they packed him up the sidehill and planted him." Thus, on July 24, 1863, Peter Gibson, aged thirty-one, became the first man buried in what became the Barkerville Cemetery. Destined to follow him were those known and unknown, rich and poor, great and not-so-great. Included was the doctor who attended Sophia Cameron; Judge Chartres Brew, lawyer, gold commissioner, and the founder of BC's police force; T.R. Pattulo, whose nephew would one day be premier of the province; John A. Cameron; and many others. They came from Scotland, England, Ireland, Wales, Germany, Italy, France, the US, and other places.

Many grave markers in the Barkerville Cemetery are the work of Johnny Nott, an old-time carpenter who found his trade more profitable than mining. He used a more or less standard design, except that for himself, he built one that was more elaborate and distinctive. But when Johnny died in 1896, an ungrateful relative sold the marker and it now decorates someone else's grave. In an ironical twist, Nott's grave is unmarked.

In this respect, he shares the fate of many others. Dozens of gold seekers were drowned and have unknown resting places. Many perished on lonely trails and were buried by those who chanced upon their bodies; many others simply disappeared. Among the latter was John Rose, one of the party with Doc Keithley when he made the first major discovery in the Cariboo Mountains. About 1863, Rose and a companion left Barkerville on a prospecting trip and were never seen again.

The fate of one miner who disappeared was discovered by a man named Sim Shively while prospecting in the Bear River area, twenty miles east of Williams Creek. He noticed an area with bark

stripped from the trees and then saw a piece of cloth fluttering on a branch. Nearby was the body of a man with a tin cup near his head. On it was scratched the pathetic words "Donald Munro, in the woods, lost June 1863, is from Inverness Town, Scotland, born June, 1825."

In 1861, one miner noted in his diary, "After quitting our encampment in the morning, we shortly passed a stake on which was inscribed, 'A young man is buried here, being killed by a bear at this spot.' Four or five miles further on our way we came upon another grave with a board over it, on which was written, 'William S., aged 23.'"

At Soda Creek on November 14, 1863, Dr. Cheadle noted in his diary, "A number of men arrived on way down from Williams Creek. Came down in canoes. One laden to water's edge with fourteen men swamped in rough water of first riffle two miles below Quesnel. Seven men lost, five of them from Prince of Wales claim."

During 1863, on the road to Barkerville, a member of a pack train died. Near Jawbone Creek, his companions buried him and fenced in the grave. Over the years the fence rotted and the grave marker fell down. One day a prospector passed, picked up the marker, and put it in the crotch of a tree. There it remained for three decades until one rainy day, a vegetable peddler seeking dry wood to start his fire noticed the marker board and used it for kindling. And so one more joined the host who sleep in unknown graves.

The following pages present biographical data on a few of the thousands of people involved in the gold rush.

RICHARD WILLOUGHBY

A peculiarity of gold is that each creek leaves its own markings on it, and an experienced observer can tell the creek of origin. Richard Willoughby knew this, but he had evidently decided to have some fun at the expense of the storekeeper at Burns Creek, although some accounts insist it was an assayer with whom he was joking. "This is Williams Creek gold," Willoughby said.

"This is not Williams Creek gold," the storekeeper replied. At this exchange, nearby miners sidled closer. The gold Willoughby was showing was

in coarse chunks, and the nuggets were a different shape from those with which they were familiar.

Willoughby finished buying his supplies and left, but he didn't head for his claim until night. He knew that he would be followed, and after a while he waited for those trailing to catch up. "Is everybody here?" he asked.

"Not yet," someone replied, "there are several hundred strung out." Willoughby waited until they were all crowded around and said, "Boys, this is it. I am standing on my claim. You can begin staking."

By daybreak the entire creek was alive with miners hammering claim posts. Willoughby christened the creek "Lowhee" after the "Great Lowhee," a secret society in Yale to which many miners belonged during the Fraser River rush. Between July 27 and September 8 of 1861, Willoughby took out from his Discovery Claim 3,037 ounces from a strip along the creek measuring four hundred feet long by twelve feet wide. Nowhere did his excavation to bedrock exceed four feet, and usually it was only three. Much of the gold was in nugget form, with individual pieces weighing up to ten ounces. The creek, which drains into the meadows at the lower end of Jack of Clubs Lake, was less than two miles long, yet yielded nearly $3 million.

Willoughby had been an adventurer all his life, and he was to be one until he died. After his Cariboo success, he tried farming in the Fraser Valley but it didn't suit his restless temperament. When the Cassiar and Omineca gold strikes were made in 1869, he again yielded to the call of the wilderness. The rest of his life was spent in northern BC and Alaska. He died at Nome in 1904, leaving an estate of over a hundred thousand dollars.

JOHN ANGUS (CARIBOO) CAMERON

In John (Cariboo) Cameron, fate singled out a man who was to experience possibly the greatest triumph and the deepest tragedy of the entire gold rush. When news of the strike in the Cariboo reached Ontario, Cameron was a clerk with a wife and a fourteen-month-old daughter. He was devoted to both, and with the hope of being able to provide more comforts than could be bought with a clerk's pay, he headed for the Cariboo. His wife insisted on accompanying him.

They arrived at Victoria on February 27, 1862, after a twelve-thousand-mile voyage from Halifax around South America. He was almost broke, and then to compound his troubles, his daughter sickened and died. At this point, the grief-stricken Cameron had the fortune to meet Robert Stevenson, an old friend from Ontario. Stevenson was well known in Victoria and helped Cameron get two thousand dollars' worth of supplies on credit.

In early spring, Stevenson headed for the goldfields and later in the year, Cameron and his wife arrived on Antler Creek. On August 22, a company was formed consisting of Robert Stevenson, John and Sophia Cameron, Richard Rivers, Allan McDonald, and Charles and James Clendening. They staked ground on Williams Creek a short distance downstream from Billy Barker's claim.

As winter approached, the claim showed no sign of paying off. Then Mrs. Cameron became ill with typhoid fever and on October 23, with the temperature thirty degrees below zero, she died. She hated the creeks, and her last wish was to be buried in Ontario, far from the desolate and cruel wilderness of the goldfields. Cameron, now blaming himself for the death of both his wife and daughter, vowed to carry out her last request. He bought two coffins, one tin and one wood. He placed Sophia's body in the tin

coffin and then buried both in an abandoned cabin. Of eight thousand miners on the creeks during the summer, only ninety were left to attend the funeral.

Shortly afterwards they struck gold, and it proved to be the Cariboo's second-richest claim. But the gold did little to ease Cameron's conscience. He felt the loss of his wife and daughter more deeply now that he had money but was unable to share it with them. After New Year, he decided to take her body to Victoria on the first stage of the journey to Ontario. Stevenson insisted on accompanying him, and on January 31, in negative fifty degree weather with snow seven feet deep, they set out. The casket and fifty pounds of gold borrowed from the Barker Company was tied to a sleigh.

Port Douglas was 400 miles away. Some 250 miles was through wilderness, with only a trail to guide them, and the first 30 miles were over the roof of the trackless Cariboo Mountains. The party reached Victoria on March 7 after an incredible journey that wore out three horses, and after having survived a smallpox epidemic that left dozens of dead throughout the area.

In Victoria, Cameron had the tin coffin filled with alcohol and again buried his wife. He and Stevenson then returned to their claim and by autumn, Cameron was $350,000 richer. On November 8, he

sailed with the caskets of his wife and daughter from Victoria. At New York, he was horrified when Customs refused to believe that the 450-pound casket contained his wife's body. They wanted it opened. Cameron finally convinced them that he was telling the truth and was allowed to proceed. After he reached Cornwall, his wife had a third burial.

But ugly rumours started—the casket didn't contain her body at all. It was full of gold that Cameron had received for selling his wife to an Indigenous chief. Finally, Cameron could no longer tolerate the rumours. In the presence of Sophia's parents and friends the casket was opened. The alcohol had preserved her perfectly.

After the final funeral, Cameron tried to live quietly. He invested his money but never fully recovered from his tragedy, and his fortune gradually disappeared. He finally returned to Barkerville and on November 7, 1888, and died penniless at the scene of his triumph and tragedy.

JUDGE MATTHEW BAILLIE BEGBIE

A notable feature of the Cariboo gold rush was the comparative absence of violence characteristic of the California rush just ten years before. This fact is even more remarkable considering that there were only sixteen officers policing an area covering thousands of wilderness miles with a floating population of armed men and gold being mined by the ton. The primary reason for the overall lawful nature of the gold rush was a man named Matthew Baillie Begbie.

Begbie was a severe-looking man with a Van Dyke beard and mustache waxed to sharp points. He stood over six feet tall, had the muscular body of a boxer, the temperament of a bulldog, and the stamina of a long-distance runner. He needed all these qualities. During early gold-rush days, for instance, the only transportation was by foot or horseback, and usually a combination of both was required. Many times after a day in the saddle, wet and chilled by mountain storms, the judge's only shelter would be a tent so damp that even his books mildewed.

He was called by some a modest, generous man of intellect, and by others a harsh autocrat who made up the law as he went along. Although many of his latter judgements were questioned, there is no questioning the fact that during the critical first years of the gold rush stampede, he was the hinge upon which the door of justice hung. Perhaps his greatest contribution was his insistence in equal treatment of Indigenous and Chinese people before the law.

He always carried his robes and wore them wherever he held court, whether it be in a tent,

Edward Stout. HERITAGE HOUSE ARCHIVES

store, saloon, or cabin. In later years, he was called a "hanging judge," but he never hanged a man the jury didn't convict, and hanging was the only legal penalty for murder. His drumhead justice was the law that American miners could understand; his fearlessness won the respect of all. He was willing to fight with fists or with lawbooks, and never relented. At Clinton, he once sentenced a man and later in his hotel room heard the fellow's companions plotting to shoot him. The judge listened for awhile, then emptied his chamber pot over them.

A Victoria jury once released a man who had sandbagged a miner and killed him. Begbie considered the man guilty but the jury didn't. As he let the man go, Begbie concluded with the remark, "Prisoner at the bar, the jury have said you are not guilty. You can go, and I devoutly hope the next man you sandbag will be one of the jury."

Dr. Cheadle passed the judge near Clinton on the Cariboo Wagon Road in 1863 and wrote, "Passed Judge Begbie on horseback. Everybody praises his just severity as the salvation of Cariboo and terror of rowdies."

One miner summed him up thus: "Begbie was the biggest man, the smartest man, the best looking man, and the damndest man that ever came over the Cariboo Road."

Judge Begbie died at Victoria in 1894, by then the Chief Justice of British Columbia. He had helped guide the province through an era when he and a few policemen were the only difference between justice by might and justice by right.

EDWARD STOUT

Among those in the vanguard of the Fraser River rush was Edward Stout. He was born in Bavaria in 1827 and went to the United States in 1846. Three years later, he travelled to California and spent the next eight years mining for gold. When news of the northern strike reached San Francisco, he and some companions hired a schooner for transportation to Bellingham, Washington. Here, they built two flat-bottomed scows and, by oars and sail, made

their way to the Fraser River and upstream to Fort Yale, arriving May 20, 1858. The party made its way to the Thompson River when they were confronted by Nlaka'pamux people, who drove them back down the Fraser. In the ensuing skirmishes, Stout was shot in the arm and breast, and some of his party were killed. After peace was established, he recovered and joined those venturing into the Cariboo Mountains and was a member of the party that discovered Williams Creek. Stout's Gulch, just upstream from Barkerville, is named after him. After the gold rush, he settled at Yale and, in 1924, died at the age of ninety-nine, proud that never once in his life had he taken a drink of liquor.

LEE CHONG OF KWONG LEE COMPANY

Of the thousands of Chinese people who arrived in British Columbia during the gold-rush years, Lee Chong was the best known. He was the manager of the Kwong Lee Company's chain of stores in Victoria, Yale, Lytton, Clinton, Lillooet, Quesnel, Stanley, and Barkerville, In fact, he was so associated with the company that most called him "Kwong Lee." As head of the company, he was involved in many other activities, from mining, to packing, roadbuilding, and land acquisition in the new colony.

Lee Chong arrived in Victoria in 1858 and was joined by his wife in 1860, the first Chinese woman to arrive in what would become Canada. In 1863 an English visitor referred to "Kwong Lee" or Lee Chong as "quite a gentleman of most polite manners and very intelligent" and a fluent speaker of English "free from Yankee twang and slang." Because of his position in a business that was only second to the Hudson's Bay Company in British Columbia, he was a strong advocate for the Chinese population in the colony.

FLORENCE WILSON

Florence Wilson was one of a surprising number of unattached women who ran businesses in Barkerville. She had arrived on one of the "bride ships," the *Tynemouth*, that brought sixty unmarried English women to British Columbia in 1862. After working as a seamstress and salesperson in Victoria, she headed to the Cariboo, travelling on the first Barnard's Express stagecoach up the Cariboo Road in 1864.

Arriving in Barkerville, she set up a saloon and reading room that boasted 130 books and entered into the cultural life of the bustling city. She was a co-founder of the Cariboo Amateur Dramatic Society, where she initially performed with the group at the Parlour Saloon. In 1865, she sold out to a Mr. Moss and, that spring, her collection of books was purchased by Judge Cox and a lending library was set up. On her trip from Barkerville for Victoria, the stagecoach was unable to continue past Boston Bar due to deep snow. Undeterred, she put on snowshoes and hired a Nlaka'pamux man to guide her to Yale. She got to within four miles of Yale before she became exhausted and sought shelter in Hodge's Four Mile tavern.

Wilson returned to Barkerville and set up a new saloon, but the great Barkerville fire of 1868 totally destroyed her business. With characteristic determination, she rebuilt next door to the newly constructed Theatre Royal, in which she regularly acted. With the gold excitement in the Cariboo dwindling, Wilson struggled to survive financially and finally left Barkerville in December 1873 with her husband, blacksmith Samuel Tomkins. The two went to San Francisco and never returned to the Cariboo.

JEAN-JACQUES (CATALINE) CAUX

In every trade, there are always a few who tower above all others, and early-day packers were no exception. In this case, Jean-Jacques Caux, better known as "Cataline," was outstanding. He came west during the 1860s from the kingdom of Béarn in the Pyrenees Mountains, near the Spanish border. He quickly built a reputation for honesty and reliability.

He was a broad-shouldered man with a barrel chest and slim waist. His hips were narrow, and while he possessed tremendous strength, he was also very agile. He always wore a stiff shirt but

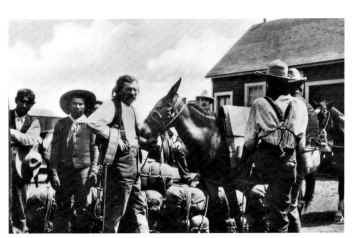

only on special occasions attached the collar. *A silk kerchief* around his neck, woollen pants, and riding boots completed his outfit. A distinguishing feature was his shoulder-length hair. His favorite drink was cognac, and with each drink he rubbed a little on his hair, considering this ritual a preventative for baldness. As he massaged the liquor into his scalp, he would say, "a little inside and a little outside."

He was friendly with Indigenous people and never once in half a century of packing did he have trouble with them. Another reputation of which he was proud was that he never failed to fulfill a packing contract. On two occasions his mule teams were virtually wiped out, but his freight was delivered with the help of Indigenous women he had hired.

When freight wagons made packing to Barkerville unprofitable for mule outfits, he simply moved north. For decades his pack train was known to mining camps, telegraph crews, settlers, trappers, and communities throughout northwestern BC. But time

finally caught up with Cataline. He made his last trip in 1913, ending a career of fifty-two years. In 1922, he died at Hazelton, believed to be at least eighty years old. He is buried on a high bench overlooking the country that he knew so well.

WILLIAM (BILLY) BARKER

William (Billy) Barker was born in Cambridgeshire, England, in 1817. He left his wife and young daughter in the mid-1840s and went to the US to seek his fortune. After mining in the California goldfields, he joined the rush to British Columbia in 1858. In early 1861, he was one of the first miners to arrive on Williams Creek, where he formed a company of six men to mine in the ground above the canyon. After labouring all summer on the claim, Barker sold his share of the claim and decided to try his luck downstream. The area below the canyon was considered barren, but Barker decided to stake anyhow. On August 13, 1862, he and six companions registered

their claim, each holding one hundred feet of channel. To the amusement of the miners above the canyon, they threw up a log-walled shaft house and started digging.

As they burrowed their way through centuries of boulder and gravel litter, other miners paused to joke about the mad-dog Englishmen. But Barker was a stubborn man, and the jibes of the miners made him more determined to carry on. They reached twenty feet and then thirty-five feet, deeper than any of the claims above the canyon.

With their shaft down fifty feet, far deeper than the level at which anyone had struck gold, Barker's companions were glum and discouraged. But he encouraged them to dig still deeper. Suddenly they struck the old channel. It was as rich as anything yet discovered—a pan of gravel yielded five dollars; a foot, a thousand dollars. The miners made fun of Barker no more. In his honour they named the collection of stores, cabins, and saloons that grew up around his shaft "Barkerville."

Barker, now a rich man, went to Victoria and, having heard of the death of his first wife, married Elizabeth Collyer, a widow who had arrived from England. In 1863, the couple travelled to Williams Creek for the summer. The following year, Barker sold his share of the claim and returned to Victoria. His wife died in 1865, and Barker's extravagant life and well-known generosity exhausted his fortune. He returned to the Cariboo and continued prospecting and mining until the 1890s. He died on July 11, 1894, at the Victoria Old Men's Home.

ROBERT STEVENSON

One of the most successful and best known of the Cariboo miners was Robert Stevenson. Judge Begbie once said of him that he knew more about Cariboo mining than any other man. Except for Stevenson, John A. Cameron would have never reached the creeks or staked the claim that yielded him a fortune.

Stevenson was from eastern Canada, arriving in BC in 1859. But he decided that the Fraser River had been greatly exaggerated and left for the Territory of Washington. With a party of thirty-four men, he crossed Snoqualmie Pass and eventually arrived at Fort Okanagan in the middle of June.

The party reached British territory at Rock Creek, where a gold rush was happening. Stevenson was appointed a customs inspector at Osoyoos, but when news of the strikes in the Cariboo reached the outside world, he resigned his job and headed for the goldfields. Learning that horses were in demand, he bought one hundred head at Osoyoos and drove them to Lillooet, selling them for an average profit of a hundred dollars a head. Because of this, he was one of the few men who actually took money *into* the Cariboo.

In the fall of 1861, he arrived at Williams Lake in time to see a horse race that became a classic. Popular accounts put the amount wagered at $100,000, but Stevenson believed the total was between $60,000 and $70,000. Only two horses were in the race, with the winner owned and ridden by Benjamin Franklin (Doc) English.

Stevenson remained in the Cariboo until he married in 1877; he then settled in the Fraser Valley near the present city of Chilliwack. He divided his time between farming and mining. His farm became a showplace, and he had mining claims throughout southeastern BC. In all, he was one of the most successful of the Cariboo miners.

opposite A group of those in the fore of the rush to the creeks of Cariboo photographed at Barkerville in 1907. HERITAGE HOUSE ARCHIVES

top, left Of all those who ventured to the creeks, a Yorkshire-born man named Jack Deighton has the most impressive epitaph. Unsuccessful in his quest for gold, he turned to the Fraser River and for several years was the captain of a stern-wheel steamer. In 1867, he left the river and on the shore of Burrard Inlet built a shake-roofed saloon, the Globe. Around the saloon appeared other buildings, and since Jack Deighton was a talkative man, the settlement was named Gastown in honour of "Gassy Jack." In 1870, however, residents changed the name to the more dignified Granville, then in 1886 to Vancouver.

Deighton died in 1875 at the age of forty-five. A news-paper article remarked that he "*was an original in his way,* and his name became almost a household word with most of our citizens." Nevertheless, he was soon forgotten. For nearly a hundred years, his grave in New Westminster's Fraser Cemetery was virtually unknown. Then a public subscription drive headed by Fred Hill raised money for a headstone. Bright gold on black granite, with etchings that include a river and a steamboat, it is now the most impressive in the cemetery—an appropriate memorial to a colourful pioneer. HERITAGE HOUSE ARCHIVES

bottom, left A unmarked miner's grave in the Barkerville Cemetery. HERITAGE HOUSE ARCHIVES

top, right Billy Barker, Judge Begbie, and many others who took part in the Cariboo gold rush are buried in Victoria. From a bois-terous collection of saloons, Victoria matured into the dignified capital of Canada's third-largest province. HERITAGE HOUSE ARCHIVES

Francis J. Barnard. HERITAGE HOUSE ARCHIVES

FRANCIS J. BARNARD

On April 14, 1861, at Union Bar, two miles above Hope, the sternwheel steamer *Fort Yale* was shattered when her boiler exploded. So powerful was the blast that a ninety-pound chunk of boiler was blown a quarter mile inland and five of her crew killed, including the captain. Among the shaken survivors was purser Francis Jones Barnard. After the explosion, he left steam-boating and started delivering letters and papers to the Cariboo mines. From this beginning emerged the famous BC Express Company.

F.J. Barnard was born in Quebec in 1829. When news of the Fraser River gold strike reached the east, he was living with his wife and family in Toronto. He decided to come west and in 1858 arrived at Yale, his assets a five-dollar gold piece. With money earned by cutting cordwood and carrying it into Yale on his back, he staked a claim, then sold it for a profit. Afterward he served as a constable and then as purser on the *Fort Yale.*

During his life he was actively engaged in political as well as business affairs. He was one of the group who fought successfully to have BC join Canada in Confederation instead of remaining a crown colony of England. Later, he was a member of the provincial legislature from 1866 to 1870 and a federal member of parliament from 1879 to 1887. He died July 10, 1889, a hardy pioneer who contributed much to the development of BC.

BARKERVILLE LIVES ON

AS THE GOLD-LADEN gravel of the creeks was gleaned of its treasure and the miners departed, the host of communities that housed, fed, and entertained them waned and vanished. Slated to survive was only one, the hodgepodge of buildings named after Billy Barker. After burning in 1868, Barkerville was rebuilt, but even as new buildings were optimistically hammered together, the community was fading. The town that in the 1860s flared in the wilderness died to a glow and then to a faint spark.

To the casual observer, she wasn't impressive—a weary collection of aging buildings squeezed against the bank of a mountain creek. She stood thus for over ninety years, almost a century of watching the snows of winter gild the peaks of the surrounding Cariboo Mountains, the warm winds of spring lick them bare again. With the coming of each summer, her hopes for survival diminished, her golden past became a little more forgotten, her population smaller until there were more buildings than people.

Some called her a ghost town, but she never reached this dreary status. Always there were a few to tread her single main street, a few to gather the relics of a vivid past, a few with faith in her future. They somehow felt that she would not be left to crumble, her historic buildings flattened by winter snows, then swept away by spring floods. And their faith was not in vain.

There were a few men and women of vision who knew the community's historical heritage, men and women who urged that she be preserved. They succeeded in arousing public interest, and this public interest was noted by the government. In 1958, the year British Columbia celebrated its centennial, the initial restoration steps were taken by the BC Centennial Committee, and the next year, Barkerville was designated a Provincial Historic Park.

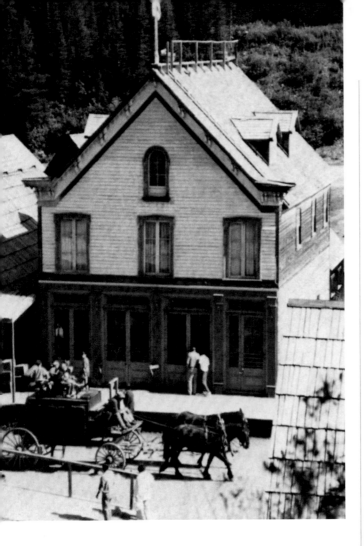

The Barkerville Hotel, now over 150 years old, is one of the original buildings to rise from the ashes of the 1868 fire. Construction began in 1869 by Johnny Nott, whose carpenter shop is among today's exhibit buildings. During restoration, post office receipts dating from 1869 to 1874 were found under the floor, as well as newspapers from across Canada and Abroad.

Barkervill's rebirth is not in the rip-roaring fashion of the 1860s, when her golden flame attracted the attention of the world. Today her progress is orderly and planned. And the nuggets are not gold from the creeks but people from BC, other provinces, the US, and elsewhere. Less than one hundred people visited her in the summer prior to the restoration announcement; the number then jumped to five thousand, then ten thousand, and now approaches sixty thousand a year.

In Barkerville, BC has an attraction unique in North America, a genuine segment of a colourful past.

On the following pages are pictures of some of the hotels, offices, saloons and other buildings which have been restored.

HERITAGE HOUSE ARCHIVES

The restoration is bringing back the Barkerville of the past. There are now 129 displays and walk-in exhibits, merchants and restaurants. Visitors can look inside Denny's Saloon, Wellington D. Moses's barbershop, John Bowron's home, and see Billy Barker's mine shaft and Cariboo Cameron's grave. They can attend service in St. Saviour's Church, have a meal at the Wake-Up Jake Restaurant, established in 1863 by Andrew Kelly and advertised in the first edition of the *Cariboo Sentinel*; they can stop by the Goldfield Bakery and buy one of the staples of the prospector and wilderness traveller, sourdough bread; and to help pay for it, they can pan for gold at the El Dorado Gold Panning and Gift Shop. The Mason and Daly General Store is a genuine step back into history, since all items for sale are in keeping with what was on hand in 1870. Another window to the past is Louis Blanc's photo studio, where visitors can have their photos taken wearing period costume in the atmosphere of a Victorian photo studio. (Louis Blanc arrived in Barkerville in 1867 and remained for five years.)

The registers at St. Saviour's Church and the pages of the *Cariboo Sentinel* record the births, marriages, and deaths of many pioneer Cariboo residents. On the opposite page is a photo of the church and Reverend James Reynard, who designed and helped build the over hundred-year-old landmark.

On page 142 are images of George Wallace, founder of the *Sentinel*, and the restored office where the paper was published. The *Cariboo Sentinel* was the first newspaper in the Interior of British Columbia, the first issue appearing June 6, 1865. It survived for ten years, its pages an invaluable record of Cariboo history.

Construction of St. Saviour's began in 1869 after Reynard paid $200 for the lot and $150 for foundation material. He hired the two best carpenters in Barkerville and recorded in his diary:

The wages $10.00 a day each, timber costing 10 cents a foot, and nails (very cheap) 25 cents a pound. My means, consisting of subscriptions, balance of church fund grant, and my Christmas quarter's stipend, just covered the first amount

top St. Saviour's Anglican Church in winter. The pews were made in Barkerville of local pine and square-headed, hand-forged nails. They were never varnished or finished in any way. The Bishop's chair, of English oak with not a nail in its construction, arrived in 1870, its exact age uncertain. The stove has a patent date of 1867, with church officials noting "it is almost certainly the original."

The church was opened on September 18, 1870. As a pamphlet by the Anglican Church in the Diocese of Cariboo notes, "Saint Saviour's still stands today as a tribute to the skill and solid workmanship of its designer and builders. The pews and interior of the building are as they were finished originally. Only slight repairs to the roof and foundation have been necessary as a result of more than a hundred Cariboo winters, when the temperature sometimes drops to 40'F below zero [-40 degrees Celsius] and six feet of snow is a common occurrence." HERITAGE HOUSE ARCHIVES

bottom Reynard was minister until 1871, when he moved to Vancouver Island. He died in 1875, still a young man but worn out from overwork and privation. During his first winter in Barkerville, for instance, he and his family decided they should have "potatoes on Sundays to mark this Christian Feast Day, and on Christmas Day, for a special treat, Cabbage. HERITAGE HOUSE ARCHIVES

for labour done. I was compelled to stop work when the building was a mere shell, not quite roofed in. I was resolute to have service on Christmas Day in the schoolroom, and therefore set to work myself, with my two lads for assistants. They are only little fellows: but they could hold one end of a board while I secured the other, and between us we finished the room in time.

Among names in St. Saviour's burial register is that of John A. Cameron. After his fortune of $350,000 had brought him only grief, he returned

top For many years a wooden carving of Billy Barker, left, welcomed Barkerville's visitors but eventually became weather-worn and had to be removed. In Barkerville's visitor centre, however, Barker's watch, right, and gold poke are among gold-rush artifacts on display. HERITAGE HOUSE ARCHIVES

middle Barnard's Express Office is among the buildings that have been reconstructed. For over half a century, it was Barkerville's link to the outside world, with passengers, mail, and express parcels arriving by stagecoach in summer and sleigh in winter.
HERITAGE HOUSE ARCHIVES

bottom The interior of J.P. Taylor's drugstore. The hundreds of bottles on the shelves, the stove, chairs, wall clock, and other items in this and all other displays are authentic of the 1869–85 era. Since the restoration started, companies and individuals have donated over fifty thousand items of period furnishings, but thousands more are needed. HERITAGE HOUSE ARCHIVES

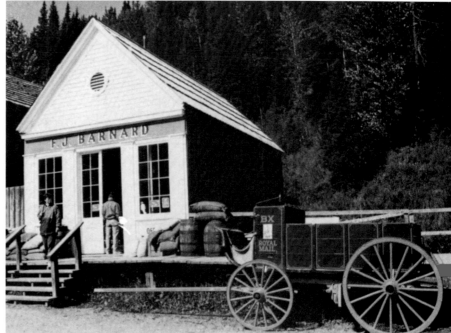

to the Cariboo in 1888. But as his friend Robert Stevenson noted, "... Dame Fortune does not often favor her protege twice. Poor Cameron. Six weeks after his arrival in Barkerville he died of a broken heart. Who knows?"

Cameron's grave in Barkerville's cemetery is almost opposite the claim that was so bountiful to him. His tragic life was paralleled by that of another miner in the cemetery—John A. Fraser, son of explorer Simon Fraser, after whom the Fraser River is named. In the early 1860s, John's three sisters and two brothers mortgaged the family farm in Ontario to send him to the Cariboo to invest in mines that looked promising. He did so but neglected to keep up the mortgage payments. On May 20, 1865, he received two letters—one telling him that the farm had been foreclosed, the other that his fiancée had married another man. That night he cut his throat with a penknife and rushed toward the woods.

Robert Stevenson and another man caught him and carried him into Dr. Chipp's surgery, where both Dr. Chipp and Dr. Bell tried to save him, but in twenty minutes he was dead. Ironically, a few days later, a rich paystreak was found on the Saw Mill claim, in which he had invested much of his money.

During his short stay in Barkerville, Fraser became very popular. He was president of the Literary Society and the Library Association, and was a member of the Methodist choir, then considered the best in BC. Of his funeral, the *British Columbian* newspaper at New Westminster noted: "His remains were borne to their last resting place by his Masonic brethren and by the largest concourse of friends ever before assembled in Cariboo for such a purpose."

Ten years later, Dr. Bell died at the age of fifty-three and was also buried in the Barkerville cemetery. Five years previously, another well-known resident, Mrs. Janet Allen had been buried in the cemetery. While driving to Williams Creek in a horse and buggy, she turned to talk to a miner and pulled too much on one rein. The buggy tipped over the bank and she broke her neck.

top The restored office of Gold Commissioner John Bowron, one of the Overlanders of 1862. Bowron Lake and Bowron Lake Provincial Park are named after him. HERITAGE HOUSE ARCHIVES

bottom The late Les Cook, park supervisor during the first eight years of Barkerville's restoration, discusses a historical point with then ninety-nine-year-old Fred Tregillus, "the grand old man of Barkerville." Tregillus came to Barkerville in 1886 and lived there longer than any other person. He died in 1962, a few months before his hundredth birthday. HERITAGE HOUSE ARCHIVES

1 Administration Building, Archives and Library

4 Visitors' Reception Centre, Admissions, Security, **Washrooms**

5 Eldorado Gold Panning & Souvenirs ◆

6 Tregillus Family Buildings (a-g) ❖

7 Wesleyan Methodist Church

9 Frank J. McMahon's Confectionery ◆

10 Blair House

11 Miners' Boarding House

12 St. Saviour's Anglican Church (privately owned) ❖

13 Williams Creek Schoolhouse ❖

14 King House Bed & Breakfast ◆

15 Bibby's Tin Shop

16 William Bowron House

17 John Bowron House

18 Wendle House ❖

19 McIntyre House

20 Cameron & Ames Blacksmith Shop ❖

21 Provincial Government Office ❖ Cariboo Literary Institute Library

22 Wilford Thomson House

23 J.H. Todd General Store

24 Barnard's Express Office (stagecoach tickets & rides) ◆

25 Wake Up Jake & Coffee Saloo

26 Goldfield Bake

27 W.D. Moses Ba

28 Barkerville Pos (full postal serv

29 Dr. Hugh Watt Office & Resid

30 J.P. Taylor Drug

31 Nicol Hotel Mu

32 Barkerville Sch

33 St. George Hot

34 Dr. Jones Denti

35 Masonic Hall C (privately owne

36 Louis A. Blanc Photographic C

37 Joe Denny's Sal

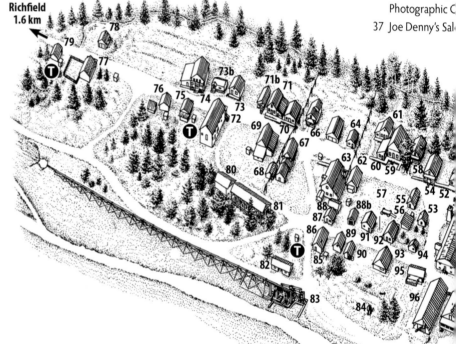

128
Richfield
1.6 km

BARKERVILLE
HISTORIC TOWN

◆ **Operating Business**

❖ **Walk-in / Interpreted Exh**

🅣 **Outhouse Toilet**

🆂 **Smoking Area**

NOTE: The restoration of Barkerville is ongoing, with existing heritage buildings being restored, those which have disappeared rebuilt, new displays opened and facilities changed.

On the above map, for instance, the Gold Rush Diner (2) is closed but there are two restaurants on the Historic Townsite—the Lung Duck Tong (63) and the Wake·Up·Jake (25) which was advertised in the first issue of the *Cariboo Sentinel* in 1865 (see page 142).

38 Louis Wylde, Shoemaker
39 House Hotel Coffee Saloon ◆
40 Pioneer Clothing ◆
41 Government Assay Office ❖
 J.O. Travaillot, Surveyor
 Joseph Parks, Barrister & Solicitor
42 Carriage Shed #2
43 McPherson's Watchmaker's Shop ◆
44 Kelly Saloon
45 Kelly General Store
46 Mason & Daly General Merchants ◆
◆ 47 C. Strouss Drygoods & Provisions ◆
48 Barkerville Hotel ❖
49 Carriage Shed #1
50 Theatre Royal &
 Williams Creek Fire Brigade ◆
51 Williams Creek Fire Brigade
 Hose Tower
52 Van Volkenburgh Cabin
53 Sandy McArthur's Blacksmith Shop
54 Cariboo Sentinel Print Shop
55 Giddings Cabin

56 Giddings Shed
57 The Clearing (special events)
58 Dr. Callanan's Residence
59 Kerr's Phoenix Brewery
 Washrooms
60 Kwong Lee Wing Kee Butcher Shop
61 Tsang Quon Residence ❖
62 Marie's Sporting House ❖
63 Lung Duck Tong Restaurant ◆
64 W. Hill Cabin
66 Kibbee House ❖
67 Halverson House Mining Museum ❖
68 Tai Ping Fong (Peace Room)
69 Chee Kung Tong ❖
 (Chinese Freemasons)
70 Wa Lee Store
71 Yan War Store
71b Torstensson House
72 Lee Chong Co. Store
 Chinese Museum ❖
73 Min Yee Tong
73b Lai Soy Lum Shop ◆
74 Kwong Sang Wing Store ◆
75 Lee Chung Laundry
76 Sing Kee Herbalist

77 Houser House
78 Fink Garage
79 Chinese Miners' Cabin
80 Ruston Engine
81 Waterous Sawmill
82 Eagle Claim Cabins
83 Cornish Water Wheel & Flume ❖
84 Stamp Mill
85 Sheepskin Co. Shaft
86 Sheepskin Co. Cabin
87 Wong Dan's Cabin
88 Trapper Dan's Cabin
88b Barker Co. Shafthouse
89 Anderson Cabin
90 Beamish Cabin
91 Myatovic House (Chinese School) ❖
92 Ah Cow's Cabin
93 Hibernia Co. Claim Building
94 Theatre Royal Storage
95 Lowhee Mining Co. Cabin
96 Lowhee Mining Co. Barn
97 Butterfield Barn
98 Barkerville Hotel Ice House
99 McKinnon Barn
100 McKinnon House
101 Kelly Woodshed

102 McKinnon Warehouse #1
103 McKinnon Warehouse #2
105 Blair Barn
106 Michael Claim Cabin
107 Barwise House
108 Barkerville Power & Light Co.
 Power House (1/2 of original)
109 Kelly House Bed & Breakfast ◆
109b Skid Shack
110 Turner Warehouse
111 W. Baker Stables
112 Mundorf Stables
113 McIntyre Cabin
114 Goldfields Garage
115 Holt & Burgess Cabinetmakers
116 Chicken House
117 Barkerville Power & Light Co.
 Power House (1/2 of original)
118 Morford House (privately owned)
119 McLeod Cabin
120 Tregillus Cabin
122 Smoking Room ❖
125 Kelly Workshop
126 Canadian Co. Cabin & Tunnel ❖
127 Gunn Claim Hydraulic Mining Pit ❖
128 Richfield Courthouse ❖
129 Wells-Barkerville Cemetery ❖

above Among the first buildings restored was the Wake-Up Jake Coffee Saloon, at centre. Next to it is Wellington D. Moses's barber shop. Moses, who arrived in Barkerville in 1865, was a friend of the murdered C.M. Blessing. Moses was an easygoing, talkative man whose shop was opposite Barnard's Express office. He was able to watch who arrived and departed and recorded this and other information in his diaries.

"Fine Clear Day," notes his entry for July 4, 1874: "BC Express [arrives] with mail, Mrs. Sarah Greer, Miss Annie, and a Chinaman as prisoners. Mrs. Greer and Annie Jones [in jail] for one year each, the Chinaman for 3 years. The Hurdies arrive and Dance at Wm Forest R Lipsett old Saloon."

Like many people of the time, Moses had a limited education. Nevertheless, his diary is a valuable record of 25 years of local events. He died in 1890 aged sevety-four and was buried in the Richfield cemetery. HERITAGE HOUSE ARCHIVES

left The street-facing front of Joe Denny's Saloon. HERITAGE HOUSE ARCHIVES

top Inside Joe Denny's Saloon. The first issue of the *Cariboo Sentinel* of June 6, 1865, contains several advertisements from saloon proprietors. Included were the Fashion, Terpsychorean, Parlor, Billiard, and Gazelle. The Gazelle was located in Camerontown and owned by S. Adler and W.P. Barry. They later moved to Barkerville, and on September 16, 1868, became famous—or infamous, depending on the viewpoint. That day, their saloon caught fire, which spread and burned Barkerville to the ground. HERITAGE HOUSE ARCHIVES

middle A freight wagon typical of those that served the Cariboo for over half a century, with Joe Denny's Saloon and the House Hotel in the background. When the Barkerville restoration program began in 1958, only a few of the original buildings were left. Because the first Barkerville was destroyed in the 1868 fire, the restoration and reconstruction covers the period from 1869 onward. HERITAGE HOUSE ARCHIVES

bottom Barkerville offers several types of accommodation: the King and Kelly House Bed & Breakfast, the St. George Hotel, and modern cottages outside the heritage zone. There are three campgrounds, which have campsites or cabins available for rent. Here visitors drive tent pegs or park motorhomes on gravel which once yielded a thousand dollars and more for every foot but where wages were only eight to ten dollars a day. Most of the vehicles used by visitors cost more than the average miner earned in a lifetime. HERITAGE HOUSE ARCHIVES

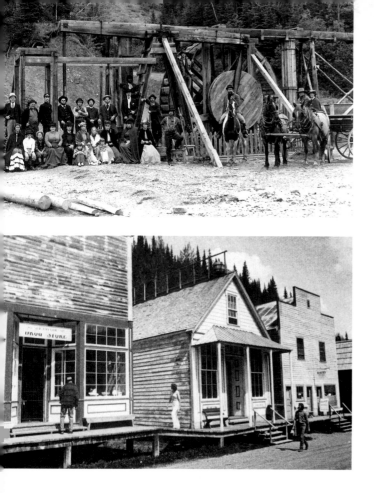

top, left Operating exhibits at Barkerville include the Eldorado Gold Panning & Gift Shop, where visitors can pan for gold, and a Cornish waterwheel, pictured here with Barkerville interpretive staff in 1985, typical of those used in the 1860s. HERITAGE HOUSE ARCHIVES

bottom, left Pictured here are three of the exhibit buildings: a bakery that sells fresh baked goods, a post office with regular postal service, and J.P. Taylor's drugstore. HERITAGE HOUSE ARCHIVES

top, right The *Cariboo Sentinel* building in Barkerville and, inset, the paper's publisher, George Wallace. HERITAGE HOUSE ARCHIVES

bottom, right The front page of the first edition of the *Cariboo Sentinel*. It was printed on a hand press brought nearly six hundred miles from Victoria by sternwheel steamer and freight wagon. In the first edition, editor George Wallace complained that there were too many public servants and "retrenchment is demanded." UBC LIBRARY. RBSC.

The Last Mile

AT BARKERVILLE, an interesting hike is the last mile of the Cariboo Wagon Road to Richfield. (The Wagon Road originally came to Richfield from now vanished Van Winkle via Lightning Creek, then down to Barkerville.) The only building surviving in Richfield is the courthouse, now over a hundred years old.

The easy walk to Richfield includes many points of interest, all described in a free booklet, "Walk the Last Mile to Richfield." It is available at Barkerville's museum.

In summer at Richfield's courthouse, an actor recreates the days when a few—very few—judges and policemen maintained law and order. They maintained it so well that the Pacific Northwest's foremost historian, Hubert Howe Bancroft, observed, "Never in the pacification and settlement of any section of America have there been so few disturbances, so few crimes against life and property."

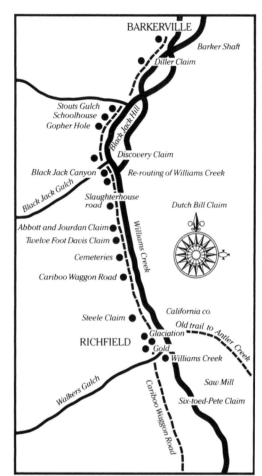

above In 1928 the Historic Sites and Monuments Board of Canada erected a commemorative cairn on the Cariboo Wagon Road near St. Saviour's Church. The inscription reads: Cariboo Goldfields Barkerville.

The centre of old Cariboo, whose goldfields, discovered in 1861, have added over forty million dollars to the wealth of the world. Here was the terminus of the Great Wagon Road from Yale, completed in 1865. The story of the Cariboo gold mines and the Cariboo Road is the epic of British Columbia.

top and middle, right Williams Creek where the first gold was discovered in 1861 by William "Dutch Bill" Dietz. The community which grew up around the discovery was called Richfield, an appropriate name since gravel was to yield $1,000 and more a foot. HERITAGE HOUSE ARCHIVES

bottom, right Richfield pre-dated Barkerville but has vanished except for the Courthouse, opposite, built in 1882 on the same location as the original log one. In it, Judge Begbie sentenced several men to hang, including James Barry in 1867 for the murder of C.M. Blessing.

The Courthouse is still in use as part of Barkerville's concept of a "Living Museum." In summer an actor recreates the days when Judge Begbie dispensed the justice which prevented the Cariboo gold rush from becoming as lawless as the California stampede 10 years before.

The Courthouse is an easy one-mile walk from Barkerville over the original Cariboo Wagon Road, top left, completed in the autumn of 1865. COURTESY OF LIZ BRYAN

The Wagon Road Today

THE WAGON ROAD is today's highway, with signs reminding travellers of the route's gold-rush heritage. From 1863 to 1886, Yale was Mile Zero and is today a highway community of 200 with most tourist services.

Points of interest are the Cariboo Wagon Road National Monument near the old sternwheel steamer landing; Yale Museum; the Yale Pioneer Cemetery, where Edward Stout is buried, although his grave was destroyed by a flood; and St. John the Divine Historic Church. Built in 1860, it is the oldest church in BC. still on its original foundation. Historical attractions along the 55-mile highway between Quesnel and Barkerville include Cottonwood House, built over 125 years ago and now a Heritage Building; Mexican Hill, Robber's Roost, Blessing's Grave, and the community of Wells, born in the 1930s as a result of hard-rock gold mines. With a population of 200, it has most visitor services.

Cottonwood House Historic Park, completed in 1865, preserves not only one of the best known madhouses on the Cariboo Wagon Road but machinery, tools, barns, and other buildings now over a century old. At the Barkerville Museum, the legacy of those who trudged northward to the Cariboo in the early 1860s is summarized. The miners needed food, equipment, and many services. Their supply points became the towns and cities of today. Their travel route, the famed Wagon Road, was and is now a vital artery to central BC. The pioneer farms and madhouses remained to give stature to BC sawmills, grist mills, telegraph, freight and express services, which set wheels of progress in motion. Miners continued to prospect and find wealth on which BC grew for decades. Every person in British Columbia enjoys a better life today because of events which took place in the Cariboo over a century ago.

top Historic St. John the Divine church. HERITAGE HOUSE ARCHIVES

middle This painting by Rex Woods, reprinted courtesy Confederation Life Insurance Company, shows Royal Engineers at work on the Cariboo Road in the Fraser Canyon north of Yale in 1862. A wall of rock has been, blasted with gunpowder and a chasm is being cribbed with logs and filled with broken rock. Near right center on a completed section of road two, horses pause with a "go-devil," a rough sled used for skidding logs.

Today, a Stop: of Interest plaque about 3 miles north of Yale commemorates the achievements of the 165 men of the Royal Engineers and nearby a short section of the Engineer's original rockwork forms part of the modern highway. HERITAGE HOUSE ARCHIVES

bottom Today's Trans-Canada Highway bridge over the Fraser River and, below it, the one built when the Fraser Canyon route was re-opened in 1926 after the original Wagon Road was destroyed by CPR construction in the 1880s. The 1926 bridge is on the same site as the 1863 one. HERITAGE HOUSE ARCHIVES

above "We had to pass where no human being should venture," wrote Simon Fraser of Hells Gate in 1808 when he was the first white man to descend the river which bears his name. COURTESY OF LIZ BRYAN

left Today's highway bypasses Lytton on benchland above the community. It has a population of some 400 and visitor facilities. ANDREW BOWDEN, CC BY-SA 2.0

top In 1886, with completion of the CPR, Ashcroft replaced Yale as the gateway to Cariboo. Bypassed by today's highway, it is a peaceful riverside community of 1,900 with most visitor facilities. The church of St. John at the Latin Gate was built in the 1860s at Ashcroft Manor and moved to its present location on the reserve of the Ashcroft Indian Band in 1920. In Skihist Provincial Park just north of Lytton is a section of the original Wagon Road. COURTESY OF LIZ BRYAN

middle Hat Creek House was established in the 1860s and served stagecoach passengers for almost half a century. Now an official Heritage Building, it is open from June to September. Don't miss the completely rebuilt BX stagecoach typical of those which travelled the Cariboo Wagon Road for over 50 years. HERITAGE HOUSE ARCHIVES

bottom Clinton's graveyard was established in 1861, two years before the one in Barkerville. HERITAGE HOUSE ARCHIVES

opposite, top, left Ashcroft Manor is a living link to history. Established by the Cornwall brothers in 1862, it served for decades as a stopping place and also a courthouse, complete with jail in the cellar. The two stately elms which shade the building were brought as seedlings from England well over a century ago. The Manor is today a popular museum, open daily in summer with attached teahouse. COURTESY OF LIZ BRYAN

opposite, bottom, left In Clinton, a village with a population of 750, the original Wagon Road is the main street, the same as in gold rush days. Some of its false-fronted buildings date back to the 1860s. Other windows to history are Pioneer Cemetery which dates to 1861 and the excellent museum on main street. Built in the 1890s of local hand-made bricks, it served for many years as a courthouse, then a school. Open from June to August, it is also the Travel InfoCentre. COURTESY OF LIZ BRYAN

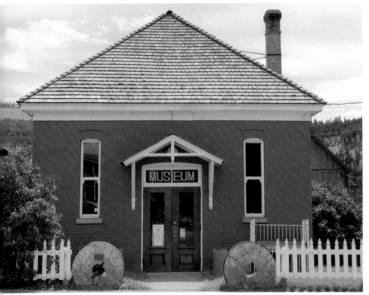

right, top The Palace Hotel was built in 1862 as the LaForest residence but later sold by Emile LaForest and became the Palace Hotel. **COURTESY OF LIZ BRYAN**

right, bottom At 100 Mile a replica BX stagecoach, above, is on display at the Red Coach Inn, built on the site of the original 100 Mile roadhouse. The community, population 1,700, offers a wide range of visitor services and centers a region famous for dozens of trout fishing lakes. **COURTESY OF LIZ BRYAN**

above A portion of the original Cariboo Road with abandoned buildings. The Wagon Road wound upwards and crossed near the 4,187-foot summit. In gold rush days ox teams could be a day plodding to the top. **COURTESY OF LIZ BRYAN**

right At the community of 150 Mile, a branch of the Gold Rush Trail heads eastward to Horsefly and Quesnelle Forks, left, a community which predated Barkerville but is now a ghost town. At bottom left is the restored Tong building at Quesnel Forks, evidence that the town was a major Chinese centre in the late 1800s. At bottom right can be seen other restored buildings. **COURTESY OF LIZ BRYAN**